What is Art History?

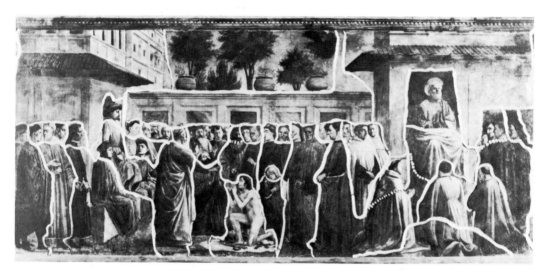

Frontispiece: Masaccio and Filippino Lippi, *The Story of Theophilus*. Brancacci Chapel, S.Maria del Carmine, Florence. The white lines indicate the sections of fresco painted on successive days (*giornate*). See p. 50.

WHAT IS ART HISTORY?

MARK ROSKILL

with 127 illustrations

THAMES AND HUDSON · LONDON

For Jonathan, Andrew and Damian

who by hook or by crook
will be first in this book.

© 1976 THAMES AND HUDSON LTD,
LONDON

Filmset and printed in Great Britain
by BAS Printers Limited, Wallop,
Hampshire

Contents

Photographic Acknowledgments

All photographs are the copyright of the museums concerned, with the following exceptions:

A.C.L. 112–14, 116–20
Alinari 35, 36, 45–47, 50, 51, 54, 55, 60, 66, 95
Anderson 38, 43, 44, 56, 58, 76, 77, 80, 83
Annan 102
Cameraphoto 62, 68
Country Life 12
A. Dingjan 16, 101
Gabinetto Fotografico, Uffizi 8, 29, 30
Giraudon 87–90, 107
Greater London Council 110
S. F. James 72
Mansell Collection 1, 2, 25, 31–34, 42, 53
Novosti 63
Walter Steinkopf 65, 91
Roger Viollet 6

Preface

THE choice of material for this book was arrived at in the following way. Each of the chapters, with the exception of Chapter 1, focuses on a single problem, illustrated by a key example. First, I chose examples from fields with which I am most familiar, and which include artists in whom I have a strong personal interest. I refer to Renaissance through modern art. The Renaissance is a particularly appropriate area to include, since it is in this field that the basic problems present themselves most definitely; and all of the early illustrations are taken from it accordingly. Secondly, I chose particular problems which can be illustrated in a small number of plates. Thirdly, the problems selected do not lead into any great controversy. Either there is reasonable agreement now concerning their solutions, or else they are ones that can be set out with a maintenance of openness as to possible answers.

I have chosen to use paintings throughout because, amongst works of art in general, these tend to have the most immediate appeal, and also because painting represents (in proportionate terms) the dominant area of art history.

Together with a supplementary book-list of books on the artists discussed which are well illustrated and in English, and of the books and articles by contemporary art historians that I have drawn on for the making of each chapter, a list will be found at the end of valuable books in the field which are available in paperback.

I am most grateful to a number of colleagues and friends who have given time to reading and improving different parts of the manuscript or discussing the problems involved: in particular, Iris Cheney, Sydney Freedberg, Creighton Gilbert, J. Richard Judson, John Shearman and Seymour Slive. Fabio Coen of Pantheon Books made a number of valid suggestions which I have used. Deirdre Roskill, at an earlier time, also contributed much in the way of ideas, criticism and practical help. In the later stages of revision, Louise Bloomberg gave strong and at the same time sympathetic editorial assistance and advice. As to my three sons, to whom the book is dedicated, I eagerly wish them well for whenever it is that each of them comes to read it.

M.W.R.

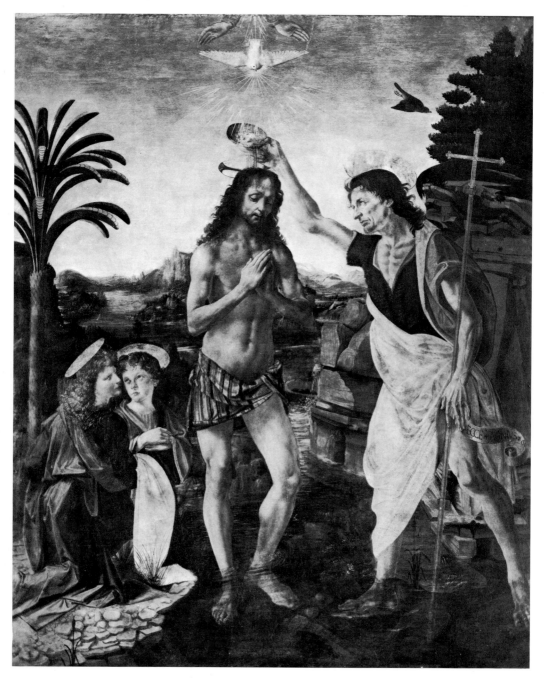

1 Andrea del Verrocchio and Leonardo da Vinci, *The Baptism of Christ*. Uffizi, Florence.

Introduction: the origins and growth of art history

THIS BOOK is an introduction to the way art history works. It aims to show, in terms which can be understood without any background knowledge, that art history is a science, with definite principles and techniques, rather than a matter of intuition or guesswork. Basic questions which the professional finds himself asked are answered in it, in a form resembling a series of miniature detective stories. The pleasure in itself of looking at works of art, a pleasure quite obviously felt by art historians in what they do, is not thereby discounted. But it takes second place here to the excitements and rewards of the discipline, which can also be communicated.

Art history may consist in large part of a series of opinions and judgments made by individuals, but the personal and subjective element in it should not be overrated. Though the artist is long since dead, like the corpse in a mystery (or unwilling to talk about what he did), and though much is lost or missing, both in the way of works and in the way of evidence, it does not follow that all is hypothesis, and that one man's guess or opinion is as good as another's. Changes of labels on works of art, and changes in what is known and said about them, are not simply a shifting kind of game, which goes on without altering the fundamental nature or value of the work itself. A work of art is affected in the way in which it is seen, by the label it carries, reflecting how it is rated and what is known behind that label. And if it is to give up its secrets, assuming it has some, it most often has to be worked at. Particularly if it is a great work of art, it does not spontaneously lay itself open to us.

The way in which knowledge and interpretation are arrived at, in a field with the highly developed technical character of modern art history, may seem also excessively intricate and slow. But the process itself can be a source of insight and fuller appreciation. By going over what art historians have noticed and put together that led them to their conclusions, more can be seen in the work, in terms of what it contains and the way it is done. So this book assumes, thereby complementing in its approach what surveys of art set out to do.

Every visitor to a gallery is gently instructed in art history without being aware of it by the very arrangement of the pictures on the walls. There is a room for Italian primitives, another for French Impressionists. No director

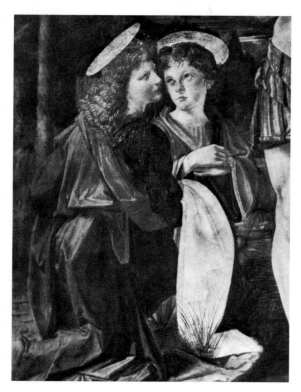

2 Andrea del Verrocchio and Leonardo da Vinci, *The Baptism of Christ*, detail showing the two angels. Uffizi, Florence.

3 Lorenzo Lotto, *Andrea Odoni*. Royal Collection, Hampton Court.

would dream of mixing them up together. Discrimination is part of enjoyment. The more easily one can distinguish between historical periods and geographical regions, the more pointed and relevant becomes one's reaction. The principles on which this is done, and the pictures themselves arranged— partly on the basis of tradition, partly on the basis of art historians' concepts —can therefore profitably be grasped in their fundamentals.

Discrimination also involves the ability to recognize with some confidence, through familiarity and study, the leading features of the art of particular periods and particular great painters. Even the most experienced connoisseur is very far from being infallible here. But a more moderate degree of expertise, or sense of what to look for and how, can still bring its rewards. Take, for instance, the famous painting in the Uffizi of *The Baptism of Christ*, which is labelled as the work of Andrea del Verrocchio and Leonardo da Vinci together. Even without the historical information that while Verrocchio painted most of the picture, he gave one of the angels to his young assistant Leonardo, then only about 19, and even without having studied in detail the other works of these two artists and of the period generally, one's eye should be alerted simply from looking to the marked differences which exist here between the left-hand angel and his companion to the right. The left-hand one shows much greater subtlety in expression and the handling of light and atmosphere. The pose is more graceful and there is more of a harmonious

10

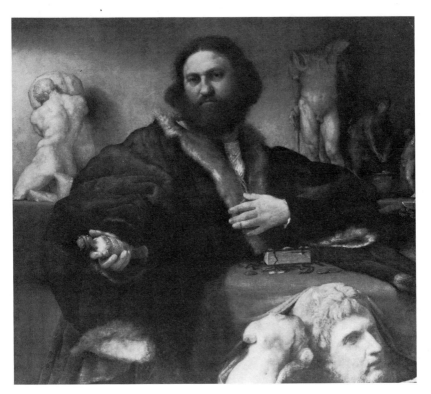

flow in the movement and fall of the hair and drapery. This, in fact, is Leonardo's angel: visual comparison, which can be confirmed and refined by the use of other works, makes concrete what the written sources say on the subject.

Works of art are part of the society from which they spring, and one cannot learn about one without learning about the other. They are mutually enlightening. In the Queen's collection at Hampton Court is a portrait of a burly gentleman in a fur-lined coat. According to the label, the man's name was Andrea Odoni, and the artist who did this painting of him, in 1527, was a Venetian, Lorenzo Lotto. There are things about this portrait which claim attention, in the sense of raising questions which are not simply visual ones, as to what they are and why they are there. Most notable are the many pieces of sculpture around the figure—standing against the back wall to the left and right and sticking out from under the tablecloth. The reason for this is that Odoni was a collector and connoisseur of sculpture: in particular he was a collector of pieces of Greek or Roman sculpture. They are so identified by the fact of there being heads, legs or arms or bodies missing, from destruction or the ravages of time, and from the general familiarity of the subjects or poses of the sculpted figures, which the artist in fact animates to an extra degree. Odoni is holding one miniature piece in his outstretched hand: he is showing a prize piece of his to the viewers of the picture,

outstretched

11

gazing out with a meaningful stare so as to fix the attention, and at the same time resting his other hand on his front in a way that conveys his personal pride of ownership. On these lines, from basic clues contained in the subject-matter, the whole presentation of the sitter and what surrounds him becomes understood. Questions of intellectual and social background, religious belief, patronage, choice of theme—all these affect our understanding of a painting and are therefore part of the history of art.

Art history is not only an illuminating discipline. It is also a profession. The techniques put to work in it are in essence the tools of the trade not merely for teachers but for art-dealers, museum curators and a host of others whose living depends on their being right about questions of attribution, dating, authenticity and rarity. Suppose yourself confronted by a work claiming to be a self-portrait of Van Gogh. What would you need to know in order to decide whether or not it was genuine? First you would need to know whether there are similar self-portraits by Van Gogh. There are in fact three different ones to consider, but the one most like the example does not have all the elements included here, like the pipe and the Japanese print to the rear. Those elements are matched almost exactly in the other two cases, which are separated by more than a year in date. And while Van Gogh did second, and sometimes further versions of many paintings of his, they are marked by modifications and revisions that he introduced, or by changes and adjustments that came about in a natural sort of way; not by a piecing together, almost like a jigsaw puzzle, of parts available for re-use from then and earlier. When suspicion falls on the authorship of a painting, its past history must also be known, and in whose hands it had previously been. A fact directly to the point here is that unknown Van Goghs are rarely found, because, with a few exceptions that are usually known about from the artist's correspondence, the works that Van Gogh produced almost all passed to his brother, and then to his brother's widow and to their son. This means that there should be a record of ownership, or some reliable and convincing explanation in lieu, to back up the sudden appearance of a work of this kind. This particular painting was first recorded, in the 1920s, as belonging to a private individual in Switzerland: supposedly brought there by a Russian refugee. The final argument in questions of doubtful authorship, as in almost all problems of art history, must come from close study of the picture itself. In this case, study of the brushwork shows that besides being messy it has characteristics of several different stages in Van Gogh's development. In fact this work is generally taken today to be a quite simple and clumsy forgery; and indeed it did not take long, following the picture's appearance, for this judgment to establish itself.

The chapters that follow have been written to illustrate various distinct aspects of the art historian's work: the problems of attribution, the 're-assembly' of an artist's work leading to the discovery of a virtually unknown genius, the reconstruction of complex works to arrive at an understanding of how they originally looked and were taken in by the viewer, the detection of forgery (this being indeed a fascinating topic with implications that challenge the whole aesthetic basis of connoisseurship), and finally the light

12

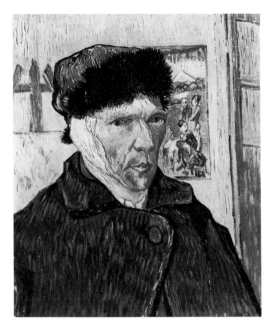 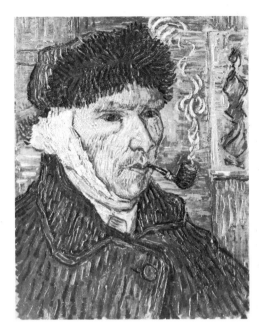

4, 5 Two paintings claiming to be self-portraits by Vincent Van Gogh. That on the left (Courtauld Gallery, London) is genuine; that on the right (Fogg Art Museum, Harvard University, Cambridge, Mass., Bequest Annie S. Coburn) is a forgery.

which an art historical approach can shed even on a modern work like Picasso's *Guernica*.

It happens that all of the examples used are paintings, but the same sort of problems come up with sculpture, architecture and prints. All are also Western paintings, not older than the fifteenth century. This is not accidental. Classical, medieval and Oriental art have special problems of their own. Classical art is to a large extent nameless. Although many names of painters and sculptors are known from literary sources, very few examples of sculpture, and no paintings, can be attributed to a named artist. With vase paintings, conversely, there are some signed works beginning in the sixth century BC, but no outside information as to who those artists were. Medieval art involves an equal or even greater proportion of losses out of what originally existed, its major arts being particularly perishable, and the study of Oriental art is still approximately in the state that the study of European art was in a century ago: the basic material is still being collected and sorted.

It is important to realize at the outset that art history overlaps with a number of other areas of study. The study of ancient art overlaps with archaeology. Both the study of primitive art and comparative study of the arts of different cultures overlap with anthropology; and the study of popular art forms (such as posters, billboards and graphic illustrations of the

13

kind that appear in popular magazines) reaches over into sociology. The study of the ideas of a period, as they are communicated in art, leads across to and links up with the literature, music and philosophy of the same period; and the theory of art, defined as a body of material to include the artists' own statements and the critical writings of contemporary supporters, ties in with philosophy in another way, in content, as does also the study of the principles of criticism.

The study of aesthetics, whether this means investigating the history of taste or the governing principles of art in a particular medium, equally acts as a bridge between art history on the one side and philosophy on the other. The study of artistic techniques leads across into scientific work on the technical structure and make-up of works of art, involving problems such as colour analysis and radiographic analysis, which require special scientific equipment. And the study of the processes of human perception in the case of works of art overlaps with psychology.

The museum man, in a different way, combines two disciplines since he is trained as an art historian but works as a curator. He will normally be in charge of looking after the whole collection of his museum, or the collection in his special area. He will see that the works are kept in proper condition, with the help of his conservation staff, and will deal with aesthetic questions of display, and also very often be engaged in cataloguing the collection, so that all the relevant information on each work, such as where it came from or how it was displayed, is tracked down and made available in published form or on file. He will deal with the organizing of special exhibitions, getting the works together, hanging them, and preparing the catalogue, which may range from a simple check-list of the works all the way to a book-size publication. He may also deal with the effective use of the museum for teaching purposes, working with schools and colleges, and may lecture within such a programme.

The strict art historian, who is normally either a teacher or an independent scholar, may approach his subject from many different angles other than those already mentioned. For example, he may study the common characteristics or directions of development shared by several different artists of a period. He may investigate how art was affected by a historical event of particular importance, such as an earthquake or plague or war, or a religious upheaval or the evolution of new knowledge or learning, or by revolution or a change of monarchy or government. He may also probe into the narrower inter-relations between different arts within a certain period, with a view to better defining, or redefining, the labels used for such periods.

The most basic kind of publication that art historians produce is probably the monograph on a particular artist. In it all the artist's works will be sorted out and catalogued, with illustrations to match; and an interpretative essay will usually be provided to go with this. There the development of the artist's work will be dealt with from different points of view (style, subject-matter, technique and so on), and the discussion of how the artist developed and of his total achievement may well shade into criticism. The art historian

14

should also be something of a critic, in order to provide fresh viewpoints concerning an artist, and new insights into his work, rather than simply describing and surveying his subject.

Whether writing a monograph or doing any other kind of study, the art historian should, in principle, be informed about the political, social and intellectual aspects of the culture and period on which he is working, and in particular have knowledge of its other art forms, such as its poetry and music. Apart from the possibility of drawing specific parallels with those other art forms, there has always been a sense—not just in the Western tradition, but seemingly universal to all cultures—of a broad companionship between the different arts, and very many cases of their being used in combination together. For example, artists have worked on theatre or ballet designs or the illustration of books, and works of art have been used, along with music or dance or declamation, in state or religious ceremonies.

In what people say about art historians, and the way they describe their studies, there lurks the idea that they are mainly concerned with the sources on which an artist drew, with the influences upon him and his influence upon others. There is a half-truth here, but it contains the seeds of misunderstanding. Art historians *are* concerned with sources, but not for trivial reasons. The artist 'uses' his sources, not in the sense of reproducing them or depending on them for ideas that he lacks himself. Artists never begin from scratch. However fresh and original their own vision, they cannot entirely break free from their own age; they can only extend and transform what they inherit from the past. They act on and with their source-materials, to enhance or transform them, through their personal handling of the medium, or the possibilities they see for putting different elements together, or the context into which they put them: as Titian, in using for the goddess Venus a pose known to him from an ancient relief sculpture, turned the figure in this pose, through his paintwork, into a creature of flesh and blood rather than cold marble; or as Rembrandt, for a self-portrait which he etched in 1639, drew separate elements from a famous portrait by Raphael and one by Titian, both of which he had seen in an auction earlier that year; or as Gauguin took from a photograph the pose of a native Tahitian drinking at a spring and the general arrangement of water and jungle around, and fitted these, in his painting entitled *Mysterious Water,* into a setting composed of simplified decorative forms. A large, even immense, fund of images is likely to be stored in the artist's mind. These may provide a continuing basis of a broad kind for compositional ideas, or they may carry special associations for him. Here too, therefore, there is plenty of interpretative work for the art historian to do, beyond simply seeking to establish where a particular gesture or form of composition came from.

Every aspect of an art historian's work, as described, involves comparing and relating large numbers and groups of works. Here it must be noted to what extent photography has transformed the study of art history. With the availability of magnified details and good colour reproduction, the present-day art historian is in an infinitely favoured position, compared with his

15

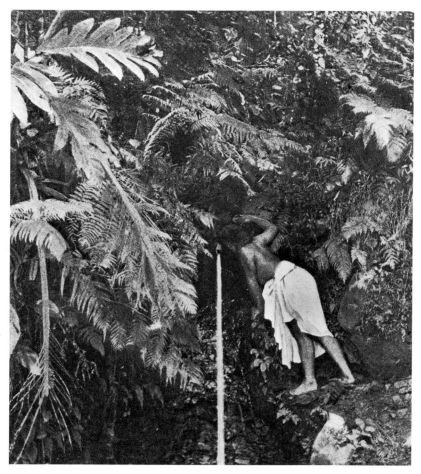

6, 7 Photograph of a Tahitian drinking at a spring, used by Gauguin as a basis for
Mysterious Water (*Papa Moe*). Kunstsammlung E. Bührle, Zürich.

predecessors. For example, the books of the great Italian art historian
Cavalcaselle, written a century ago in collaboration with an Englishman
named Crowe—*A History of Painting in Italy* and *Titian, His Life and Times*,
which came out in 1871 and 1877—were written purely on the basis of
visual memory and notes made in front of the works; and they were
published without any illustrations.

Nevertheless, despite source material, background knowledge and the
additional aids provided by modern science, it is the individual work of art
that is the ultimate source of insights. The knowledge that is provided in
other ways, about the work or the circumstances surrounding it, only
enriches and deepens those insights.

16

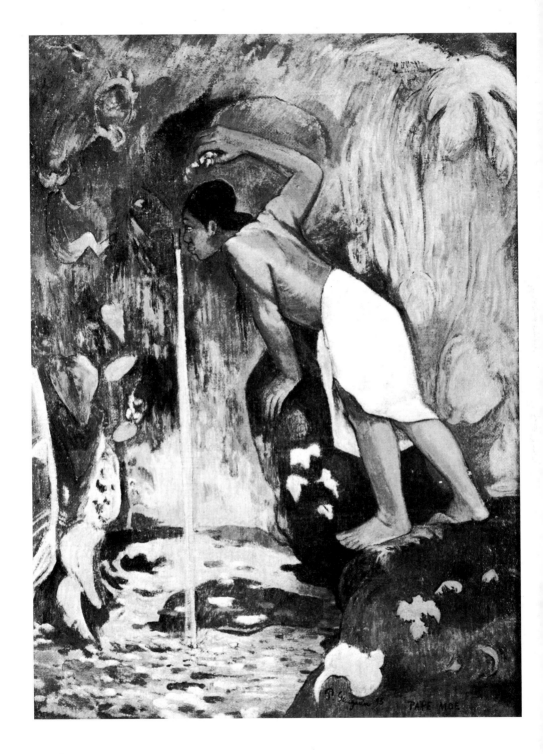

8 Berenson's library at I Tatti, Settignano.

Chapter one
The attribution of paintings:
some case histories

WE normally expect an art history class to deal with personalities: with artists, one or many, whose lives and make-up as human beings can be seen reflected in the work that they did. Whereas with classical vase painting and medieval manuscripts the authorship of particular groups and sets of works cannot generally speaking be studied in that sort of way, it becomes possible with Western European, and especially Italian, art roughly from the fourteenth century on. The reasons for this are themselves art-historically interesting. They go back to the fulness of pride felt by writers concerned to commemorate the artists of their country and region, but most especially in Italy those of their native city, part of the purpose of these writers being indeed to celebrate that city and to immortalize its achievements.

Feelings of such a kind were nothing new. Medieval cities had been proud. But civic pride in combination with the new humanism led increasingly, from the time in question, to an appreciation of the individual which was foreign to the Middle Ages. It is an appreciation which has passed down to us. We tend to see art correspondingly as the aggregate of the work of particular gifted individuals. We want to know about their personalities and assess their careers. Similarly, it was during the Renaissance that artists themselves began to be aware that art was the expression of personality. Differences between masters began to be noticed and relished.

But at the same time medieval attitudes to the artist's social status and historical importance still lingered on. There are journals and there are account-books kept by Renaissance artists, and very complete business records survive of some artistic transactions; but the idea of a complete archive of information explaining everything that posterity might want to know about how, when and why a work was done would not have crossed the mind of either artist or patron, and the recovery of such information proved arduous even five or fifty years later. Hence the problem of attribution as an ongoing one in time. Contemporary or near-contemporary statements about the authorship of a painting cannot always be relied upon, and even signatures do not automatically prove authorship. To begin with, they can be put on later, with or without intention to deceive. Also, signatures in cursive form (that is, put on in the same sort of way as an

artist would sign a letter or document) did not come into being until the seventeenth century; and formalized, but personally made, monograms of the artist's initials, such as are also used on documents, only a little bit earlier. Before that, if there was anything on the work or attached to it carrying information about its authorship, it would be in the form of an inscription. Though documents concerning the authorship of a painting, records of its history and a trustworthy date can sometimes be found as evidence, in the majority of cases, at least as far as old paintings are concerned, there is nothing. It is at this point that attribution as a science begins.

The person who first gave attribution a scientific basis was a brilliant and quite extraordinary man called Giovanni Morelli, who was essentially an amateur in the field. He was born in 1816 in Verona in Italy and was trained as a doctor, but never practised. In a series of books which came out in the 1890s he presented his fundamental argument about attribution. This was that, in order to decide the authorship of paintings, it was neccessary to study particular details in them of the smallest kind; for it was precisely in those details that an artist revealed—because he could not help revealing—the idiosyncrasies of handling which were personal to him and which cannot be reproduced by a copyist or imitator. The idea which is implied here of an artist having a unique, personal sort of handwriting is one that we shall come back to later (p. 55). A basic issue raised by Morelli's approach is that it tends to confuse recognizable *morphology,* such as handwriting has, and the *style* of an artist, which always involves non-personal factors—most especially the work of other artists.

Morelli's method is, of course, by no means all there is to attribution. Where written evidence exists, or any other kind of evidence, it needs to be used or at least taken into account; and one has to decide on more general grounds whether there is a particular point of time in the artist's development at which the painting reasonably fits in. But essentially the evidence is in the painting itself, and it is here that Morelli was a pioneer in developing a procedure more concrete than had previously existed in art history.

Morelli was a man with a whimsical sense of humour who liked little mysteries, and so he wrote his books in dialogue form and pretended, charmingly that they were by a Russian, Ivan Lermolieff (a Russian-sounding anagram of his surname), and were translated into German by Johannes Schwarze, which represents a German translation of his name. But he was no dilettante, and the basic aim in what he wrote was to show that there is nothing mysterious or peculiar about the attribution of paintings. One has to have a gift for doing it and plenty of practice; but it is not a question of divination or possessing supernatural powers. Still less was he the charlatan that he was denounced as being when his books first came out; as proof of this, forty-six paintings in one national museum, the Dresden Gallery, were relabelled because of his work and his method was quickly adopted by professionals. Reproduced here is a plate from one of the books, showing the particular way in which individual artists of the

20

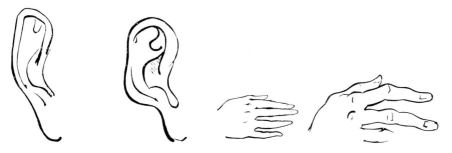

9, 10 Plate from Giovanni Morelli, *Italian Painters*, 1889; Lorenzo Costa's and Cosimo Tura's shapes of ear and hand.

fifteenth and sixteenth centuries depicted the shape of ears and hands. One can see here how Morelli put to use the knowledge of anatomy that he had gained from his medical training.

In 1895 a young man following Morelli's method burst upon the scene, to the consternation of the experts, by publishing a pamphlet on an exhibition of Venetian art in London. In it he proved that the exhibition positively teemed with attributions that were either wholly incorrect or greatly over exalted. The young man's name was Bernard Berenson, soon to be recognized as the greatest connoisseur of Italian painting of our time.

Berenson had been born in Eastern Europe but was educated in the United States. Five years after his pamphlet was published he was able to establish himself at a villa called I Tatti, on a hillside overlooking the little village of Settignano, outside Florence, and remained there until his death in 1959. The villa now belongs to Harvard University, and scholars and students of the Renaissance gather here from all over the world for the purpose of study and research.

At the very beginning of his career Berenson began compiling his 'lists' of Italian paintings, which he progressively revised and added to up to the time of his death. These have become an essential handbook and source of reference for the subject. He not only visited the great galleries of Italy and the rest of the world in order to examine the paintings, but also made daily trips to the Uffizi Gallery, in Florence, to study the collection of drawings there. In this way he brought into being what is probably his most enduring book of all, the *Drawings of the Florentine Painters,* which first appeared in 1903.

Apart from a personal library of books and art collection, what draws scholars and students to I Tatti is the vast collection of photographs which Berenson formed there during his lifetime and filed as his work progressed. Many of these photographs were sent to him by people who wanted, for commercial or personal reasons, his judgment of their paintings. On the backs of these photographs one can still find Berenson's handwritten or dictated notes, recording who he thought the artist was or might be.

Quite often the artist who is taken as responsible for a painting or a group of paintings is, for lack of information, historically nameless—at least

for a time. In that case he needs to be given some kind of identity, for the purposes of study and reference; and the way in which Berenson did this was to use as a basic identifying feature some notable trait of the way in which the artist worked, or the place where a key work, amongst the paintings grouped together, had been housed (or still was housed). A name was then fashioned by putting in front of that trait, or place, the title 'The Master of'. So we have, to take examples from the fifteenth century which come up on Berenson's lists, the Master of the Bambino Vispo, that is, the 'Lively Christ Child', illustrated here by a work with a very wriggly baby in it; and the Master of the Castello Nativity, who is taken as responsible, according to this designation, for a painting that was once in the town of Castello, and others related to it.

In other cases, Berenson might invent a name, based on a link which he felt existed with the work of another artist of the time. A famous case of this is his invention of the name 'Amico di Sandro', meaning 'the friend of Sandro Botticelli'. Berenson called these names 'temporary designations' and there are cases where the names he gave to groups of 'anonymous' paintings have later lost their anonymity, as he hoped would happen as scholarship proceeded. The 'Friend of Sandro' would, in fact, turn out later to be a known artist, Filippino Lippi, the works in question being ones he had done in his youth, and therefore forming a separate group from his mature and easily recognized works. Similarly, Berenson developed a system of notes, to be used in his published lists, according to whether he thought that the work was a copy of a lost one, only partly by the artist, or a school piece. The notes on the photographs were constantly revised, as Berenson changed his mind and shifted them over from one name to another. His lists were similarly treated, when he felt it time to expand and revise them.

The significance of Berenson's work here came from extraordinary powers of judgment on his part, along with great experience. His opinions were respected, even by those who came to think differently about particular paintings.

While Berenson was elucidating the story of Italian painting, Max J. Friedländer was doing the same for the study of Flemish art of the fifteenth and sixteenth centuries. Their routines, when faced with a painting or a drawing of unknown origin, were closely parallel. They would begin with the region where the painting or the drawing was done. Italian painting, and Netherlandish painting similarly, divides itself up into regions or areas according to the main centres out of which the artist worked. So Berenson would say 'Tuscan', 'Umbrian', 'Venetian', as the case might be, forming his verdict on the basis of the most general characteristics of the work.

He would then go on to suggest a presumed date for the work. Generally speaking, this kind of dating of works is made possible by two different elements: firstly a resemblance to known works, particularly by leading artists, which carry dates themselves or at least can be dated approximately; and secondly period characteristics which depend on the principle that, in the words of Henrich Wölfflin, 'every artist finds certain visual possibilities

11 Master of the Bambino Vispo, *Madonna and Child with angels*. Martin von Wagner Museum, University of Würzburg.

before him, to which he is bound. Not everything is possible at all times'. That is, no artist can break away completely in every respect from the artistic conventions of his day. A work of art will betray its period in so far as it adheres to those conventions, especially in secondary elements like the treatment of drapery or rocks or the rendering of background landscapes. A great artist creates new conventions, which have parallels in the work of equally great contemporaries or are subsequently adopted by others. In this way the date of a work can usually be narrowed down to a period of ten or twenty years as a convenient unit of time.

Finally, after these preliminary stages, and perhaps with more hesitancy, Berenson would give his opinion as to authorship, if he felt that there were clear indications in the shape of the kind of features which Morelli had studied. If he judged that the work was sufficiently outstanding, he would suggest a major name. Otherwise, he might end with a looser designation, such as 'School of Fra Angelico' or 'Manner of Leonardo'.

The science of attribution has helped to promote or confirm the discovery of previously unknown works as well as ones which have been lost. Such discoveries have rather naturally become news, not least because of the startling rise in the value of works of art which has taken place over the last hundred years. Nowadays it is probably rarer to find paintings in attics and dark unvisited corners of churches and convents but nonetheless it still happens.

There may well be luck involved in finding a hitherto unknown painting. However, it requires experience and flair to know where to look; judgment to assess the work's real quality; and research to do further investigation and checking as to what one has found. The examples that follow, of recent discoveries from different periods, have been chosen to illustrate just how important these skills are.

In 1961 an English art historian, Michael Jaffé, saw a painting on the stairs of the Duke of Northumberland's home in the South of England. It showed two men at a table against a background of a hanging and a piece of landscape, one writing at the dictation of the other. The composition had long been known from a great number of copies, mainly of the eighteenth and nineteenth centuries, a number of them in English collections. Jaffé knew that Berenson, in 1901, had listed the work as by a minor Venetian of the early sixteenth century, an attribution which he never repeated, and then in 1957 he had listed one of the versions mentioned as a copy after Titian, with the implication that the original was lost. Though the picture, as Jaffé saw it, had never been cleaned and was extremely dirty and hard to see, and in a nineteenth-century frame, he immediately felt on looking at it that this was the original and by Titian.

Cleaning of the picture confirmed this view; it was beautifully painted and of the highest quality, apart from a few areas of damage. Meanwhile Jaffé was able to establish, in confirmation of his view, the identity of the two people portrayed. There had been numerous guesses made as to who these two men were: in the seventeenth century they had been called 'A Senator of Venice and his Secretary' and even 'The Duke of Florence and

24

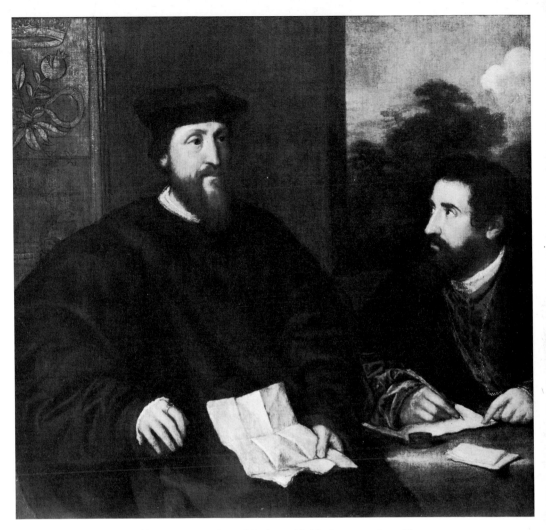

12 Titian, *Georges d'Armagnac, Bishop of Rodez, with his Secretary*. Syon House, Middlesex.

Machiavelli', and in modern times 'Cosimo de' Medici and his Secretary' and 'Columbus and his Secretary'. When Jaffé first saw it, the work was labelled, in an extraordinary combination of some of these varied suggestions, 'Duke Sforza of Milan and his Secretary Machiavelli'. From the golden wheatsheaf, pomegranate and coronet shown on the hanging to the rear, which serve as personal emblems of the man depicted, like a coat-of-arms, Jaffé was able to establish, for the first time, that the prelate in his biretta was in fact the Bishop of Rodez, Georges d'Armagnac, with his Secretary, Guillaume Philandrier, and this gave an approximate date for the painting in the late 1530s. Jaffé also established that the first English

25

owner was probably the Duke of Buckingham, whose agent wrote to him in 1624 of 'the picture of the secretary of Titian' which he had bought in France. In 1635 the Duke had that picture listed in his collection as the 'French Ambassador Dictating', so that knowledge of the true subject was already lost by the early seventeenth century; and it evidently descended from him to the tenth Earl of Northumberland, ancestor of the present owner. Here then one has brought back to light a painting which is not only a most important Titian but also a major landmark in the history of the double portrait in the sixteenth century.

The next example concerns the work of Caravaggio and involves deciding which of two different versions of the same picture was actually by this artist. Two writers of the seventeenth century had described a painting by Caravaggio of *St John the Baptist* as being in the Palace of Cardinal Pio in Rome. A corresponding painting in the Doria Gallery in Rome had first been discussed by an Italian art historian, Lionello Venturi, in 1910, and had since become generally accepted as the work in question. It is recorded as being already in the Doria Collection in 1794. In 1953, however, another English art historian, Denis Mahon, who had previously accepted the Doria version, published an account of another version in the Capitoline Museum in Rome, which had been removed from exhibition early in this century. Mahon asserted that this was in fact the version that had belonged to Cardinal Pio; he found that it was recorded in the inventories of the Pio Collection in 1740 and 1749 and was already in the Capitoline in 1765. It was also in its original frame. The Museum subsequently cleaned the painting and returned it to its place, and it was then found that it included what is called a *pentimento*: a change made by the artist in the course of working, which would not be found in a copy. The change in question here is barely visible, but it involves the position of the drapery hanging down at the bottom left, which originally extended much farther towards the corner. Since then, this version has become the generally accepted one, rather than the Doria version. Though it is not impossible that there should be two originals, both by Caravaggio, the Capitoline painting certainly has a stronger claim to be the one, because of the history of ownership which is established for it. Important paintings in the Renaissance and Baroque periods were often copied, sometimes many times over. Sometimes copies were made because a collector wanted a version of a painting which he admired, and sometimes they were made by a later artist as a token of his admiration and an exercise from which he could learn. It is in this way that the situation arises of multiple copies, with the possibility that the original may lurk unrecognized amongst them, or that the version taken to be the original may not be it after all.

In recent years a number of new additions have been made to the early work of Rembrandt, but until quite recently the earliest signed works of this artist were ones dated 1626. Then, in 1961, the Museum of Fine Arts in Lyon, France, sent to the Netherlands Institute for Art History in the Hague a batch of photographs showing works in the Museum store room, including one of the *Stoning of St Stephen*, labelled 'School of Rembrandt'.

13 Caravaggio, *St John the Baptist*. Musei Capitolini, Rome.

 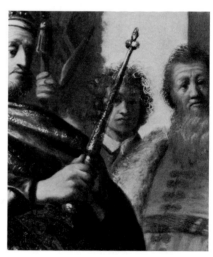

14, 15, 16 Top: Rembrandt, *Stoning of St Stephen*. Musée des Beaux-Arts, Lyon. Bottom: detail from the *Stoning of St Stephen* showing Rembrandt's self-portrait; and a similar detail from another Rembrandt painting, subject unidentified. (Lakenhal, Leiden)

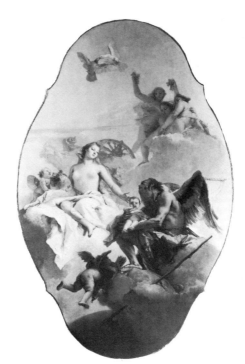

17 G. B. Tiepolo, *Allegory
of Venus and Chronos*.
National Gallery, London.

Simply on the basis of this photograph, two Dutch experts attributed the
painting to Rembrandt himself and dated it around 1625. Then in October
1962 they went to see the painting in Lyon, and in their own words 'a swipe
with a damp swab' (used for cleaning off dust and varnish) revealed
Rembrandt's monogram in the upper left corner and the date 1625, exactly
the one they had guessed. Interestingly, the painting includes a self-
portrait of Rembrandt in between the main executioner and St Stephen's
left arm, and such a self-portrait also appears in two of Rembrandt's five
surviving paintings of the next year, 1626.

A work may also be found simply by looking for it where it ought to be.
In the late nineteenth century a banker named Bischoffsheim installed in his
London house a ceiling, painted by the eighteenth-century Venetian artist
Giovanni Battista Tiepolo, which had been removed from its original setting.
This ceiling was mentioned in print in 1876 and engravings of parts of it
reproduced. There were also later mentions, one of about 1898 and one of
1911, but in a 1962 catalogue of Tiepolo's work, the paintings were recorded
as missing. Early in 1965 an Englishman, Francis Watson, who knew of
these mentions, went to the house, which was now the Embassy of the
United Arab Republic; and sure enough, in the former drawing room, he
found the Tiepolo ceiling just as the banker had installed it. The subject of
the decoration is an allegorical one, with figures of Venus (Love) and
Chronos (Time), and four ovals of the Virtues around. Subsequently the
central section was acquired by the National Gallery in London.

29

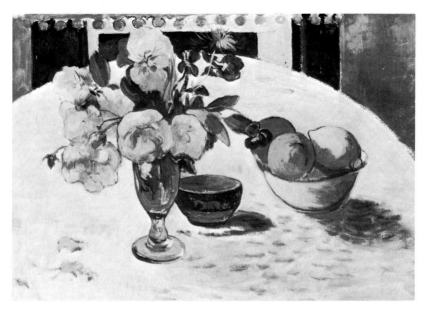

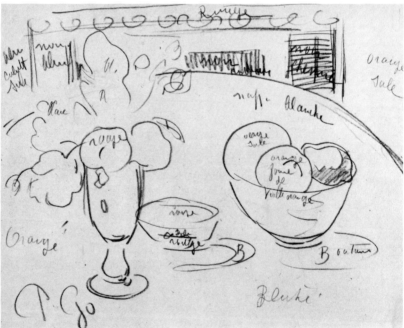

18, 19 Top: Paul Gauguin, *Flowers and a Bowl of Fruit*. Courtesy Museum of Fine Arts, Boston, Bequest of John J. Spaulding. Bottom: Gauguin's preliminary study for the painting. Courtesy Museum of Fine Arts, Boston.

In 1964, I made a discovery myself. The Boston Museum of Fine Arts has owned since 1948 a still-life by Paul Gauguin, which had previously belonged to a collector named John Spaulding. This painting had been done by Gauguin in 1894, when he was laid up in bed in Brittany after breaking his leg in a brawl with some sailors, and Gauguin had given it to an artist friend called Gustave Loiseau who visited him to cheer him up during his convalescence. While I was going through the Museum's file on the painting, to check on this story because the painting had sometimes been wrongly dated, I found an envelope with a note on it, in Spaulding's writing, saying that it contained a drawing by Loiseau after the Gauguin painting. Out of curiosity I took out the drawing inside and I saw at once, to my great excitement, from the technique and the handwriting of the colour notes, that it was by Gauguin himself. If confirmation were needed, there was 'P.Go.' the abbreviated form of signature which Gauguin used, inscribed at the bottom left.

What had happened, as I was able to reconstruct it, was that in 1921 Loiseau had sold the painting to a Paris dealer. Fourteen years later, when Loiseau died, the same dealer bought some of his effects at the posthumous sale, including this drawing. He did not recognize what it was, since Gauguin's drawings were little studied and of no great value at that time, and, taking it to be a copy by Loiseau, he sent it as a gift to Spaulding (who now had the painting). Spaulding kept the drawing in its envelope, and there it remained, probably never looked at again, until I came upon it. So the Boston Museum's collection turned out to be richer by a drawing that it did not know that it had. And also this seems to be one of the very few preliminary studies of Gauguin's for a painting which is known, so that it has special importance as evidence of his creative procedure.

Frequently, attributions can actually add to historical knowledge. An example of how this happens, where the knowledge gained is also of great human interest, concerns the young Rembrandt and his contemporary Lievens.

During Rembrandt's early years in Leiden he and another artist called Jan Lievens were in contact with one another. Lievens was a year younger, but at the beginning of their careers his work was more advanced than Rembrandt's (by about five or six years). In Amsterdam there is a *Portrait of a Boy* which is inscribed in Dutch, 'Lievens, retouched by Rembrandt'. The Fogg Museum in Cambridge, Massachusetts, has in turn a *Portrait of an Old Man* with a Rembrandt signature on it, which is unquestionably authentic, and the date 1632. But, as I said earlier, a signature is not necessarily a firm guide to authorship. In this case, the signature is Rembrandt's, but the painting is not by him; experts who looked at it carefully found unmistakable signs of the soft and silky touch developed by Lievens around 1630. This, then, is an exceptional instance of a painting signed by Rembrandt but attributable, at least in major respects, to someone else. And it represents correspondingly an important clue as to the relationship between Rembrandt and the artists who worked round him or with him.

The human interest in this is that Rembrandt, by the time in question,

should have come to look on the younger artist more or less as a pupil of his; and that Lievens (though the positions a few years earlier had been somewhat the other way round) apparently never had any ill feelings on the subject. We do know of other cases where artists put their signature to works by their pupils—Corot, for example, did this in the nineteenth century, when he was at the height of his success and felt sorry for those who were having a harder time. And there are also, in modern times, cases of artists putting wrong dates on their own works retrospectively, either because they could not remember accurately, or in order to pretend that they had been ahead of other artists at that time. The German artist Kirchner did this with his early paintings, after a nervous breakdown during the First World War. Cases of this kind do quite often occur, but are not generally made known, in order to protect the artist's reputation.

Fascinating in a different way is the question of the authorship of a group of Italian paintings of around the mid-fifteenth century, which are clearly by the same hand, and include a beautiful *Annunciation,* with a very distinctive treatment of architecture and figure elements. From the fact that two of the paintings in the group, a *Birth of the Virgin* and *Presentation in the Temple* which go together, came from the Barberini Collection in Rome, the

20, 21 Jan Lievens, *Portrait of a Boy* (retouched by Rembrandt). Rijksmuseum, Amsterdam; and *Portrait of an Old Man* (signed by Rembrandt). Fogg Art Museum, Harvard University, Cambridge, Mass., Naumburg Bequest.

32

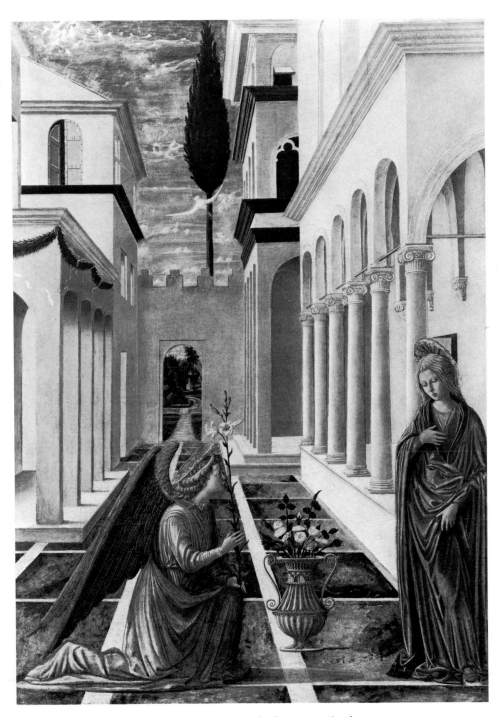

22 Master of the Barberini Panels (Giovanni Angelo di Antonio ?), *The Annunciation*. National Gallery of Art, Washington DC, Samuel H. Kress Collection.

23 Master of the Barberini Panels
(Giovanni Angelo di Antonio?), *The
Presentation of the Virgin.* Courtesy
Museum of Fine Arts, Boston,
Charles Potter Kling Fund.

artist responsible had been named for convenience 'the Master of the
Barberini panels'. The connection between his work and the artistic centre
of Urbino in the east of Italy had been recognized; and Florence also would
presumably have been within the orbit of his activity, because for instance
the *Annunciation* itself came from the palace of the Strozzi family there.
Then, in a book published in 1961, an Italian scholar Federico Zeri, who
had already added further paintings to the group, reconstructed from all
these paintings an outline of what he thought the artist's career and contacts
must have been. He proposed that the artist got his training in Perugia;
went to Florence towards 1450; had a strong contact with the milieu of
Camerino; knew works at Rimini; and also that he participated in the
decoration of the Ducal Palace at Urbino. At the close of his book, he
dramatically proposed that the artist in question could be identical with one
Giovanni Angelo di Antonio, from Camerino, who is recorded in documents
but by whom no works are known. According to the records this man
went to Perugia and then to Florence. He left Florence suddenly in 1451,
recalled to Camerino, and he was much favoured by a lady of Camerino who
was connected by marriage with the lords of both Rimini and Urbino.
Though the identification can, at least for the present, be only hypothetical,

34

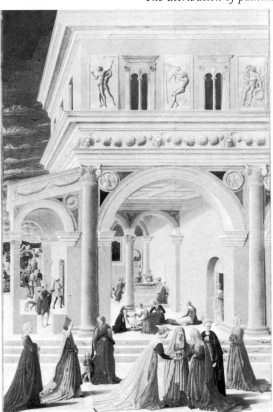

24 Master of the Barberini Panels
(Giovanni Angelo di Antonio?), *The
Birth of the Virgin*. Metropolitan
Museum of Art, New York, Rogers
and Gwynne M. Andrews Funds,
1935.

all these points seem to fit remarkably. This is a striking case of how an art historian can reconstruct the personality and the development of an artist, historical and biographical, simply from the works themselves, and also of how a possible name for a previously anonymous master can turn up, as investigation proceeds. (In a strange way it does make a difference if an artist has a name!)

In all these cases something new was discovered, or evidence was put together which threw new light on a group of works. And while attribution and connoisseurship are not by any means the sole basis for arriving at such results and confirming them—there being the provenance or record of ownership to consider, and also such historical circumstances as are directly reflected in the work's subject or character—they underlie all genuine discoveries, as the examples in this chapter have suggested. At the same time, as Berenson's lists showed, attributions serve as temporary hypotheses, which are then revised or reviewed as new evidence appears, until the evidence is complete or strong enough for a firm answer to establish itself. Interest then shifts to another line of inquiry, and in this way the total process that takes place is a cumulative one. The chapters that follow present more extended examples of how art-historical knowledge proceeds.

35

25 The Brancacci Chapel, S. Maria del Carmine, Florence (see also diagram p. 53).

Chapter two
Collaboration between two artists:
Masaccio and Masolino

DURING the fifteenth and sixteenth centuries it was not uncommon for artists to collaborate on a painting or series of paintings. In such a case the art historian is faced with the problem of disentangling the work of the painters involved, a necessary first step both to assessing the work of the individual artists and, in certain cases, to tracing an important development in the history of art. The most notable example of such a problem is that posed by the collaboration between Masaccio and Masolino when they were working side by side, in the mid 1420s, on a fresco cycle that was destined to become one of the most influential in the whole history of Western art— that in the Brancacci Chapel of the Church of the Carmelites in Florence.

'Masaccio' and 'Masolino' were both actually nicknames. Both are derivatives of Maso, short for Tommaso. Masaccio means 'Big Tom' or 'Loutish Tom', a nickname given because of the artist's carelessness and absent-mindedness. According to the sixteenth-century art historian Giorgio Vasari, Masaccio 'never paid any attention or gave any thought to the cares and affairs of the world, nor even about his clothes'. Masolino means 'Little Tom', which was a term of endearment rather than a reference to the artist's stature. The two men actually came from the same part of the country, to the south of Florence. Masolino was the elder; he was born in 1383, Masaccio in 1401.

The Church of the Carmine lies on the further side of the River Arno in Florence, and the chapel in which the two men worked together belonged to a wealthy family of the Florentine nobility, the Brancaccis. The church was consecrated in 1422 and the following year Felice Brancacci returned from an embassy to Egypt. It must have been then or very soon after that the decoration of the chapel was commissioned. In September 1425 Masolino was called away to Hungary. At this period, if a Church dignitary or a patron such as a monarch summoned an artist, then he simply had to go— there was no choice; so that work in the chapel was interrupted at this point. Masolino was back by July 1427, but he was then summoned to Rome, presumably leaving Masaccio behind him to carry on with the frescoes. Masaccio, in his turn, had to go to Rome too, where he died in the autumn of 1428 at the age of only twenty-six.

We have therefore two presumed periods of intensive work by Masolino

1424-25
1427-28

and Masaccio (or just one of them) in the chapel: the first in 1424–25 and the second in 1427–28. Masaccio did not complete the frescoes. He left the lowest order, or bottom line, unfinished. The Brancacci family were subsequently exiled from Florence in 1434 and returned only in 1474. A third artist, Filippino Lippi, was then called upon in the 1480s to finish off the work. He completed the remaining scenes and put further figures into the frescoes which Masaccio had started on the lowest level. There were, therefore, altogether three artists involved in decorating the chapel, but in this chapter only the work of the original two, Masolino and Masaccio will be dealt with. The question to be discussed is what exactly the relationship was between them, and how art historians have been able to decide who did what, among the different frescoes.

The question of collaboration between these two artists does not in fact end with the Brancacci chapel, but extends, in the view of art historians today, to at least one other work as well. There is an altarpiece of the *Madonna and Child, St Anne and Angels* which is now in the Uffizi Gallery and comes from the Church of San Ambrogio in Florence. Vasari, the first person to write full-scale biographies of artists, states in his 1568 *Lives of the Artists* that this was the work of Masaccio. The altarpiece was labelled as a Masaccio, accordingly. But art historians of this century saw that the prominence of St Anne here and the amount of space given her, with a flat cloth of honour behind her, were features suggesting the later fourteenth rather than early fifteenth century. They were tempted, therefore, to assume that Masaccio was working here on a design given to him by an older artist, to whom he went or had gone for training; and it seemed not unlikely that this older artist could have been Masolino, because of their later collaboration and the fact that they came from the same part of Italy. In other words, the design and the actual painting were two separate things; the assumption being that the young Masaccio had been given a design of a stiff and frontal kind as the basis for the altarpiece, and that he then painted the figures in his own much more vigorous style.

The salient features which bear on this view are as follows: in the foreground there sit a Madonna and Child whose strongly built and muscular bodies occupy very definite three-dimensional space. Beyond the figure of St Anne, on the other hand, who stands behind the Madonna, the flat cloth of honour completely closes off any strong sense of space continuing behind the throne; this cloth is held up by two angels at either side, who are simply painted to fit within the outside edges of the composition, and are correspondingly out of proportion with the main figures in terms of their position in space. Early art historians were aware of these features, which make the altarpiece a mixture of the old and the new, but they were unable or unwilling to see, in the actual painting of the work, any reason for departing from the authority of Vasari's word that the whole thing was by Masaccio.

Our picture of the altarpiece and who it was by might have remained that way, had a brilliant Italian scholar, Roberto Longhi, not looked at the work afresh and seen its make-up differently. In 1940, he published an

38

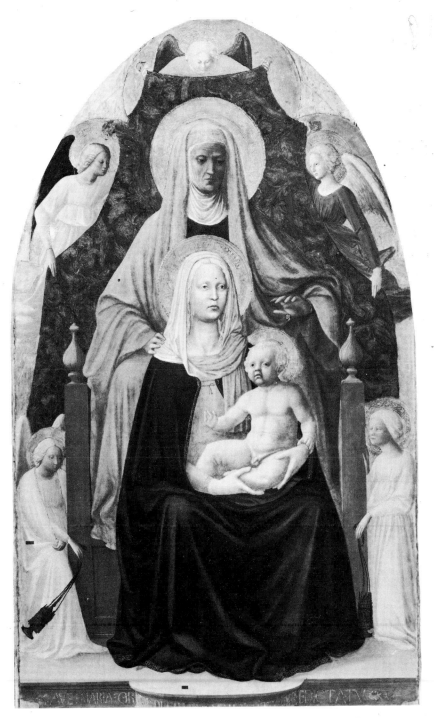

26 Masaccio and Masolino, *Madonna and Child with St Anne*. Uffizi, Florence.

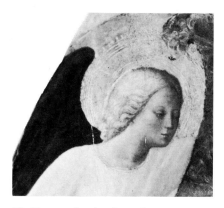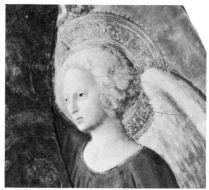

27, 28 Two details of angels from Illustration 26, that on the left by Masolino, on the right by Masaccio.

article suggesting that some parts of the altarpiece, just about half of it in fact, were actually by Masolino. What he saw was that the angels at the left and the ones at the top and bottom right have all the characteristics of Masolino's treatment of the human figure. A detail of one of these angels shows that the flesh has a soft and almost doughy character. The expression on the face is sweet and benign, even a little bit vacant. But the angel opposite this one forms, as Longhi saw, a striking contrast. The head is altogether more sharply delineated, the flesh gives a stronger and firmer sense of bone structure underneath, and light and shade are used to clarify and emphasize this structure, rather than simply for the sake of atmosphere. The hair springs strongly up and out from the forehead, and its movement is natural and free as compared to the stylized waves of hair on the other head (which seem simply a pattern for its own sake, irrespective of the actual substance). Finally, the expression gives a very strong sense, which is completely lacking in the other case, of vigour and force coming from inside the person and imparting their stamp on the features as a whole, particularly the look of the eyes and the set of the mouth and chin. It is an altogether clearer conception of a human head: it could in fact be a portrait.

Similarly, the figure of St Anne (though much restored) distinguishes itself in much the same kind of way from the Madonna and the Child. Here the differences lie in the treatment of the drapery (for instance in the two headpieces). The drapery of the Madonna gives a strong sense of gravity in the way it falls downwards and the knees push powerfully forward. In contrast, St Anne's drapery is stiffer in its patterns. So Longhi's suggestion was that both artists had a share here, the general design, St Anne and four of the angels being by Masolino, and the Madonna and Child and the angel at the middle right, the work of the young Masaccio.

What do we know of Masolino's and Masaccio's backgrounds leading up to this altarpiece? According to Vasari, Masolino devoted himself to painting at the age of nineteen (that is, in 1402) and, after a period of study in Rome,

he returned to Florence and worked there in the Church of the Carmine. He entered one of the Florentine guilds, as all artists did at this time (the first step towards setting up on their own) at the beginning of 1423. Masaccio, born at the end of 1401, was something of a prodigy, rising much more rapidly to independence when he was still in his early twenties. He joined the same guild in January 1422, and two years later became a member of the Company of St Luke, an association of fellow artists. The fact that in the Uffizi altarpiece the haloes of the Madonna and Child are still vertical and stuck to the back of the head, like that of St Anne, whereas in the Brancacci Chapel they are shown in foreshortening like plates on top of the head puts the altarpiece sometime between 1420 and 1425. The search for an earlier work by Masaccio continues. The latest, and most interesting claimant so far, is an altarpiece from San Giovenale di Cascia, Reggello, near Masaccio's birthplace, which is dated 1422.

It is not known for certain under which artist the young Masaccio had received his training prior to this. That he should have been Masolino's pupil, though an attractive notion in terms of providing a reason for their working together, seems incompatible with the fact that he was the first to join the guild. But the important things, if Longhi's findings are accepted, are the amount he painted of the Uffizi altarpiece; the fact that he did the most important figures in it, the Madonna and Child; and finally, the sheer extent of the contrast between the two artists. It follows that, at the time of his work on this altarpiece, Masaccio cannot have been simply a pupil or apprentice learning his trade; he was evidently working there as an independent collaborator. According to Longhi's distinction, Masolino belongs, by virtue of his date of birth, to the lyrical, flowery world of the late Middle Ages (what is called the International Style), Masaccio to the new world of gravity and dramatic intensity of the early Renaissance. And the discrepancies within the Uffizi altarpiece are the product of a conflict between these two worlds, rather than of the fact that the younger artist was not yet free to do as he wanted.

There is another work which, though more problematic for a number of reasons, also seems valuable as a piece of evidence. In a private collection in Florence, now a museum, there is a little panel of the story of St Julian. It shows the saint at the left being tempted by the devil, disguised as a young man, to kill his parents, who are sleeping in bed at the centre. At the right, the same saint implores pardon from heaven in the presence of his wife. Even though this panel is damaged almost to the point of ruin, and can barely be made out, there are signs in it of a treatment of the human figure which is distinctively like Masaccio's. The male bodies to the left and right have very characteristic, almost tubular, shapes, with strong contrasts of light and dark on the arms and legs. Alongside this, there is the remarkable treatment of the dog, dramatically and powerfully foreshortened, with a strong twist of its muscular back and neck.

Judging from the size and character of this panel, it must have formed part of what is called the predella of an altarpiece—the horizontal strip which was often tacked on underneath, depicting narrative scenes related

41

to the main subjects above—and we have a statement by Vasari about a corresponding altarpiece. In his 1568 Life of Masaccio, Vasari recorded that this artist was responsible for an altarpiece in the Church of Santa Maria Maggiore in Florence, depicting the Madonna, St Catherine and St Julian, with narrative scenes below of the lives of the same two saints, and the Birth of Christ in between. (In the 1550 edition of his *Lives* he called only the predella the work of Masaccio; the rest of the altarpiece he attributed to Uccello.)

The altarpiece in question, which was in the Chapel of the Carnesecchi family, has been dismembered. Much of it seems to be long since lost, and there is no complete certainty as to how it was made up (Vasari seems to have been unclear in his mind as to who had done the main parts). One possible component from it to have survived is a standing figure of St Julian, which is lit from the same direction as the predella panel and which seems to fit as coming from the main part of the altarpiece (along with a Madonna and Child from the centre). This *St Julian* clearly looks to be by Masolino, given the stiffness of the pose and the drapery, and the soft treatment of the face and its somewhat languid expression. The figure looks more like a courtier than a stalwart saint and martyr. There is, therefore, a striking contrast between this part of the work and the predella panel; and a variety of evidence—the date of the dedication of the chapel which housed the work, and analogies with an altarpiece which Masaccio painted at Pisa in 1425–26—dates the work in 1425 or thereabouts. It looks then as if this may have been another case in which Masaccio worked *with* rather than *for* Masolino. In 1425 Masolino, summoned to go to Hungary as soon as possible, could well have seen that he had more works on his hands than he could reasonably finish himself before he had to leave; and this could well be the reason why he brought in Masaccio to assist him, both on this work and on the Carmine frescoes. The Uffizi altarpiece may have proved to the older artist that such a collaboration was both feasible and productive.

To recapitulate: in the Uffizi altarpiece we have a single painting which, simply on the basis of its internal character, can clearly be seen to involve two different contributions combined together. And whereas the gap or discrepancy between those two contributions prompted earlier art historians to see the work as a master-pupil type of collaboration between Masolino and Masaccio, it is in fact a collaboration of two independent contemporaries. In a second work, the altarpiece composed of multiple parts from Santa Maria Maggiore, the same pattern of collaboration seems to have been repeated, this time in terms of the two artists taking on physically separate sections of the whole. It is, however, the Brancacci Chapel frescoes that present the most difficult problem. What did each of the two men contribute, and what did their artistic association entail?

In order to understand the sequence of events we should perhaps glance forward in time and note what has happened to the chapel between the fifteenth century and today. In the 1740s the ceiling was altered from a cross- to a dome-vault, and the frescoes which existed up there were replaced with the eighteenth-century ones which are there now. The window above the

29 Masaccio, *Story of St Julian*. Horne Museum, Florence.

altar which let light into the chapel was enlarged to its present proportions. Soon after, a new marble altar was put up, in its turn replaced later in the eighteenth century by the one that is there today. All this was very much to the detriment of the frescoes. Then in 1771 there was a raging fire in the church, probably begun by a criminal, which caused some damage to the frescoes. Though the damage to the chapel was much less than to the rest of the church, the combination of smoke and dust considerably darkened the original colours. Restoration of the fire damage took place—a sign that the frescoes were appreciated—and, in 1782, the chapel was reconsecrated.

The original altar, which housed a thirteenth-century devotional image known as the 'Madonna of the People' and a marble tabernacle, may also have included specially commissioned sculpture which, in choice of subject, served to supplement and complete the story told in the frescoes themselves —the story of St Peter—by depicting episodes which were not otherwise shown. A relief by Masaccio's contemporary, Donatello, which shows the Ascension of Christ and the Giving of the Keys to St Peter, has been suggested as having perhaps come from there and served that role. Whether or not that is right, the principle that paintings and sculptures could be used together in such a fashion is an important one. Work by Masaccio and

Masolino began soon after the consecration of the church in 1422 with paintings elsewhere in the church and in the convent attached to it. We know from our early sources that Masaccio painted in the cloister a scene commemorating the church's consecration; this was destroyed around 1600 when a new cloister was built, but it is known in part from copies by later artists, including the young Michelangelo. It was clearly a very striking and original work, containing portraits of contemporaries who were present. Elsewhere, in another part of the church, between two chapels, Masolino did a figure of St Peter, and Masaccio a companion figure of St Paul (destroyed already in 1675). Just recently too, restoration work made necessary by the terrible floods of 1966 in Florence has revealed, in a room off the cloister, a beautiful fresco of the Crucifixion which was previously not even known to be there and which might be the work of Masaccio, or at least contemporary.

In the Brancacci Chapel itself, work began with Masolino alone painting the vault and the lunettes with frescoes which, we saw, were replaced in the eighteenth century. They included the *Four Evangelists* (in the vault), the *Calling of Andrew and Peter, St Peter Weeping at His Denial of Christ* and the *Shipwreck of the Apostles*. When this was done, work then moved down to the next level, the upper tier of frescoes as they are today. Scaffolding was presumably up at this level all around the chapel during the period in 1424–25 when Masaccio joined Masolino. And the work was shared out between the two men.

Masaccio's revolutionary contribution to painting was recorded in writing by his contemporary, Alberti, as early as 1436. His importance was similarly recognized in a 1481 commentary on Dante, which includes historical material, and also, very interestingly, by Leonardo da Vinci himself in one of his notebooks. He is recorded as having shared in the decoration of the Brancacci chapel, along with two other masters (Filippino Lippi being included), for the first time in the 1490s. In a guidebook of 1510 he is said to have done half the chapel. In two other texts from the early sixteenth century, the record continues, but false deductions begin to creep in— namely that Masolino's work followed Masaccio's and that the decoration of the chapel had been started by a fourteenth-century artist called Starnina, who had done the ceiling of a different chapel in the same church. Vasari, in his *Lives* of 1550 and 1568, carries on from these earlier sources, with which he was familiar. He identifies Starnina as the artist under whom Masolino had trained, which may be a false assumption on his part; and getting his dates all wrong, claims that Masolino had died after beginning work in the chapel—work which he curiously dated around 1440—and that the completion of the frescoes was entrusted to Masaccio subsequently (he thought that Masaccio had died in 1443). Obviously Vasari, more than a century later, had difficulty in getting at the truth. At the same time he sought to distinguish, for the first time, which of the main narrative frescoes represented the work of Masaccio, as opposed to Masolino and Filippino.

In the eighteenth and early nineteenth centuries there was considerable debate as to who had done what in the chapel. But because later frescoes

30 Masaccio(?), *Crucifixion* (detail). Cloister of S. Maria del Carmine, Florence.

by Masolino, which had been discovered elsewhere, appeared very different in character, much more courtly and decorative, the general inclination was to believe that Masaccio had done the whole thing, or at least the greater part.

Modern opinion is quite different. To understand why, we may begin with the paired frescoes on the upper level of pilasters flanking the entrance of the chapel: those which depict *Adam and Eve in the Garden of Eden* on the right and, on the left, The *Expulsion from Paradise*.

45

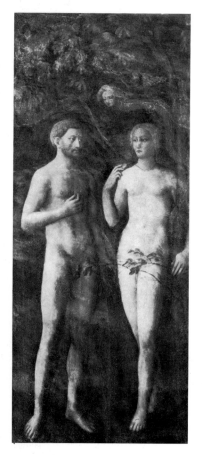 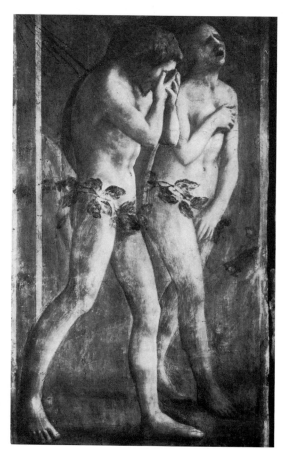

31 Masolino, *Adam and Eve*. Brancacci Chapel. 32 Masaccio, *The Expulsion from Paradise* (detail). Brancacci Chapel.

Using the same criteria as we applied in the Uffizi altarpiece, the *Adam and Eve* is clearly by Masolino, and the *Expulsion* by Masaccio. This is not a question of subject-matter; if the subjects had been reversed, Masaccio could have painted figures who were tranquil and Masolino ones who were agonized and ashamed. And the story equally called for a flowered garden setting in one case and a barren landscape in the other. Though the two artists probably understood each other's stronger points and apportioned the two subjects accordingly, the differences lie in the stronger and harsher modelling of the figures in the *Expulsion*; the tensed curves of Adam's back and Eve's thigh, related to their gestures and movements, as opposed to the melodious and continuously flowing contours in the other case; and the way in which light clarifies physical detail, as well as investing it with atmosphere.

46

The *Adam and Eve* seems to exist more on the surface, the *Expulsion* to give space a more active role, as in the violent foreshortening of the angel, as opposed to the decorative role of the tree and the serpent.

If we now move to the other end of the same level of frescoes, to the scenes either side of the altar showing *St Peter Preaching* and his *Baptism of the Neophytes,* we find a corresponding contrast. The first is clearly by Masolino, the second by Masaccio. The young man shown with his arms crossed over his chest on the edge of the water was already singled out as remarkable in one of our early sixteenth-century sources; Vasari gave the whole scene a special mention in his life of Masaccio. If we compare the two St Peters, we can see that the feet in Masolino's fresco are in profile rather than being foreshortened, the drapery does not conform so closely to the lines of the body, and the whole figure has less of an inner-directed energy. At the same time, the similarity of the two landscapes implies that the two artists consulted together and agreed about the kind of setting they would use. There was also agreement on the inclusion of a range of types amongst the bystanders. But from that point on, each artist was free to follow his own bent, Masolino giving his figures a somewhat restricted characterization, while Masaccio modelled his on observed everyday reality.

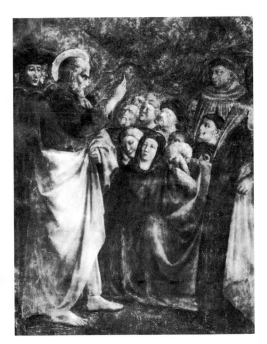

33 Masolino, *St Peter Preaching* Brancacci Chapel.

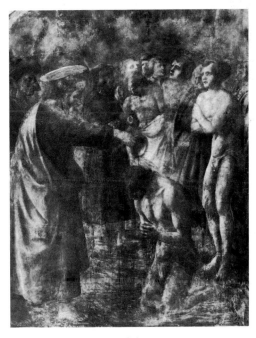

34 Masaccio, *Baptism of the Neophytes.* Brancacci Chapel.

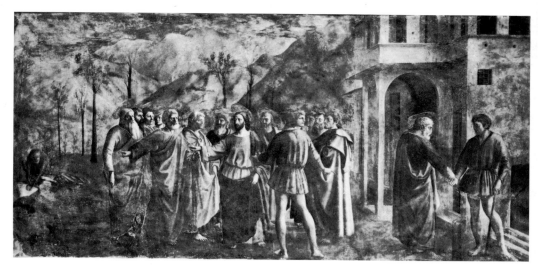

35 Masaccio, *The Tribute Money*. Brancacci Chapel.

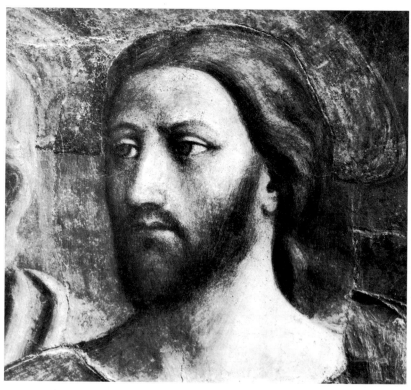

36 Masolino (?), Head of Christ from *The Tribute Money*.

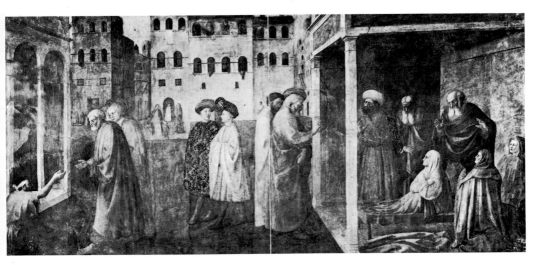

37 Masolino and Masaccio, *The Healing of the Cripple and Raising of Tabitha.* Brancacci Chapel.

In the two main frescoes facing each other on opposite walls at this level, the collaboration turns out to be more complex than in the frescoes discussed so far, though the essential distinction is perfectly clear, as it was already to Vasari. The *Tribute Money,* with its stern-faced figures of the Apostles taking possession of the environment in which they stand, is the work of Masaccio in conception and realization. The *Healing of the Cripple and Raising of Tabitha* opposite, with figures to left and right similar to those in the *Preaching,* and a pair of courtiers in between showing off their colourful costumes, is essentially the work of Masolino.

In the *Tribute Money* there are two further scenes included besides Christ's charge to the Apostles as to what to do about the payment to Caesar: St Peter's finding of a coin in the mouth of a fish, as instructed, and his payment of the tax to the Collector. Masaccio arrived at a unified, centralized composition by showing those two scenes as supplementary ones to the left and right, placed so that they neither distract from the centrality of the Christ, nor make it noticeable that the figure of St Peter is shown in three different places at once. Opposite, Masolino used the same principle of what is called 'continuous narration', showing two different episodes of St Peter healing to the left and to the right, in the common setting of an open city square, with a colonnade to the left and an open room to the right. He also used the new science of one-point perspective, recently discovered in Florence and used by Masaccio in his frescoes, according to which lines which are parallel in nature are represented as converging towards a single vanishing point. But his arrangement of these scenes created a pull away from the middle, where the two courtiers are put in as secondary figures walking through the open and otherwise empty space; and the two St Peters are shown in the same foreground plane with their backs to one another.

49

But what was the relationship between design and execution in the painting of frescoes? According to a technique described in a craftsman's handbook of this period which goes back to Giotto in the fourteenth century, the design of the fresco as a whole was first thought out and traced on the wall in the form of an underdrawing. When the artist began the actual painting, he put a new layer of wet plaster on the wall, covering up the underdrawing, and the paint was applied while this layer was still damp. In this technique, therefore, the work of painting proceeded in portions or units corresponding to what could conveniently be done in a single session. These units are technically known as *giornate* (day's work, in the plural). After completing each such unit, the artist cut away the wet plaster surrounding what he had done, so that there would not be overlap; and correspondingly there was a line of division between each such section which can still be made out today in most places, when the frescoes are examined close up. In the *Story of Theophilus*, a fresco on the lower level, which was begun by Masaccio and finished by Filippino, the white dividing lines (see frontispiece) indicate approximately how the execution divided itself up. Also the way the sections join up at the edges show whether the artist was working from left to right or right to left, and hence provide an indication of the order of execution of the sections. So in the situation of two artists working together, it was possible for one of them to do the design and most of the execution and the other to do certain sections. He could even cut out the plaster which was already there in a particular area and then revise it. What Longhi suggested was that in the case of the *Tabitha* fresco Masaccio was responsible for the buildings to the rear, where Masolino got into trouble with the vacancy left by his use of perspective; and that, in the *Tribute Money*, Masolino was responsible for the head of Christ, which, from the dividing lines around it, was clearly done in one session of work, and was also done last of the portrait heads. The reason why each of the two artists intervened in this way in the other's work, was again probably a matter of each recognizing where the true strengths of the other lay and could suitably be applied. Masolino, that is, called on Masaccio to draw out the lines of buildings in perspective. And in the head of Christ in the *Tribute Money* where mildness of expression was appropriate, Masolino's softer and sweeter manner lent itself to this end, as against Masaccio's severity. Indeed, the very fact that these subtleties of distinction within the two frescoes were not recognized earlier is a measure of how well both Masaccio and Masolino were able to adapt themselves to each other's needs in the task that they shared as a whole.

There are certain elements in the frescoes, therefore, on which the two artists must have agreed beforehand. In particular, the figure of St Peter is given the same general appearance each time he figures in the story, and the lighting of the scenes corresponds consistently throughout to the fall of light in the chapel, coming in through the window above the altar. Thus, the *Tribute Money* and *St Peter Preaching* are lit from the right, the *Baptism* and the *Raising of Tabitha* from the left.

There were at the same time crucial new features which Masaccio was

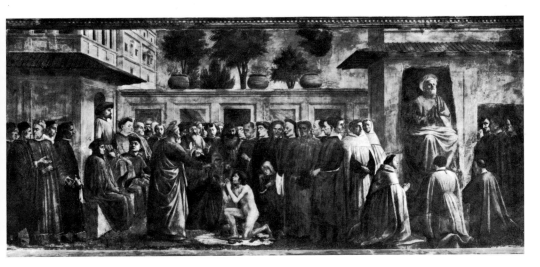

38 Masaccio and Filippino Lippi, *The Story of Theophilus*.
Brancacci Chapel.

introducing into painting. Up on the scaffolding Masolino had a practical demonstration taking place before his eyes of what these new elements were. In the execution of the *Tribute Money,* for example, the verticality of the figures implies that Masaccio let down plumb-lines from head to heel, to secure a central axis of balance for the stance and movement of each individual figure and a proper sense of weight upon the ground; Masolino's Adam and Eve look by comparison as if a slight push could knock them over. Again, in the *Tabitha* fresco a nail-hole can still be seen in the wall, corresponding to the vanishing point of the perspective lines. Masaccio, or Masolino under his guidance, must have stretched pieces of string from the edges of the area to be painted into this central nail, to mark out at the design stage the perspective of the buildings and the central space. Most probably these strings were coated with chalk which, when snapped against the plaster, would leave guide-lines as part of the underdrawing. In the buildings to the rear of the city square, as in the buildings to the right of the *Tribute Money,* there is evidence of another of Masaccio's devices: the incising of a grid of horizontal, vertical and diagonal lines into the plaster for the brush to follow, so that the lines of the buildings would be true and straight, and the whole area here should have a geometrical consistency.

With these new aids to painting, scientifically applied, Masaccio was able to achieve the unification of space and centralization of the composition which are again demonstrated in the *Tribute Money.* These new principles are accepted in the *Tabitha* fresco, to the extent that Masolino put the two courtier figures in the centre there to connect up what would otherwise be two separated halves to the composition. Those figures, set farther back as

51

they are, also modify the effect of a single line of figures strung across the foreground; and their placing accords with the pull back into space created in the centre by the perspective lines of the buildings. The turn of heads and feet in these figures, and the apostles either side, equally accords with their position in relation to the ground plan of the central square.

However, the figures here certainly do not occupy the foreground with their bulk and spiritual presence to the same extent as their counterparts do in the *Tribute Money*. Their action does not have the stark vigour and life that Masaccio's figures possess, or the quality there of the unification of different groups through the lines of direction of the gazes and gestures. The house interior at the right is rather awkwardly box-like, and the vanishing point of the perspective, coming as it does above the courtier's heads, is placed rather too high to harmonize completely with the implied point of sight of the spectator in relation to the foreground scenes. One gets a feeling of the city square being tilted up, as against the natural recession of the ground plan in the *Tribute Money*. In Masolino's use of perspective after Masaccio's death, this effect would become progressively more exaggerated.

Just because Masolino did not get everything quite right according to Masaccio's principles in the *Tabitha* fresco, we should not underrate his own artistic quality. Vasari himself in the sixteenth century, while presenting Masaccio's inventions as a decisive and tremendous step forward in the development of painting in Italy, also recognized the positive values of Masolino's art. He wrote (and the judgment stands) of the grace and nobility of bearing of Masolino's figures, seen here in the pair of courtiers; of Masolino's understanding of light and shade, which was for Vasari only a beginning compared to Masaccio, but which was capable of creating softness and harmony in his heads and draperies; and of the gaiety and charm of his colours.

The older tradition of painting to which Masolino belonged, by virtue of his date of birth and temperament, still had great force at the time of Masaccio's innovations, and considerable popularity in the early 1420s amongst the élite of Florence. Without in the least compromising his own special qualities, Masolino was strongly affected by Masaccio's presence alongside him in the Brancacci Chapel. In the course of the collaboration he drew closer to Masaccio in his own work, in the sense of superimposing some of Masaccio's technical contributions on to his own way of doing things, as the *Tabitha* fresco shows. He then moved away again, particularly after his own period of work in Rome came to an end. And Masaccio in the lowest line of frescoes in the Chapel went on to make both his figures and his architecture still more massive and imposing, and to devise still other original kinds of compositional layout.

When Filippino Lippi came to complete that lowest line in the 1480s, it fell to him to extend and carry through Masaccio's designs, in so far as they could be recognized and interpreted from the partially painted sections or the markings on the wall surface. And he also supplied for particular scenes, such as the *Story of Theophilus,* additional figures of a 'lay' kind, not strictly essential to the story. Given that painting in Florence had changed a

great deal in its general character during the intervening sixty years, we should expect Filippino's own contributions to be markedly different from Masaccio's and Masolino's, and to be in line also with those general changes. And Filippino's way of doing things does in fact show up here, particularly in the bystanders crowding in on top of one another at the miracle taking place, with the very precisely rendered detail of their faces—faces which are in fact portraits of contemporaries. At the left and right ends of this fresco, on the other hand, and in the stage-like background in the centre of coloured marble panels and trees and pots against the sky (which being at the top would logically have been painted first here), we have lay-outs and groupings which appear to represent, either in part or as a whole, Masaccio's own ideas, carried through and finished up by Filippino, including poses and heads of figures that are his. In other words, apart from the frescoes which Masaccio did in their entirety on this level, there are clues present even in the ones he did not complete pointing to the conception that he and Masolino originally worked out.

Collaboration on a large-scale project like the Brancacci Chapel was, as we have said, quite common. But the particular circumstances which have been described here make this case an unusual one. For we can gain from the frescoes themselves quite a clear and full idea of what exactly took place between Masaccio and Masolino during their collaboration in the 1420s; of how exactly the work was shared and even of the personal relationship between the two men. To do so we have had to use the records and statements of early writers; Vasari's testimony, in particular, is basic and full of perception. But they need to be interpreted, and turn out to be confused on a number of points of detail. In the end it is the works themselves, looked at analytically as we have looked at them here, which tell their own story of this crucial episode in the painting of the early Renaissance.

a Expulsion from Paradise
b St Paul visiting St Peter in prison
c Tribute Money
d Story of Theophilus
e St Peter Preaching
f St Peter healing with his shadow
g Baptism of the Neophytes
h St Peter distributing alms
i Healing of the Cripple and Raising of Tabitha
j Crucifixion of St Peter and Sts Peter and Paul before Nero
k Adam and Eve
l The Angel freeing St Peter from prison

39 Diagram showing the arrangement of frescoes in the Brancacci Chapel.

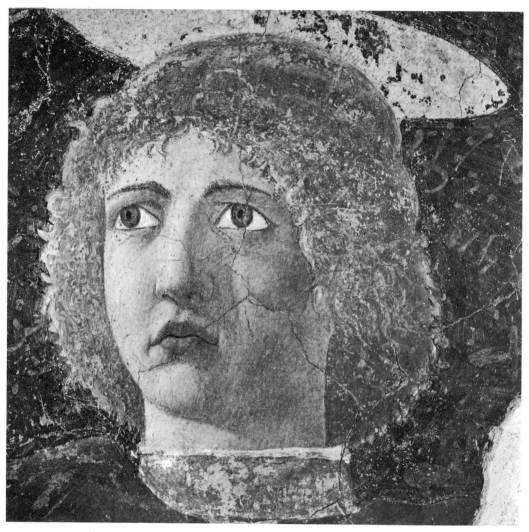

40 Piero della Francesca, *St Julian*. Palazzo Comunale, Borgo Sansepolcro.

Chapter three
Deciding the limits of an
artist's work:
Piero della Francesca

AN ARTIST of the Renaissance who was well known and had more commissions than he could carry out alone would normally have a workshop of assistants to help him. They would prepare the surfaces and mix the colours; and sometimes, if they performed well, they might be allotted minor parts of a work to do or given a design to execute. Art historians, therefore, often have to decide whether some section or sections of a work are by an assistant, rather than the master himself. Assistants would often graduate into pupils, who did more independent work directly reflecting that of their teacher. And in due course they would go out from the studio and set up on their own, producing work that was individual in style and more clearly distinguishable from that of their master. Alternatively, the master-artist might for a special purpose draw on the skills of a trained artist, in the knowledge that he would be able to conform to the master's own manner and designs and follow his instructions. Finally, as the work of an outstanding artist became known and exerted influence on other painters, some of those might choose to follow quite directly in his footsteps, even copying or adapting with minor variations things that he had done. So we have assistants, pupils and followers radiating out, as it were, from the master himself. The term 'School' is loosely used to cover all three.

But, it might be objected, any decision to attribute a work to a 'School' depends in the first place on making a subjective judgment about its quality. Judgments are fallible. A painting, particularly a fresco, may have been damaged and restored, so that the lines or modelling which impress us unfavourably may be due to the restorer. To determine in such a case exactly what is the original paintwork and what is not, one may need to look at it under a microscope and seek the opinion of those who have expert knowledge of the condition of paintings.

Then, even though we can fairly expect a great artist to maintain consistent standards in his work, he may have had a bad day, or, for some reason which we can now never discover, he may have deviated somewhat from his usual way of doing things. Or he may experiment and risk a lapse of quality or an inconsistency in doing so. Yet an artist's way of painting is like a person's handwriting; whatever the situation, it will keep a distinctive quality as compared to other 'handwritings'. (This holds true even in cases

where one might not expect it. Walt Disney's way of drawing Mickey Mouse can be distinguished from the cartoon animations of his studio, and the two authors of the Babar books, father and son, can be told apart quite clearly in the particular way they draw elephants.)

By keeping these factors in mind, and by taking account of historical evidence, or reconstruction, one arrives at a judgment as to where the dividing line should be drawn between an artist and his school. It will not be an absolutely firm dividing line. Rather, it will involve graded stages of nearness and farness from the Master, corresponding to the categories of assistant, pupil and follower. These graded stages will shade into one another, as we have seen. At the same time, the furthest removed stage will represent the work which it is least possible that the master did, so that what the master did do himself at least becomes more settled and established.

In December 1954, in the town of Borgo Sansepolcro in Umbria where Piero della Francesca was born and where he painted his famous *Resurrection* fresco, an exciting discovery was accidentally made. In the choir of a deconsecrated church originally dedicated to St Augustine and later, in the sixteenth century, rededicated to St Clare, there was found the frescoed head and shoulders of a saint which clearly suggested the work of Piero della Francesca. The fragment presumably formed part of a series of frescoes, of which there was no further trace. In 1957 it was freed from the whitewash which had been put over it, detached from the wall and re-mounted on wood; and subsequently it was shown in Florence in an exhibition of detached frescoes. Who painted it?

The fresco measures about 54" × 42", so that it is a little over life-size. And it shows the saint—who is probably St Julian, because of the similarity in pose and bearing to other renderings of this saint as a young warrior —against an imitation marble background; he is depicted wearing a green and yellow tunic with a red cape over it. The figure has the kind of golden cap of hair, firm-set expression and column-like neck and body that are characteristic of Piero. But if this fresco is compared with another by Piero, of *Hercules,* which comes from a house in Borgo Sansepolcro—quite probably Piero's own house there—we might feel that the lines of the saint's eyes are a little harsher and those of the mouth more sensual; in other words, that the execution, and perhaps even the design as well, might not be from the hand of the Master. 'Not quite by Piero himself' say some people. A purely subjective judgment. We must not be too hasty. Are we sure that we are looking at these works as the painter left them? The *Hercules* fresco was uncovered in the nineteenth century and restored rather crudely. And with the saint, little bits of paint from the hair, tunic and halo have flaked off. How can we decide whether it is by Piero, by an assistant or merely by a follower? To answer this question, we must recall what is recorded about Piero and the conditions in which his works were produced.

Detailed evidence of Piero della Francesca's career is scanty, but one thing that is known is that he had considerable difficulty in completing his paintings and that his work on them commonly stretched on for many years

41 Piero della Francesca, *Hercules*. Isabella Stewart Gardner Museum, Boston.

beyond the time when they were supposed to have been finished and de-
livered. In a document of 1455 which has recently been found, Piero's
father promises to give back the money advanced by the Confraternity of
Mercy for an altarpiece, unless his son will 'sit down in Borgo Sansepolcro
and work on the panel during the entire upcoming Lent'. (Piero had
evidently been so dilatory that his father had to intervene, as a father might
not dare to do today, and get his son back on to the job.)

Ten years earlier, in 1445, the same Confraternity of Mercy, a charitable
lodge of merchants in Piero's home town, had elected a committee to act for
them in commissioning an altarpiece from Piero, who was about twenty-five

57

at the time. In the contract, which survives, Piero promised, among other things, to do the work himself, to use good colours and gold and to meet a three-year deadline. The first of these provisions, like the second, was reasonably standard in contracts of the time, so that no special importance should be attached to it; it did not mean that the use of assistants was necessarily forbidden. But it is unlikely that at the age of twenty-five and with a name not yet made for himself, Piero already had a workshop of his own. Yet when we look at the altarpiece itself he did eventually produce, we notice some quite striking differences between the main panels and the predella scenes below. Compared to the figures in the central panel of the Madonna of Mercy, those in the central predella scene of Christ being lowered into the tomb are flatter. They have more exaggerated gestures and quirky expressions, in contrast to the static column-like Madonna up above and the serene unperturbed tranquillity which extends to the figures gathered round her. The whole predella scene is rather fussy, a quality not

42, 43, 44 Piero della Francesca, *Polyptych* (above) and two details from it, the *Madonna of Mercy* (left) and a predella panel (below). Palazzo Comunale, Borgo Sansepolcro.

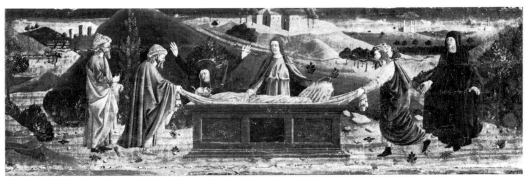

at all associated with Piero. (The matter is complicated by the fact that the altarpiece, which has a great many parts to it, was moved from its original place and 'recomposed' in 1874, so that the present arrangement and framing is modern. Moreover, it may be a different commission from the Confraternity which is referred to in the document of 1455 quoted, and also in another document of 1462. Piero may have delivered the Confraternity's work within the three years stipulated in the contract of 1445.) Nonetheless the puzzle of the predella still remains.

There are two alternatives. Either the predella scenes are by Piero and show an aspect of his work which is unrepresented anywhere else, or these scenes, and the little figures of saints in vertical strips at either end of the altarpiece which go with them, are by someone else. In which case, either work on the altarpiece dragged on and in the later stages Piero did have an assistant; or else these parts come from a different work of which the rest is missing, and were tacked on to the altarpiece, possibly by Piero himself, possibly in the recomposition of 1874. We shall not attempt to decide here between these possibilities, though more recent opinion has generally favoured some version of the second. The important point is that the art historian sometimes has to ask himself the basic question whether the parts of a work he is considering really belong together.

That Piero was not above piecing together different items to make up an altarpiece—a somewhat unusual procedure for the time—is suggested by another altarpiece of his, made for the nuns of St Anthony of Padua in Perugia. The central section consists of the Madonna and Child and four saints flanking her in pairs, with an Annunciation up above in a separately framed section and three predella scenes down below. Because of the strange way in which the Annunciation is tacked on, it has been supposed that it was a separate entity and of different date from the main part: indeed a recent technical report on the work has brought out that these parts are awkwardly nailed together instead of being structurally bonded. The Annunciation may, however, represent simply an extension of the altarpiece which raised problems for Piero of adaptation to the rest (problems which are intensified by the present, nineteenth-century framing of the top and bottom). If, along with this point, the badly damaged and much restored condition of the predella scenes is taken into account, the painting of the figures there need not call for too much attention in terms of differences from the ones above. In the scene of St Elizabeth saving a child who had fallen into a well, and in the left-hand scene also, the interest is in depicting an interior of a room in terms of space and lighting. In the central predella scene of St Francis, the concern is with the rendering of what may be called a 'true' outdoor night scene, one of the earliest in Renaissance art—one, that is to say, that has the illumination and corresponding shadows of night, as opposed to simply indicating a night setting, which was all that was possible so long as paintings had gold backgrounds. Although these interests are absent in the rest of the altarpiece, predella scenes in the fifteenth century were commonly a place for the artist to experiment. The fact that we find exactly these same interests in two of Piero's frescoes at Arezzo is certainly a good reason for

45, 46 Piero della Francesca, *Madonna and Child with saints*, and a detail from the predella showing a Miracle of St Elizabeth. Galleria Nazionale, Perugia.

 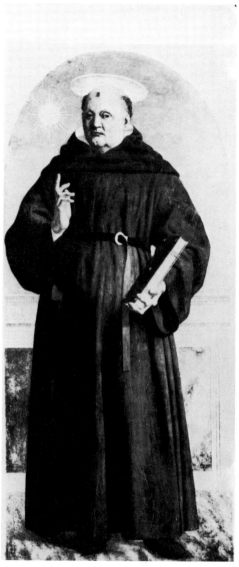

47 Piero della Francesca, *St Augustine*. Museo di Arte Antica, Lisbon.

48 Piero della Francesca, *St Nicholas of Tolentino*. Museo Poldi-Pezzoli, Milan.

49 Diagram showing
arrangement of frescoes at
S. Francesco, Arezzo.

a St Augustine
b St Louis
c Heraclius bringing the
 Cross to Jerusalem
d Finding and Proof of the
 Cross
e Victory of Heraclius over
 Chosroes
f Prophet
g Confession of the Jew
 Judas
h Annunciation
i Prophet
j Lifting of the Wood
k Dream of Constantine
l Death and Burial of Adam
m The Meeting of Solomon
 and the Queen of Sheba
n Battle of the Milvian
 Bridge

accepting that the predella scenes here, battered as they are, are by Piero.

Still another altarpiece of Piero's which was certainly executed over a long period of time is one that he made for the high altar of the Church of the Augustinian monks at Borgo Sansepolcro. Documents show that in 1454, when the contract for this work was signed and about half the fee paid in advance, Piero agreed to finish it in eight years. It was fifteen years, however, before he received another payment. The altarpiece has been dismembered and parts of it lost. In 1941 an American art historian, Millard Meiss, succeeded in showing how three figures of saints, which survive in different places now, definitely belong to this altarpiece; and he conjectured that the fourth saint needed to provide two each side was a figure of St Augustine, this being the saint that the monks would have expected. Then in 1947 the English art historian, Sir Kenneth Clark, discovered this very figure in the museum in Lisbon, which had acquired it in 1936, but had not recognized what it was. While the head and body of this saint are extremely impressive, Clark suggested that the little scenes depicted on the vestment were by an assistant. The Annunciation that one can just make out on the left side is based in its architecture and grouping on Piero's fresco of this subject at Arezzo; and since this altarpiece took so long to complete, it is reasonable to assume in this case that Piero took on an assistant in the later stages.

The most important and extensive work of Piero's that survives is the series of frescoes illustrating the Story of the True Cross in the Church of San Francesco at Arezzo, south of Florence. Because of the extent of the work, it provides a very full subject for art-historical study. It has been suggested that certain figures in the frescoes which are in the main chapel, seem not up

63

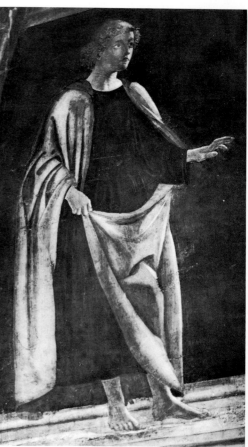

64

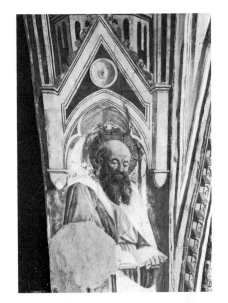

50–53 Four details from Piero della Francesca's fresco cycle at S. Francesco, Arezzo. Far left: *St Louis*. Left, above: *The Lifting of the Wood*. Left, below: *A Prophet*. Right: *St Augustine* (with Bicci di Lorenzo).

to Piero's standard, for instance a prophet at the top of the window-wall, the scene of the *Lifting of the Wood* on the same wall one level lower, and the figure of St Louis on the entrance arch. In the first two cases the hair is rather frond-like and the faces harsh both in expression and in the handling of light and shade, and in the third case the geometry of the face seems rather crude and the expression somewhat vapid.

Before jumping to conclusions, however, account must be taken of the history and structure of the chapel. It belonged to a local family by the name of Bacci, one of whose members had directed in 1416 that the chapel should be painted. It was only in 1447 that his son and two of his grandsons saw to this. They brought in an artist called Bicci di Lorenzo to do the work. Bicci painted the four evangelists in the vault of the chapel, a *Last Judgment* over the entrance arch and parts of the borders of that arch, but then had to leave. According to Vasari, he hoped to return and carry on. But instead he died in Florence in 1452; and it was at this point that Piero probably took over. He worked, as one more or less has to, from the top down. One of the high-up border saints on the entrance arch, a figure of St Augustine which is in a Gothic frame, clearly seems to be by Bicci in design, but looks at the same time to have been finished by Piero. So it seems altogether likely that in other cases too, in the upper part of the chapel, Bicci left behind him designs—probably in the form of underdrawings—which Piero followed; and this would then provide a reasonable explanation why the features of the prophet do not quite conform to those of Piero's figures farther down.

In the case of the *Lifting of the Wood*, this scene comes to the right of the chapel window and therefore in one of the least well lit parts of the chapel; this might be the reason for Piero's use of a stronger and harsher modelling here, so that the fresco could be seen better.

65

54 Piero della Francesca, *St Louis*. Palazzo Comunale, Borgo Sansepolcro.

55 Piero della Francesca, *The 'Madonna del Parto'*. Cappella del Cimitero, Monterchi.

As usual with Piero, the decoration of this chapel seems to have gone along very slowly, in successive stages, extending from the early 1450s well into the 1460s. In Borgo Sansepolcro there is a detached fresco of *St Louis* which is mentioned in 1835 as carrying an inscription with the date 1460. In the last forty years it has generally been felt that this saint does not show the quality of Piero himself. One can point particularly to the rather crude geometry of the head, neck and hands. Furthermore, the pose and arrangement of this figure is almost the same as the figure of the same saint at Arezzo only in reverse. This fact suggests that it was done from the same cartoon, a preliminary drawing the same size as the actual work which was used to transfer the design on to the wall. Thus by 1460, the date on the detached fresco, it looks as if Piero had an assistant; and modern art historians have generally assumed that an assistant worked with him correspondingly on the later stages of the Arezzo frescoes. That assistant may well have done the St Louis there, since this is a supplementary figure

that is on the same level as the middle tier of frescoes. Vasari in 1568 mentioned a certain Lorentino of Arezzo as a pupil of Piero's, saying that he did many paintings at Arezzo in imitation of Piero's manner and also completed the works that Piero left unfinished at his death. Possibly Lorentino may have been the assistant in question in the Arezzo frescoes.

Another detached fresco which raises problems is in a little chapel in a cemetery at Monterchi, not far from Borgo Sansepolcro. It shows two angels parting the curtains of a tent to reveal the pregnant Madonna. As Piero's mother came from Monterchi, and on the assumption that she was buried there too, it was thought that Piero would have painted this fresco in her memory. Unfortunately, however, this line of argument has no real basis, for the present cemetery dates from the nineteenth century. More to the point, the heads in this fresco involve rather heavy contours, which cancel out some of the roundness and volume of the forms themselves. And the two angels, mirror images of one another, clearly seem to imply the use of

67

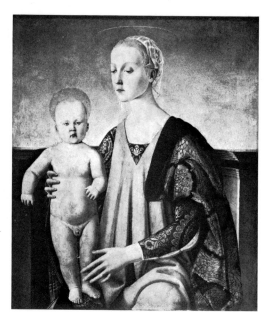

56 Follower of Piero, *Virgin and Child*.
Collection Villamarina, Galleria
Nazionale d'Arte Antica, Rome.

57 Piero della Francesca, *Virgin and
Child enthroned with four angels*.
Sterling and Francine Clark Art
Institute, Williamstown, Mass.

58 Piero della Francesca, *Virgin and
Child*. Palazzo Ducale, Urbino.

the same cartoon for both, as in the case of the two figures of St Louis. If,
then, the association of the place with Piero's mother is put aside and the
work was commissioned for what was in fact an out-of-the-way country
chapel, it seems quite reasonable to assume that Piero sent along an assistant
or pupil, armed with a design which he provided.

There remains the question of Piero's followers. Vasari, in his 1568 Life
of Piero, named as followers two later artists who were well known in their
own right. One of these is Perugino, who, he said, did a painting of a saint
at Arezzo for the nuns of St Catherine. Elsewhere, however, Vasari states
that Perugino was the pupil of a different artist, Verrocchio. The second
follower that he names is Luca Signorelli from Cortona, and he comments
that up to 1475 Signorelli's own early work was indistinguishable to his
eyes from Piero's, a comment which seems justified by such early works of
Signorelli as we have, including some in Arezzo. Vasari also attributes to
Signorelli one of the lost frescoes which Piero was commissioned to paint in
the Vatican in 1458–59; and, if right, this would mean that Signorelli began
as a pupil of Piero's then, at the age of about seventeen.

On this basis Bernard Berenson in 1926 sought to establish as the work of
the young Signorelli, still working closely in the manner of Piero, a group of
paintings of the Madonna and Child which are clearly all by the same hand
and show distinctive characteristics. One of these paintings is in Oxford and
includes an element based directly on Piero's example: a parapet at the back
of the Madonna and angels of exactly the kind that Piero had used, in the
altarpiece of which his *Saint Augustine* formed part. It runs behind that
saint and equally behind the other three which survive, and presumably
continued through the lost centrepiece also. A second work from the same

68

group is in Rome, and illustrates particularly well the way in which this artist did faces and bodies, somewhat more thinly and delicately than Piero himself, but on the same principles of proportion and modelling. However, this artist's grasp of anatomy seems on the whole rather weak, too weak for Signorelli, and so Berenson's suggestion has not won acceptance. Instead, he has simply been identified since as a close follower of Piero's.

Another altarpiece which equally presents problems of authorship is a *Madonna and Child* with four angels (42″ high) which was exhibited in London twice in the late nineteenth century, but received official mention in print for the first time only in 1930. A photograph of it was included in a book on Piero in 1942, but the work belonged at that time to a private collector in America who rarely allowed it to be seen. It is only quite recently that it has passed, along with the whole of that collection, to the Museum which he established in Williamstown, Massachusetts. There is no information at all as to where it originally came from.

This altarpiece is at least close to Piero. But there are problems about it. First it seems to have been damaged and quite extensively restored in certain areas, for instance the steps of the throne at the bottom centre, where the lighting is peculiar as it stands. It also appears to have been overcleaned. And finally, the heads of the Madonna and the angels seem to be based in a strongly derivative way on heads found in works which are certainly by Piero. Thus, the second head from the left and the one at the extreme right look very like those of the angels either side of an altarpiece of Piero's at Urbino, and the Madonna's head and veil can also be compared with those there.

So one is again left with a choice. Either this altarpiece is by Piero, which

means trying to find a place for it in his work in terms of a possible date (a difficult undertaking because there is only one securely dated work of his, a fresco of 1451), or it is by a close follower, a 'School' painting.

An important consideration which bears further emphasis is the fact that many works of art, major and minor, have been removed from their original locations, dismantled, broken up or cut up, taken out of their frames, or had sections removed from them. A work may sometimes have been moved in order to preserve it, particularly if it was already damaged or was in a perishable medium, but most often the motives were not primarily dis-interested and respectful ones. Lootings and thefts have been and are a frequent occurrence, with the work subsequently turning up in another country or place, as the spoils of the victor or as an object for profitable sale. Buildings are redesigned and rebuilt and works of art in them are moved, removed, remounted, renovated or simply destroyed. Damage may result in a section being cut off, in order to make the remainder present a uniform and more pleasing appearance; or in the whole object being divided up into units in a way which dispenses with damaged parts, and which can be expected to increase the proceeds if the units are now individually sold off.

Two examples which came up in the course of this chapter were Piero's altarpiece for the Confraternity of Mercy, 'recomposed' in 1874; and the one he did for the Augustinian monks, broken up so that the central section is lost and the four saints (one cut down, the others repaired in ways that conceal the physical effects of the division) are in four different places. Nor are such hazards, of course, confined to the works of Piero. An altarpiece painted by Masaccio for the town of Pisa, mentioned in passing in the previous chapter (p. 42), exists only in dispersed fragments. The very form of their arrangement, and of the frame which contained them, cannot in this case be recovered with any certainty. There are cases too of the single, un-divided surface on which the artist worked being sawn or cut so that paintings done on the front and back of the same piece of wood are now detached from one another. In the next chapter, on Giorgione, mention will be made of a canvas having been added to at the edges, or cut down along one of its sides. Such additions and subtractions alter, to some extent, the relative dimensions and proper proportions of the painting. How much more drastic in its effect, then, is the cutting up of a canvas so that there are, let us say, five different pieces in five different places. None of those pieces can fairly be looked at in isolation, except as a fragment, existing in a kind of limbo. And furthermore the process of mounting and framing each separate piece will almost inevitably mean that damage has been done to the painted surface at the cut edges, which allow no margin for mounting in these circumstances, and that parts of that surface may have been lost from sight in the process.

The kind of reconstruction which is frequently made necessary as a result of all this is another of the basic tasks in which art historians engage. It enables them to see individual paintings once more as parts of a larger whole; and also, if a full reconstruction is possible, to experience the work as originally intended. The most basic kinds of evidence that are available in

this connection—evidence of subject, and of form and design, and evidence involving the spatial and architectural context in which the work was displayed, along with any written or visual record there may be of the work's appearance before changes took place—will be shown in use later, in Chapter 5. And there are three other kinds of evidence that may be valuable in particular cases: the matching of technical features, such as the embossed designs used for gold haloes, which are likely to be repeated for each one of the figures; indications or clues that might come from studying the backs and sides of works, as to which part fitted on where, or which particular edge was cut or sawn through; and any traces that might remain in place of the work's physical make-up or the context into which it fitted. One can, for instance learn from an empty frame still in place, at what height and under what lighting conditions the picture was to be seen, and the direction of the spectator's approach to it. In the same chapter we shall see, from a full-scale example of reconstruction in practice, how the available pieces of such evidence can be used to arrive at a consistent and logical conclusion; and what particular gains of understanding that conclusion brings with it.

59 Giorgione, *Self-portrait as David*. Herzog Anton Ulrich Museum, Brunswick.

Chapter four
Cutting through mystery and legend: Giorgione

IN OCTOBER 1510 Isabella d'Este, Marchioness of Mantua and a great patroness of the arts, wrote to her agent in Venice instructing him to try and obtain for her a painting of the *Nativity* by Giorgione, which she had heard of as being 'very beautiful and exceptional'. She named two people who were to be called upon to give their opinion of the picture and said that, if everything was satisfactory, the agent was to make the purchase on whatever terms he saw fit, 'in case someone else should take it'. In his reply two weeks later, however, the agent reported back that Giorgione had died, of the plague, just a short while earlier, and that there was in any case no such painting available. Giorgione had, it was true, done two paintings of this kind for collectors, one, according to his sources of information, better than the other. But one of those collectors was out of the country, and neither of them was willing to part with his painting at any price, because they had had them painted for their own enjoyment.

This exchange of letters is a fine example of how informative documents referring to an artist and his works can be. They tell us here, first, the date of Giorgione's death and how he died; and also that, at the time of his death, Giorgione's pictures were in great demand amongst collectors in Venice and nearby, and there were not enough to go round. To have such documentation is especially valuable in this case, because though Giorgione was already famous in his life-time, particularly in Venice, very little is actually known about his life and his work. We may begin this chapter by considering, along with the little that is known, why this should be so; and how legend about the artist correspondingly came into being. And we may then go on to the second and larger half of the Giorgione 'mystery', which involves the number of paintings that he did, and their special character.

Besides letters, the documents that we have for the Renaissance period are most often of two kinds: public records, such as those of birth, marriage and death (which were kept then as they are today); and legal contracts for a piece of work, along with records of payments that resulted from that contract. In Giorgione's case, though we know from the letter quoted where and when he died—in Venice and in September or October 1510 (for another source tells us that that was when the plague struck that year, with particular virulence in the month of September)—no record has been found

of his birth. Two years before his death, however, his name turns up in two different places in Venetian records. In August 1507 and January 1508 he was paid forty-five ducats altogether—quite a considerable sum of money—for a large painting for the Audience Hall in the Doges' Palace: the room in which official state hearings took place. There are also records from the year 1508 of how Giorgione had been frescoing the exterior of a building on the Grand Canal. This was the 'Fondaco' or warehouse of the Germans, by the Rialto, which had just been rebuilt after a fire and was used for lodging the German merchants who came in to do trade. Giorgione had made a complaint about the amount he was being paid, and an arbitration committee was appointed to evaluate the work, which ended with a payment being made of 130 ducats. This was satisfactory to the artist, though it was twenty ducats less than he had asked for. In both of these cases, therefore, Giorgione was involved in the creation of works which were on public view in Venice. To receive such commissions, he must already have made a considerable name for himself.

The same documents further tell us that the name by which the artist was known at that time was 'Zorzi (or Zorzo) of Castelfranco'; it is not until a text of 1548 that he appears as 'Giorgione'. So he came from Castelfranco. This is a small fortified town out in the country about thirty miles northwest of Venice. Evidently he went from there to Venice because Venice was the nearest artistic centre; and 'Zorzi' was presumably a dialect version of the name Giorgione.

Two other records, of still another kind, can now be added. They consist of notices written on the backs of paintings at a very early date, perhaps even in the artist's own lifetime. One of them says that in June 1506, when he did this work, 'Master Zorzi' was the 'colleague' of another Venetian artist, Vincenzo Catena. The other, on the back of a male portrait, states that it was painted by Master Zorzi in 1505 or 1508 or possibly 1510—the last figure of the date is not quite clearly legible. That completes the documentary record that survives from within Giorgione's lifetime. It is not much to go by, particularly when, as we shall see, the Audience Hall painting is a complete mystery, and the warehouse frescoes are almost completely ruined or destroyed.

When the documentary evidence is so scanty we have to turn to early lives of the artist: those written within, say, fifty years of his death. In Italy, beginning in the fifteenth and still more in the sixteenth century, there was a demand for biographies of this kind. The artist was now increasingly thought of as the maker of a great contribution to his city and to posterity. He was looked on as a man of learning and wide interests, rather than merely a skilled craftsman. People wanted to learn more about him— the sort of person he was, where his works were to be seen, how he came to do them, and so on. The man of the Renaissance who did most in the way of satisfying this demand and producing reliable biographies of artists was Giorgio Vasari, whom we have already met in the two previous chapters. Vasari was a painter and architect himself, so he knew his subject well; and his book *The Lives of the Most Eminent Painters, Sculptors and Architects* (or

Lives of the Artists, for short) first came out in 1550. It contains a chapter on the life and work of Giorgione. But this is where the historian begins to run into difficulties.

First, Vasari spent his life mainly in Florence and Rome. He travelled to Venice in the 1540s and collected information for his book by looking at paintings and asking questions there. But in the case of Giorgione this was not enough—at least compared to what he could have written had he known Giorgione personally, or spent his earlier life in or near to Venice. Vasari certainly wanted to get at the truth and be accurate. But Giorgione's sudden death of the plague, just when he was beginning to get a lot of public attention in Venice, had meant that, in the wake of that death, there had begun to be legends about him: stories which embroidered or exaggerated the truth, or ones that were completely fictitious. Word of mouth was, at the beginning, the only channel by which knowledge about the painter was handed on and kept alive. So there was every encouragement for legend to spread. And though Vasari did his best, it was formidably difficult for him to separate out truth from falsehood. Exactly the same difficulties confronted another mid-sixteenth-century writer, Lodovico Dolce, who published a *Dialogue on Painting* in 1557. Dolce, unlike Vasari, was a Venetian. He too tried to put down a few facts, in some respects independently of Vasari's Life, which he knew, but after more than forty years, it was just as hard for him to get things straight.

The mystery and legend surrounding Giorgione's life extends its web to make the attribution of paintings to him also very difficult. Throughout most of his lives of sixteenth-century artists Vasari generally talks with confidence and knowledge about the works each artist had done. But in the case of Giorgione he was not so sure at all. This is clear from the fact that, when he came to produce the second, revised and expanded, edition of his *Lives,* which came out in 1568, he no longer mentioned as Giorgione's some of the works which he had included in his earlier version of the text.

To understand why, in this case, it was so hard for Vasari to be sure about the works, we must go back once more to the end of Giorgione's life and the aftermath of his death. The letters of 1510 from and to Isabella d'Este show how already then collectors in and around Venice were vying with one another to acquire Giorgiones for themselves. Fifteen to twenty years later, we have a further indication of what the situation was like, in the shape of a journal kept by a Venetian art-lover, most probably one Marcantonio Michiel. In it he put down, from year to year, what was to be seen in the private art collections owned by rich Venetians: quite a number of pictures are mentioned as being by Giorgione (eighteen altogether, half of which are lost). It can also be assumed that in the meantime, because there were few real Giorgiones and they were so precious to their owners, pictures by other artists had begun to be called Giorgiones, out of pride on the collector's part, or because this made them more valuable, or because they were paintings of a type which Giorgione had pioneered and popularized, and which could therefore be loosely (though wrongly) associated with his name.

These various biographical accounts have liabilities therefore which clearly impair their historical usefulness. To give some examples of stories found there which are entertaining, but have the ring of legend: we are told by Vasari that Giorgione was extremely musical and an accomplished lute-player, and that he caught the plague from contact with a girl friend, who did not realize that she had it; by Dolce that the young Titian, working with him, made Giorgione jealous by painting better than he could, so that Giorgione stayed shut up at home for several days in chagrin; and in a still later, mid-seventeenth-century biography—contained in Carlo Ridolfi's *The Marvels of Art,* which is a history of Venetian painting by artists, published in 1648—that Giorgione was the son of a noble family, the Barbarellas, rather than of humble origin, as Vasari had said. Disregarding these stories, then, we are left, really, with only one additional fact: namely, that Giorgione was born in the later 1470s. This means that he was still young, in his early thirties, at his death in 1510.

As for attributions, confusion on this subject begins in the sixteenth century. The works mentioned by Vasari in his first edition, apart from the warehouse frescoes, are either lost ones or ones about whose authorship he was unsure. And the same also applies to the further works that he added in his 1568 edition, with the single possible exception of a self-portrait, which may survive. Dolce's text of 1557 adds nothing new from this point of view. We are therefore left with two works which are mentioned in the journal referred to, and which can be identified with reasonable certainty; and a further work which is first mentioned in print as a Giorgione only in the mid seventeenth century, in Ridolfi's text, but which can also be reasonably assumed to be by him. From that point on, confusion and un-certainty reign—and they have continued, and even increased, right up to the present day.

At the same time, Vasari, being a historian and interpreter of the de-velopment of art, far more so than any of his contemporaries who wrote about Giorgione, did provide a general picture of his development and contribution to painting as he understood it. He presented Giorgione as essentially self-taught; as having spent time when young with two older Venetian artists, the Bellini brothers; as having had some acquaintance with the art of Leonardo da Vinci, and particularly with the way of suggesting atmosphere (*sfumato*) found in Leonardo's work; and lastly as having participated, from around 1507 on, in the creation of a new kind of painting which was for Vasari essentially 'modern'—that is early sixteenth-, rather than fifteenth-, century in character. This account must be treated with caution. But it seems justifiable to assume that, incorrect in its details though it may be, it has nonetheless a framework of truth underlying it.

To summarize and put together, then, what we have so far: Giorgione was born in Castelfranco in the later 1470s. He was commonly known as 'Zorzi'. The earliest date we have for a work of his is 1505 or 1506. He established himself in Venice. There, in 1507 and 1508, he was paid by the Venetian government for a canvas for the Doges' Palace; and he was also given the important task of doing frescoes on the German warehouse. In the

autumn of 1510 he died of the plague, after which collectors began to prize his pictures very highly.

Out of the very large number of works which have been attributed to Giorgione or associated with his name, between the early sixteenth century and the present day, some may be no more than copies—informative only if they are of high quality and seem closely based on a Giorgione that is otherwise lost. Others may be the work of Titian, done as a young man while he was closely associated with Giorgione, or of Sebastiano del Piombo, another major artist who is recorded as an associate of the same period. Others again may be imitations from the period following Giorgione's death, or works deriving loosely from his manner, or even later pastiches of that manner. There are altogether a great many possibilities.

We may begin with a painting in the Uffizi Gallery in Florence which has claims to being the earliest Giorgione that we have. It shows the *Trial of Moses*. This subject, which is a very unusual one, comes not from the Bible but from the Talmud. The story told there is that Moses, when still a baby, threw down Pharaoh's crown; as a test of whether he was responsible for his actions, he was given the choice between a red-hot brazier and a platter full of jewels and bravely chose the brazier. In the centre is Moses in the arms of his mother; behind her a judge seated on a high throne; and a number of spectators standing round in a half circle. The area in which the figures stand consists of bare, stony ground, but behind this the setting changes to rich fertile landscape with trees, water and grass, a castle and various farm buildings.

This painting goes with a second one, a *Judgment of Solomon*, again in the Uffizi, which is also painted on wood and similarly composed. There is a good case for taking it that only the landscape setting in this painting is by Giorgione and that the figures are by another artist. The two paintings together can be traced back to 1692, when they were in the collection of the Grand Duke of Tuscany. They entered the Uffizi in 1795 and were then said to be by Giovanni Bellini, Giorgione's great predecessor in Venetian painting. It was a great Italian art historian, Cavalcaselle, who first suggested in 1871 an attribution to Giorgione.

Now why should art historians take this to be Giorgione's earliest work, and what follows from this about his first beginnings as an artist? The two questions really go hand in hand.

Any attempt at an answer must hinge on what can be inferred from the character of the painting itself. There is no related factual evidence about Giorgione that really helps, apart from his date of birth, which implies the approximate time that he started to paint on his own, and Vasari's rather vague statement that he learnt as a young man from Giovanni Bellini and his elder brother Gentile.

We can begin in this situation with the evidence of costume. From evidence based on other paintings as to when costumes of the kind shown here were in fashion, the *Trial of Moses* can be roughly dated around 1500. The general hallmarks of the painting's composition, such as the way light falls, the treatment of space and the way in which the figures stand, agree

equally with that same rough date. No one, therefore, doubts that the picture dates from the very beginning of the sixteenth century. Everyone also agrees that it was painted in Venice or some nearby centre in the east of Italy: this follows from the type of interest shown in costume on the one hand and landscape on the other.

Then there are points about the painting which suggest that it is by an artist who is just beginning. He shows a pronounced interest in geometry in the faces such as the one to the left of the mother; and in harmonious balance in the way the figures stand and act. But the geometry is somewhat concealed by the interest in light and shade and atmosphere, which causes the edges of the faces to melt away in places into shadow; and the figures are relatively slight in build, particularly in the tapering legs and dainty feet of the men. The poses are essentially vertical ones. Where the bend of a head, or a head and shoulders, leans away from the vertical axis, it does so in a graceful but rather gentle and timid way.

Then the landscape is more like a painted backdrop or curtain behind the figures than a full and open space into which the eye moves after crossing the foreground. We are not led back smoothly from the bare ground in front to the patch of water and the path leading to the castle. Instead, our eye has to cross the bank with the large trees on it with something of a jolt. One cannot really tell whether that bank is steep or gradual in its incline. And the figures themselves appear composed in what is called an 'additive' fashion: that is they seem placed one after another at intervals across the foreground, with extra figures tacked on at either end so that the half circle should be complete. All these points suggest an ambitious and highly inventive artist who has not yet reached maturity or become completely sure of himself.

To anticipate a little, we can find specific similarities and correspondences in two paintings which are reasonably certain Giorgiones, the *Tempest* and the *Castelfranco Madonna*. The fact that the landscape contains architectural and natural elements which make it like those in the backgrounds of those two paintings is not a decisive point, because this kind of landscape was taken up and imitated very closely by Giorgione's followers, including the young Titian. But the trees are certainly, in their detail, very close indeed to those in the *Tempest* and the little figures in the landscape to the right belong to the same 'family' as the ones in the right background of the *Castelfranco Madonna*. Again, the head of the woman to the left of the mother compares very closely, in general shape and specific details like the nose, eyes and mouth, with the female heads in the other two paintings; and the two men to the right of the mother are very much like the man in the *Tempest* in their profiles and the way they stand. These similarities, then— of the kind studied by Morelli (see Chapter 1), who himself accepted this as a Giorgione—can be taken as supporting the Giorgione attribution.

As we mentioned earlier, the leading Venetian artist of the later fifteenth century was Giovanni Bellini; Bellini was at the height of his powers between 1480 and 1500, with a great many artists working under him both as pupils and more independently. One of Bellini's greatest achievements

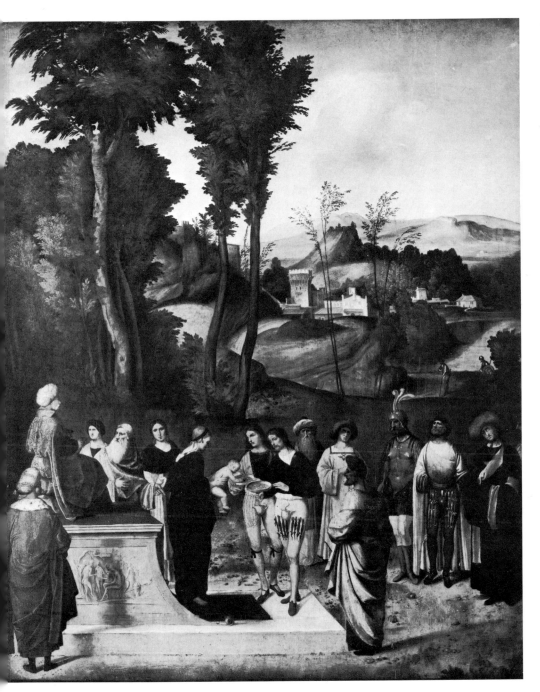

60 Giorgione, *The Trial of Moses*. Uffizi, Florence.

had been to depict landscape in terms of both light and atmosphere, down to the last fine detail of rocks and blades of grass. Bellini's landscapes have a truly magical quality in terms of the way in which light shows up the details of nature and transfigures them with its revealing power. The landscape of the *Trial of Moses,* even while it is like a backdrop, directly recalls that achievement of Bellini's in its precise delineation of detail like the leaves, and its rich and harmonious atmospheric quality which extends to the water surface and the hills behind. This relationship, then, fits with Vasari's assertion that Giorgione spent time with Giovanni Bellini in his youth, so that he would have been familiar with Bellini's work of the late fifteenth century. But the paintings of Bellini's which the *Trial of Moses* recalls most specifically, in its arrangement of figures in relation to the landscape and the dreamy quality of the figures' expressions, are ones of the 1470s and 1480s—rather than later ones, closer to 1500 in date, as we might expect.

Furthermore, the anatomy of the figures and the attention paid to costume are not elements which can be related back to the work of Bellini. Rather, they bring to mind the work of another Venetian of the end of the fifteenth century, Carpaccio. Carpaccio, though not so great a painter, was the leading Venetian artist of that period after Bellini. Whereas Bellini had been concerned to represent the human body as it moves and works, in itself, and in relation to the space around it—its muscles and sinews and the way the power of the body pushes out through the drapery into space— Carpaccio's interests as a figure painter had been different and even opposed ones. In his large mural paintings of miraculous events, Carpaccio presented the whole scene like a pageant, with a great deal going on everywhere on the canvas. Carpaccio's figures, relatively small in size, are characteristically shown walking or standing in groups and wearing splendid, elaborate costumes. They are rather thin in build and pose quite stiffly, so that they are in a way more like marionettes than people of flesh and blood. No one figure stands out more than the rest in importance, and the expressions on the faces are all very much alike, rather pinched and pursed up. Carpaccio created a certain type of figure and then used it again and again. This kind of multiplication is typical of Carpaccio, and represents his personal legacy to Venetian painting, through the artists who worked under him. It is a method which lends itself to subjects involving ceremony: pictures of solemn occasions with many extras standing by. And it is precisely these aspects of Carpaccio's art which bear directly on the treatment of the figures in the *Trial of Moses,* for we find corresponding features in the way the figures there are costumed, the way they are laid out, and the expressions on their faces, and their thin, rather slight build and again somewhat marionette-like quality.

Now if Giorgione was born in the later 1470s, and went to Venice to become a painter, he would, according to the normal pattern of the period, have done his first independent paintings in his early twenties: that is around 1500, the approximate date of the *Trial of Moses.* Vasari says that, while he spent time with the two Bellinis, he was essentially self-taught, but

sixteenth-century biographies sometimes exaggerated the independence of a major artist in relation to his predecessors; and in any case Vasari was not fully informed in Giorgione's case. But, if the *Trial of Moses* is accepted as the earliest Giorgione that we have, the features of the work which have now been discussed do seem to fit reasonably enough with the picture of this artist as learning considerably from Giovanni Bellini's art (particularly in the case of landscape) but at the same time keeping his independence to the extent that he adopted elements from other art of the time in which he grew up as well, notably Carpaccio's, which in turn has connections with Gentile Bellini's.

The Trial of Moses is, nonetheless, a strikingly original painting. It is not based directly on the work of any one older master. Then the *Trial*—itself an unusual subject—is shown taking place in an outdoor setting. The dreaminess of the figures is not of a religious or mystical kind, as in Bellini's works of the 1480s. Rather, they seem to stand or move in a state of languid trance, cut off from one another and the central drama of the baby's choice. (Look at the curiously muted behaviour of the young man holding the platters.) There is also the marvellous imaginary landscape to the rear, which contributes in such a major way to the feeling of the work as a whole. Vibrating in its brushwork, it fades away gradually and turns from green to blue as one reaches the mountains. No artist of the fifteenth century had painted a landscape which has this kind of pure 'poetry' and also such rhythmic sweep. These are points of quality which certainly seem to favour the attribution of the painting to a major artist.

There are, too, reasons for saying that this artist's knowledge was not simply limited to Venetian painting of the end of the fifteenth century. Connections seem to exist, in the masquerade-like quality of the work and the fantastic character of its landscape, with the painting that was being done in Ferrara, south of Venice, just before and just after 1500. And, more interestingly still, some of the faces are rather like those found in the work of the contemporary Flemish artist Hieronymus Bosch. Bosch's faces have pointed chins, sharp little noses and narrow eyes. How are we to explain elements of this kind getting into a Venetian work, when Bosch himself lived and worked in the north of Europe, several hundred miles away? The answer is that paintings by Bosch were to be seen in Venice at this time; we know that collectors there had them in their possession. So this is a fascinating little example of how the elements in the work of great artists could pass from one country to another, in fact right across Europe, at a time when travel was slow and difficult.

A number of drawings have been attributed to Giorgione, but the only one which has a really convincing claim to being by him is the sheet, in the Rotterdam Museum, of a *Shepherd in a Landscape*. In the early eighteenth century this drawing belonged to an Italian collector who put an inscription on it, calling it a Giorgione and identifying the shepherd as a self-portrait of the artist and the landscape in which he is sitting as a view of Giorgione's home town, Castelfranco. The idea that Giorgione depicted himself here is a romantic one which has no real basis; the town to the rear is not Castelfranco

81

61 Giorgione, *Shepherd in a landscape*. Museum Boymans-van Beuningen, Rotterdam.

in any exact sense though it is certainly rather like it, with its medieval wall with battlements and turrets, and outside this wall a rolling countryside of tufts and hills, a winding river and a bridge. In support of Giorgione's authorship, we can point to the insubstantial body and thin legs tapering down to pointed feet which appears here and in both the *Trial of Moses* and the *Tempest*. In fact, the shepherd is altogether rather feminine-looking and can be compared directly, both in build and in pose, with the woman on the right in the *Tempest*. The way in which the trees and fortifications are drawn is also, to a remarkable degree, similar to the trees in those two paintings, given the different medium. The drawing seems altogether to fit very neatly in between these two works in date—that is about 1502.

Already in Flemish art of the late fifteenth century we have paintings of religious subjects in landscape settings, such as the *Flight into Egypt* and saints in the wilderness, in which the figures are relatively small in scale, so that the story is of secondary importance and the subject, such as it is, is essentially an excuse for the rendering of an elaborate landscape around and behind the figures. The Flemish artist who went furthest in this direction was Joachim Patinir. As with the case of Bosch's work, it is more than

likely that Giorgione was familiar with examples of landscapes of this kind, since they were certainly represented in Venetian collections. This drawing uses the convention in Patinir's art of showing the figure or figure-group on a foreground knoll, sitting absorbed in reflection, with a panoramic landscape around and behind which is full of observed natural detail and diminishes by graded stages in clarity as it moves back into space. What is not found in Patinir's art, on the other hand, is the immersion that we see here of the foreground figure itself in the same pervasive atmosphere as lies over the whole of the landscape. This atmosphere is soft and palpable, breathing air and moisture. It gives the landscape a poetic quality similar to that in the background of the *Trial of Moses*, and this poetic quality serves as a kind of sounding board for the melancholy and isolation of the figure. Giorgione could conceivably, as a brilliant inventor from the start, have brought into being this kind of atmospheric treatment on his own, with only the help provided by Giovanni Bellini's works of some twenty years before. At the same time, however, it helps to go back here to Vasari's statement that Giorgione knew certain works by Leonardo da Vinci which were rich and subtle in their atmospheric effect. The technical term for this in Leonardo's work is *sfumato*, meaning the subtle and delicate grading of values from light to dark and dark to light, so that the transitions of value are quite gradual and the forms melt away and evaporate gradually into pure atmosphere. Leonardo had been to Venice briefly in the year 1500, for a few weeks or less, and he might have left behind him there a few sketches or drawings, but it is more likely that examples of his work had filtered through to Venice from the main centres where he worked, Florence and Milan, and that Giorgione grasped from them the principles of this artist's handling of atmosphere, and came up as early as around 1502 with an equivalent of his own. This would then help to explain the step forward in this drawing beyond the *Trial of Moses* in the creation of an overall unity by means similar to the great Leonardo's.

Finally, there is the remarkable fact that this drawing clearly seems to be a complete work of art in its own right, rather than a preparatory study for a painting. Landscape drawings were by no means a new thing at this date. The German artist Albrecht Dürer, coming south over the Alps on his way to Italy in 1494, had done drawings and watercolours recording the countryside through which he passed. And Leonardo had done numerous drawings of landscape motifs, especially trees and water. But these drawings were more like personal jottings and sketches expressing the artist's interests in the world around him, and drawings were not yet, so far as we know, valued and sought after by collectors in their own right, as a record of an artist's thinking and creative process. When in 1508 a Florentine artist, Fra Bartolommeo, visited Venice and then made his way back across country to Florence, he made sketches on the way recording bits of the landscape through which he passed, and these drawings have come down to us in a sketch book. But the very fact that Fra Bartolommeo made these sketches reflects the attention to landscape which he had found thriving amongst the artists of Venice. The sketches were put aside by him for

83

future use, as the basis for landscape backgrounds in his later painting; and he generalized from the sketches for this purpose, treating them as a source for imaginative variations and combinations. The *Shepherd* drawing, in contrast, stands by itself as a worked-out conception; and even if it should have a subject, the concern is with the landscape itself. The figure is simply there as a conventional focus of interest in the foreground.

The question of the relationship between figure and landscape and of the reason for the figure's being there brings us directly to the extraordinary and famous little painting known today as the *Tempest*. This is one of the three paintings which can be attributed with reasonably certainty to Giorgione, for it is recorded by the diarist of the early sixteenth century mentioned earlier (p. 75) as being in a Venetian collection, that of the Vendramin family, in 1530, and as being a Giorgione; and from then on it has a continuous history of ownership, right down to the present. From the diarist's description, there can be no doubt whatever that he was speaking of this picture. For he called it 'the landscape on canvas with the tempest, with the gypsy and soldier'.

This description of the work is significant in itself. There are two figures in the foreground of the painting, a young man holding a staff and a woman seated feeding a baby, naked except for a shawl over her shoulders. What are these figures doing, in a landscape which contains strange fragments of architecture, including the remains of two broken columns standing on a base, and a bridge and further buildings like those of a small town to the rear? Those who have thought that the painting had to have a subject have tried to find a mythological one which fitted with these details. The first suggestion in the later sixteenth century was Mercury and Isis and there have been numerous others since, involving particularly myths in which a baby was exposed to the elements. The latest interpretations at the time of writing see the subject, contrastingly and both rather attractively, as an *allegory* in which Fortitude (represented by the broken column close by the 'soldier' with a staff) and Charity (represented by the woman feeding a baby) are placed in the setting of a storm, standing for Fortune; and as a representation of St Theodore, soldier-saint of Venice, together with a mother and child whom he has saved from the dragon (shown in miniature over the gateway that forms part of the architecture).

The fact is that soon after Giorgione's death the subject, if there was one, had already become lost to knowledge. Furthermore the diarist, in his description, put the landscape and the storm first, before the figures, and he then identified those figures as simply what one might call 'extras'. It is perfectly possible, therefore, that, as with the *Shepherd* drawing, there is really no subject of the kind that would be expected from earlier art, and that the real subject is again the landscape with the storm breaking over it. 'Soldier' and 'gypsy' are simply convenient labels for the two figures; the 'soldier' could be a young traveller, given his staff and costume, and there is no particular reason why a gypsy should be naked and feeding her baby. The two figures are, in any case, completely cut off from one another in separate sections of the landscape, and seemingly unaware of each other's

62 Giorgione, *The Tempest*. Accademia, Venice.

presence, so that it is the setting and the atmosphere which form the only links between them. The whole work, with its strange blue-green colouring, has in fact something of the quality of a dream, and there is a specific precedent, in a Venetian illustrated book of the late fifteenth century, for the representation of a dream-landscape with ruins of classical buildings. This precedent is perhaps the closest that one can get, in the end, to an explanation of the painting's peculiar ingredients.

Very interestingly, an X-ray was taken of the painting in 1939, and it turned out that underneath the figure of the young man there was a different figure which had been painted out: a young woman bathing, seated on the bank with her feet in the water. Some people have taken this as a further support for the painting's having no subject, the argument being that Giorgione was making up the figures as he went along. But this female figure on the left could in principle be Giorgione's first idea for the placing of the female figure whom he eventually put on the right. The X-ray does not tell us enough about the order of Giorgione's working process on the picture for any certainty to be possible one way or the other. But what it does establish beyond any doubt is that Giorgione worked directly on the canvas from the start, dispensing with preliminary studies and making changes in the paint itself as he went along. And the fact that he improvised in this way certainly seems to tie in directly with the work's poetic and purely imaginative qualities.

The *Tempest* is quite a small picture (about 31″ × 29″) and exceptionally well preserved. It also stands at the head of a whole line of paintings which were produced by Giorgione's followers. They are of the type known as pastoral idylls. In them a cast of shepherds and shepherdesses, or sometimes mythological figures, small in size, are set in imaginative landscapes with trees and rocks and water. It is from this particular painting of Giorgione's, more than any other, that a whole tradition of later pastoral painting in Venice derives.

Because the *Tempest* is a key work in this sense and the most poetic of Giorgione's creations, some historians have assumed that it must be a mature work of his, dating towards 1510, rather than earlier. If the figures are still relatively small and delicate in build, and not fully integrated with the landscape, they attribute this to the fact that Giorgione was working here on a small scale. But it seems more logical to put the painting before the *Castelfranco Madonna,* on the grounds that one can then trace a continuous development from the *Trial of Moses* through the *Tempest* to that work. In the *Tempest* the landscape beyond the figures is still like a painted backdrop, as it was in the *Trial of Moses;* and the figures, while they occupy clear pockets of space in the front of the painting are, as it were, stuck on to that backdrop; whereas in the *Castelfranco Madonna,* and the *Three Philosophers,* the figures are no longer stuck on in this way. Similar arguments can be made in terms of how the figures stand or sit and the increased fullness of the bodies and greater confidence or ease of pose. Though the point remains arguable, the *Tempest* will be taken here as dating from around 1503.

A place can then be found next, around 1504, for the *Judith* in the

63 Giorgione, *Judith*.
Hermitage, Leningrad.

Hermitage Museum in Leningrad. Judith is shown with sword in hand, with, under her feet, the head of the giant Holofernes which she has just cut off. In the eighteenth century this painting was taken to be by Raphael. Then in the later nineteenth century the idea was tentatively put forward by Morelli that it was a Giorgione, and this has since become generally accepted. One can see why, simply by comparing the head and drapery in the *Castelfranco Madonna* and the legs of the two saints at the bottom of that picture (in the way they bend and the way the feet are painted). The *Judith* was enlarged at the sides in the eighteenth century, as is shown by an engraving of that time as compared to an earlier graphic record, but was then cut back down to its original size in the mid-nineteenth century; and in 1893 it was transferred from wood to canvas. In the head there is a greater concern than before with creating a perfect oval shape. This head and the upper part of the body in fact suggest that Giorgione had by now studied antique sculptures which were available in Venetian collections. What he knew would have been Roman copies, rather than Greek originals, and his awareness of antique sculpture here seems to come to him through the filter of fifteenth-century paintings with classical proportions, such as Piero della Francesca's, and through fifteenth-century Florentine sculpture, such as Donatello's famous *St George*. Padua, where Donatello had worked, was not far from Venice, and the legacy of Piero's conception of the figure had entered Venetian art in the later fifteenth century and been kept alive there by Giovanni Bellini himself. At the same time, in the lower half of the *Judith,* the drapery falls in complex folds which are stiff and distinctly metallic. This kind of drapery pattern seems to come into Giorgione's art here from knowledge of northern engravings, particularly those of Dürer which, again, were represented in Venetian collections. Like the *Trial of Moses,* the *Judith* combines Italian and Northern elements.

A small group of portraits also seems to fit in around the same date. One, of a young woman, known as the *Laura,* has a face very obviously like the gypsy in the *Tempest.* In 1882 an inscription was found on the back of this painting which could be read as stating that the painting was by 'Master Zorzi of Castelfranco', and includes the date of 1 June 1506. The preciseness of the information suggests that it was put on soon after Giorgione's death, if not within his lifetime; and it therefore provides strong evidence as to his authorship. But the date, exact though it seems, may all the same not be absolutely reliable, in view of the early growth of myth about Giorgione's career. If the *Tempest* is put earlier, the same sort of date, around 1503–04, equally suggests itself here, because of the close resemblance. But one might still accept the 1506 date, because it is not impossible that in the field of portraiture, as distinct from his main field of subject-matter, Giorgione developed at a somewhat different pace. Who the lady here is, we do not know. She has come to be known as the *Laura* from the laurel bush behind her. There is no reason to think that her being shown with one breast exposed is any reflection on the lady's purity. Exactly the opposite, in fact. The laurel always characterizes the person depicted as virtuous and is specifically a symbol of virtue in marriage. So the exposed breast brings

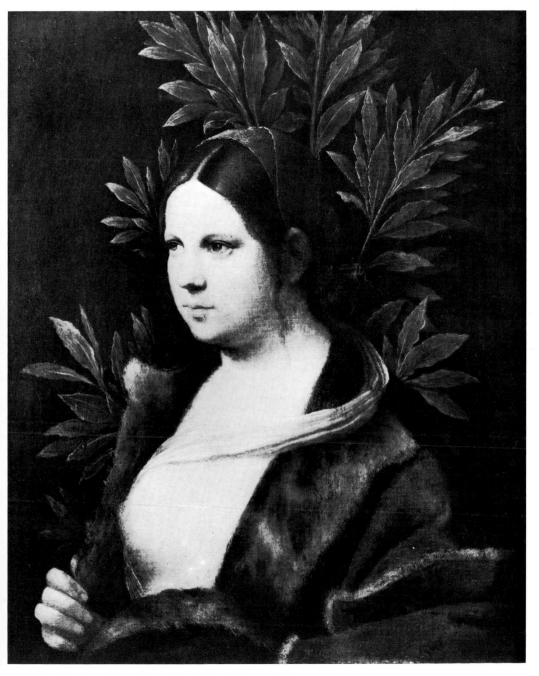

64 Giorgione, *Laura*. Kunsthistorisches Museum, Vienna.

in the idea of the woman's fertility through her marriage; it is a breast for feeding a child like the one in the *Tempest*.

A second portrait, of a young man, now in the Museum of West Berlin, has the same marvellous play of atmosphere at the edges of the face and the same richness of texture in the way that the hair and clothing are painted. This portrait was not attributed to Giorgione until the nineteenth century. When the painting was acquired by a private collector in 1884 and then sold to the Berlin Museum seven years later, it was immediately and un-hesitatingly felt to be a Giorgione, simply on the basis of its intrinsic qualities. It may possibly be a self-portrait, from the fact that, according to a convention established in Italy in the fifteenth century, the man is shown looking out of the picture towards us. This would be the way the eyes would be turned if the artist were using a mirror to portray himself. The figure is posed behind a low parapet in the foreground, a device which Giovanni Bellini had already used, and which goes all the way back to Jan van Eyck's portraits done in Flanders at the beginning of the fifteenth century. The letters 'V V' on the parapet, on the other hand, are completely mysterious. They might be the young man's initials, if he is not Giorgione, or they might stand for 'Vanity of Vanities', in reference to the transitoriness of human life and the inevitable fact that the human body is subject to decay; but this can only be a guess.

A third portrait, again attributed to Giorgione in modern times (1903), shows an old woman with a withered face pointing at herself and holding a scroll with an inscription on it referring to the passage of time. This is again a very extraordinary image, midway between a portrait and an allegory, and it probably represents a painting which was in the collection of the Vendramin family in Venice in 1569 and was said then to be of Giorgione's mother.

Today, when visitors go to Giorgione's home town of Castelfranco, it is above all to see the altarpiece known as the *Castelfranco Madonna* which hangs in a side-chapel of the Church of San Liberale there. Although this magnificent painting was first mentioned as a Giorgione only in 1648, in Carlo Ridolfi's history of Venetian painting, and there is no earlier record of it or reference to it, it represents the second painting after the *Tempest* which has been universally accepted as his. It and the *Tempest* and the *Three Philosophers* are in fact very closely related in all of the significant aspects so far considered in regard to Giorgione's work: the conception of the landscape, the shapes of the faces, the dreaminess of expression, and so on down to the drapery and the child here, who is so similar in every way to the one in the *Tempest*. According to Ridolfi, the altarpiece was com-missioned by one Tuzio Costanzo, whose coat of arms appears on the base of the throne; and Giorgione most probably went back from Venice to his home town to paint it. An eighteenth-century chronicler tells us, further-more, that Tuzio had a son, Matteo, who was killed in a battle in 1504 and brought back to Castelfranco for burial. Tuzio himself is stated to have erected a chapel to St George, the warrior-saint. And since Matteo's grave-stone was originally located in front of the altar over which the *Castelfranco*

65 Giorgione, *Portrait of a Young Man*. Gemäldegalerie, Berlin.

Madonna hangs, there seems virtually no doubt that the altarpiece was commissioned in honour of the dead son, and that both Ridolfi and the eighteenth-century chronicler were recording local tradition as to how the work came to be there. This, then, gives a date for the altarpiece of around 1505 and the chronology suggested here for Giorgione's work, up to and including this painting, fits with that date and to some extent depends on its probability.

The Madonna is shown high up on a throne against a cloth of gold, with the landscape and sky behind above the level of the wall; two saints, San Liberale and St Francis, stand either side of the throne on a tiled floor below, both looking outwards and, in the case of St Francis, gesturing towards the spectator. In terms of presentation, this is a case, as with the *Judith,* not of a new subject, but rather of a very personal version of the subject in question. *Judith* had often been depicted in the fifteenth century with the head of Holofernes, but she was normally shown exulting in her triumph. Giorgione had shown her in an open landscape setting rather than a tent, looking dreamily down at the head under her foot with her sword simply held upright at her side, more like an unconcerned goddess than a human being—more like Donatello's *David,* a comparable subject of victory over superior strength, than any previous *Judith* figure. Similarly, in the case of the *Castelfranco Madonna,* Giorgione could look back to two related kinds of composition used by Giovanni Bellini in the later fifteenth century. Bellini had done a number of paintings in which the Madonna and Child are shown outdoors in landscapes in which incidents of country life are taking place, amongst buildings, fields and trees. He had also developed a version of the theme known as the 'sacred conversation', in which he placed the Madonna on a high throne in the centre with saints flanking her on either side, the whole in a church setting. What Giorgione effectively does is to combine these two precedents. Taken by itself, the upper half of the painting, down to the wall, is like a Bellini of the first kind, while the combination of the Madonna and the saints is related to the second sort of composition described.

When one starts to look in detail at the two sections of landscape, it becomes evident that they do not join up with one another in a completely logical way. At least the ground would have to change its slope very abruptly at the back of the throne for the two levels to meet up, and the faint blue horizon-line drops slightly to the left. There are, in fact, at least three different points of sight implied in the perspective of the painting, one for each level of the throne, so that the Madonna may be seen from her own level, as the most important figure of the three, as well as the two saints.

This painting, therefore, can be taken as a kind of mid-way stage in Giorgione's co-ordination of figure and spatial elements. The strongest development here as compared to the *Tempest* and the *Judith* lies in the firm, balanced way in which the figures stand and the way in which their weight is now felt as resting on the ground, through the position of their feet and the vertical and horizontal axes of the body as a whole. It has been suggested in this connection that Giorgione had now studied with deep

66 Giorgione, *Castelfranco Madonna*. S. Liberale, Castelfranco (Veneto).

attention the way in which the figures stand and take up their balance in altarpieces of a few years earlier by the leading artists of Bologna and Ferrara. The closest parallels are found in these artists' altarpieces of 1497–1501: that is, about four to eight years earlier. The artists of Ferrara in question were already referred to earlier, in connection with the *Trial of Moses*. If Giorgione looked at their work again now, it was with a different kind of interest.

The third painting which is now universally recognized as a Giorgione is the so-called *Three Philosophers*. Like the *Tempest,* this work is described by the early-sixteenth-century diarist who recorded the contents of Venetian collections. He mentioned it as being in the collection of Taddeo Contarini and called it *Three Philosophers in a Landscape,* saying that they were contemplating the rays of the sun. What the subject really is, is another mystery. Connections have been traced between the first owner and certain learned circles of scholars and humanists who were active in the north of Italy at this time; and their ideas may well lie behind the strangeness of the subject, which seems to defy any exact identification. The three figures could be the three wise men who followed the star to Christ, pausing on their journey; or they may symbolize three stages of human thought, the ancient, the medieval and the modern. The only clue that we have as to Giorgione's intentions comes from the evidence of an X-ray taken in 1932, which shows that the old man on the far right originally had a diadem or fan-like crest on the front of his head-dress. It is thus possible that Giorgione may have thought at first of representing the kings and then combined this idea later with a philosophical or astrological significance. The old man at the right holds a paper with a crescent moon on it and what seem to be three astrological signs. The middle one wears a turban which is certainly Oriental, and the seated one holds a pair of dividers, which he might be using for recording the movement of the heavens, or alternatively for making an architectural plan. But nothing in the way of a sign appears in the sky to the rear (it is simply an evening sky) and the three men ranging from youth to old age are not doing anything positive, but rather simply sitting or standing contemplatively in a landscape of mound and cliff and tree and wood. There is a little group of buildings behind of a kind familiar from other Giorgiones, with green and blue hills beyond and the sun going down. It is no longer a soft, green, spring landscape of the kind we have seen in Giorgione's art up to now, but rather one which is autumnal, with some of the trees quite bare.

Leaving the subject-matter aside, there is certainly a stronger and more consistent harmony between man and nature here than in the *Castelfranco Madonna*. Light becomes an important agent in the creation of this harmony, since a soft evening light, which seems to come from a source other than the sunset itself, diffuses the whole of the foreground and blends the figures gently and quietly in with their physical setting. It unites together space and atmosphere, so that the intervals between the figures, and the area of semi-darkness at the lower left, become positive rather than negative elements in the composition—not merely fill-in areas, but alive in their own

67 Giorgione, *Three Philosophers*. Kunsthistorisches Museum, Vienna.

right with a quality of vibrancy and luminosity which goes with the whole mood of the work. Giorgione in fact composed the whole painting, both landscape and figures, in terms of large intersecting triangles. The figures are fuller in physique here and more completely balanced in their gestures and poses, so that the work has what might be called a supernatural lucidity, in the logic of the figures' shapes and their relation to one another and to the landscape. All these points suggest a date of around 1506, a year after the *Castelfranco Madonna*. With this painting, in fact, Giorgione's development starts to parallel that of Raphael in Florence and Rome between 1506 and 1510. Like Raphael, he begins to move in his own terms towards the creation of a complete harmony between figures and space and a correspondingly balanced and harmonious conception of the human

95

68, 69 Giorgione, fragment of female nude from the Fondaco dei Tedeschi, now in the Accademia, Venice; and an eighteenth-century engraving of the same fresco. British Museum, London.

figure. In the case of Raphael, this development is known as the creation of High Renaissance Classicism; and, taking into account the differences between Venetian and Central Italian art, the same term 'High Classicism' could be used for Giorgione's development from now on.

We now come to the frescoes which Giorgione painted on the German warehouse or 'Fondaco' near the Rialto in Venice, receiving payment for this, after arbitration, in December 1508—the one absolutely certain date that attaches to a surviving work. Sad to say, only the ruin of one of these frescoes of Giorgione is left, a standing nude female figure, twice life-size. It was removed from the wall in 1937, but by then the damp corroding air of Venice, which affects the buildings there and outdoor paintings even

more so, had taken its toll on this fresco, so that, as the illustration shows, the whole surface is blistered and cracked, the red underpainting has come through, and the whole thing is now more like a ghost than a living work of art.

After being gutted by fire in January 1505, the warehouse had been re-built by the Venetian Republic during the ensuing twelve months and we know that the roof was placed on the new building in May 1507. The frescoing of the outside must have been commissioned by the government soon after; and since the female figure we are considering comes from the highest level on the wall facing the Grand Canal, it must have been one of the earliest frescoes done, and therefore probably dates from late 1507 or early 1508. We also know (not from the documents of payment, which do not mention this, but from the early biographies) that the young Titian was employed on the frescoing alongside Giorgione, probably as an assistant working under Giorgione's supervision. Giorgione seems to have been re-sponsible for the Canal side of the building and Titian for the side at right angles to this, facing the Merceria.

Faced with deciphering the subject-matter of the warehouse frescoes as a whole, Vasari gave up in despair, saying that the allegorical meaning of the various figures was simply beyond his understanding. But from his own account and from engravings made in the seventeenth and eighteenth centuries it is clear that there were standing and seated male and female figures called by various names (such as Venus, Eve and Judith, a Levantine, and a Swiss). There was also a chiaroscuro frieze (one without colour) on the canal side, with nymphs, arabesques and other imaginative elements, which was probably the work of an assistant; and then there were heads, trophies, men on horseback, and columns in perspective. Giants and monsters in combat appear in another section of fresco that could still be read to that extent when taken off the building in 1967. How exactly these elements were arranged in relation to one another we do not know, but the indica-tions all are that this was another case of Giorgione's devising an original and highly personal subject-matter. These were not, apparently, the only frescoes that Giorgione did on the façade of Venetian buildings. Other schemes of this kind, entirely lost, are recorded by Vasari and Ridolfi, in-cluding one in the artist's own house; and within a house at Castelfranco there is a chiaroscuro decoration involving heads, scientific instruments, cameos, and other emblems and accompanying mottoes which may well be an early work of Giorgione's. But the German warehouse frescoes were clearly his most important work of this kind, which made the building on the canal into an artistic landmark for visitors and residents.

In deciphering the ruin that is left of the female figure, we are helped by the existence of an eighteenth-century engraving. It shows that the bottom half had already badly faded by then, and that the figure was standing in a niche, but to the front of it. We can have no idea of the colours, but can see from the two plates together the 'classical' character of the figure's pose and its proportions, with high, completely firm breasts, and a perfect oval shape to the face. Undoubtedly, in this figure, Giorgione was moving further, in

97

1508, into the realm of High Classicism. In Rome at this time Michelangelo, the joint creator of High Classicism alongside Raphael, was beginning the frescoing of the Sistine Chapel. Giorgione achieves here the same kind of free-standing and harmonious pose, and the same kind of relationship between figure and architecture, as Michelangelo brought into being in his famous figures of the *ignudi* (nude young men framing the central scenes) on the Sistine ceiling.

The painting in the Dresden Museum, of the *Sleeping Venus in a Landscape,* came there in the later eighteenth century, after belonging previously to King Augustus of Saxony. It was called a Giorgione in 1707, but was later listed as a Titian, until Giovanni Morelli, as part of his campaign of re-attributing pictures in this museum, identified it as the painting recorded in 1525 in the collection of Geronimo Marcello in Venice: a nude sleeping Venus in a landscape, by Giorgione. It is clear simply from the proportions of this figure, the head and breast and arms, how closely related it is to the warehouse fresco, so that it can be placed around 1508. The dream-like character of Giorgione's art reaches its highest point of expression here. Completely relaxed and completely exposed to our gaze, the nude goddess dreams, cut off from the world in another evening landscape which is equally imaginary and ideal. The rhythms of her body and even the muted state of sleep itself are picked up and echoed in the rhythms and character of the landscape. The subject is again an absolute innovation, related only, far back, to the antique subject of the sleeping Maenad (a follower of Dionysus). And again, as in Michelangelo, there is a totally original conception of the relation between outward behaviour in an ideal figure, and an inner state of perfect grace and calm.

70 Giorgione, *Sleeping Venus in a Landscape.*
Gemäldegalerie, Dresden.

71 Giorgione(?), *David with the head of Goliath.*
Kunsthistorisches Museum, Vienna.

What possible Giorgiones are left, which could be works of his last two years, 1508–10? The last two pictures that we shall look at are not mythological or landscape subjects, but half-length figure pieces; and it is possible that Giorgione concentrated on paintings of this kind during his final years.

Vasari, in his 1568 Life, mentions in the house of the Grimani family in Venice several very beautiful 'heads' by Giorgione, one of which was a painting of David, which was said to be a self-portrait. He was shown carrying the head of the giant Goliath which he had just cut off, wearing armour, according to Vasari, and with the long hair down to the shoulders which was fashionable in Giorgione's time.

In 1908 a painting in the Brunswick Museum was recognized as being very probably this work (Ill. 59). It has all the details which Vasari described, and an engraving made of it in 1650 shows that the lower part was subsequently cut off and that before that happened it also included the head of Goliath lower down, held by the figure in his hands. Some later historians thought, on the grounds of quality, that this was simply an old and accurate copy, probably from the seventeenth century. But X-rays taken in the 1950s revealed underneath the figure a painting of the Madonna and Child which can be associated in its composition with Giorgione's period, and might well be by him. When underpaintings of this sort are found they provide evidence that the canvas was first used for another purpose, and though it is theoretically possible that this happened in the seventeenth century, the argument for an original becomes considerably stronger. The strongest comparison favouring Giorgione's authorship of this *David* is with the portrait behind a parapet (Ill. 65). The resemblances in the rendering of

99

eyes and mouth and shadow, and the related point that that work also may have been a self-portrait, offer support for Vasari's attribution.

A second painting of the young David in armour, this time in a breast-plate and with the head of Goliath and a mighty sword included (Ill. 71), is in Vienna. An engraving was made from it in 1660, when it belonged to the Archduke Leopold Wilhelm of Austria. This painting is in very poor con-dition and therefore difficult to judge, but it has distinct similarities to the other *David* and is also very like the *Judith,* especially in the general shape of the head. There has been considerable disagreement over this painting, and it certainly is not as fine as the other *David.* It seems most likely, therefore, to be a copy of a lost original.

If these two works are regarded respectively as an original and a highly informative copy, they share an even broader conception of the figure than the *Three Philosophers.* In fact, these figures seem to expand out sideways in their bulk to fill up virtually the whole of the available picture space. And on this basis, we may, at least tentatively, put these works later than 1508. In them, in other words, Giorgione goes beyond the 'classicism' of the 1508 frescoes to make his figures even more severe and imposing. He places them so that they confront and challenge the viewer more immediately from within the limited space of the canvas, and he creates a greater drama of contrast between lights and darks. This we may assume to be the very last stage in his development before his sudden death.

It remains to say something, finally, about the two artists who are recorded as having worked with Giorgione during the last part of his career, and who went on to become extremely important artists in their own right: namely Sebastiano del Piombo and Titian.

Sebastiano moved from Venice to Rome in 1511 and there became involved with the example of Michelangelo. Prior to this move he had worked in Venice for several years and must have received his training there. One particularly large altarpiece in Venice which is now generally recognized to be a Sebastiano was called a Giorgione by Vasari in the first edition of his *Lives,* though Vasari subsequently realized himself that this was not right. More interestingly still, the diarist of the early sixteenth century who describes the *Three Philosophers* as being in a Venetian collection in 1525 says in his description that this painting was begun by Giorgione and finished by Sebastiano. This has naturally tempted art historians into trying to establish, from analysis of the painting itself, which parts are by which artist; but no one has ever succeeded in convincingly doing so. The *Three Philosophers* definitely holds together as all of a piece. So the diarist may very well have been wrong on this particular point. But if that is so, his statement is still valuable in implying that Sebastiano had, in fact, worked with Giorgione, presumably as an assistant, around the time of the *Three Philosophers:* that is, around 1506.

Now, in a private collection at Kingston Lacy, Dorset, there is a large and marvellous painting of the *Judgment of Solomon.* It came to England around 1830 from a palace in Bologna. Its earlier history is unknown, though it may be recorded, as we shall see, as being in Venice in 1648. For

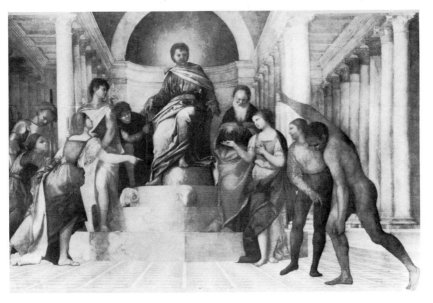

72 Attributed to Giorgione, *Judgment of Solomon*. Private Collection, Kingston Lacy, Dorset.

many years the owners would allow no photographs of this painting to be published and would only rarely let it be seen. During this time various attributions were suggested, but it is important to be aware that the art historians who made them had to work from memory, rather than making careful comparisons. The collection has now been opened to the public; and so it has become possible for the first time, during the last ten years, to study the painting thoroughly.

The family still takes the work to be a Giorgione, but there are very strong arguments for its being by Sebastiano. These arguments depend partly upon comparison with paintings that Sebastiano did while in Venice: the altarpiece mentioned earlier and a pair of painted organ-shutters in a Venetian church which are documented as having been done between 1507 and 1509. While the figures are rather like Giorgione's *Three Philosophers* in a number of ways, those in the foreground are involved in much more dramatic actions. Also the setting, with its complex architecture of tiled floor and dais and receding columns, is of a kind not seen anywhere in Giorgione's art. It can also be seen that the painting is unfinished, particularly in the foreground. The story told is of how two mothers, who disagreed as to which of them a baby belonged to, brought their case before King Solomon, who solved the problem by ordering an executioner to cut the baby in half; at which point the rightful mother reacted as would be expected. Solomon appears here in judgment upon his throne with the two mothers arguing their case before him down below, and the executioner at the far right. But the baby which should be in the centre on the tiled floor is missing and so is the sword in the executioner's right arm. Furthermore, the

101

paint in the lower half of the picture is relatively thin, so that in a good light one can actually see parts or indications of dim figures which correspond to the artist's earlier ideas. Thus the picture was blocked out in all its essentials, involving figures and architecture and lighting, but the artist never reached the stage of putting in the last elements or working up the lower figures to the same degree of finish as one finds in the three central figures raised above the rest. This means, then, that this may well be the painting described by Carlo Ridolfi in 1648 as being in the Grimani house in Venice (the same collection as had the Giorgione *David*); Ridolfi called it 'the Judgment of Solomon with the figure of the rabbi unfinished'. The history of this painting would then be taken back considerably earlier, to the mid seventeenth century.

The painting for the audience hall in the Doges' Palace in Venice, for which Giorgione was paid in 1507–08, according to documents, is a complete mystery. The fact that three different payments were made for it would certainly tend to suggest that it was finished. But it is fairly surprising that the work is never mentioned in any later record of what was to be seen in Venice. If it had been put in place, redecoration of the hall in 1577 following a fire which struck the Palace in 1574 would have made it redundant. Possibly that is what happened, but it is also possible that Giorgione in fact delegated this commission to Sebastiano, as an assistant of his at the time; and that, because the painting was not finished by Sebastiano, it therefore never entered the Doges' Palace, but passed instead into private hands. Certainly, though we do not know the subject of the commission given to Giorgione, the *Judgment of Solomon*, which involves a famous example from the Bible of a judicial decision, would have been completely appropriate for a Hall of Judgment. According to Vasari, furthermore, Titian also, in his youth, did a large painting of the *Judgment of Solomon*, a fresco, for the city of Vicenza, which is completely lost, but which decorated correspondingly the space used for judicial hearings there. So if Giorgione did not pass his commission on, all three artists, Giorgione, Sebastiano and Titian, must have been involved at this period, around 1508, in closely related projects of a monumental kind.

But what the Kingston Lacy picture suggests, now that it can be fully studied, is that, whether or not this was a Giorgione commission, Sebastiano was much more than simply a technical assistant to Giorgione at this time. He had evolved to the point where he was working on a very large scale, with strong ideas of his own about the scale of figures and architecture and the relation between them. In fact, when we compare this work, itself of very great importance, with what is left of the frescoes on the German warehouse, it begins to look as if Sebastiano contributed as much as Giorgione, if not more, to what we may call a Venetian High Classicism. Sebastiano has evolved here, as Raphael would begin to do in Rome the next year, an extremely elaborate repertoire of gestures and poses, built in a half circle in space which has its apex in the figure of Solomon; and he has created a stately architecture to match the figures in grandeur, with views down colonnades in perspective to the left and right.

The Kingston Lacy *Judgment* is, then, a crucial work, very advanced for its time as well as a magnificent experience for the visitor who sees it. Sebastiano's great merits, particularly evident in this painting, make him deserve to be as well known as Giorgione himself, or even Michelangelo. Modern art history has, in a way, rediscovered his great quality.

The young Titian is recorded as having worked with Giorgione on the frescoes for the German warehouse. We do not know if he was commissioned to do this along with Giorgione. His name does not appear in the documents of payment, but they concern only the Canal side of the building which was Giorgione's own part in the work, so this is of no help in determining what his exact status was. It seems most likely, since it is recounted that he had come to work with Giorgione after receiving his training in Venice and later studying with the two Bellini brothers, that he was taken on as a special, and somewhat independent, assistant for this project.

Which other paintings are the work of Titian between 1505–10 is very much of a disputed question. But one thing that we are told, in the anonymous diarist's mention of the Dresden *Venus*, is that the landscape and the 'cupid' there were contributed by Titian. Where is this cupid? We do not find him in the painting now. According to Ridolfi he was holding a little bird in his hand. In the 1840s a first search was made for this missing figure. And it was duly found through cleaning at the feet of Venus at the right—but owing to its very poor condition, it was covered up again. Much later, around 1930, when it had become possible to take X-rays, these were used to confirm afresh the one-time existence of the figure.

As for the landscape, though the general conception of it in relation to the figure is to be taken as Giorgione's, it does indeed look as if its execution was also the work of Titian. For the handling of the trees and buildings is very close indeed to a painting of about 1512 which is certainly by Titian: the *Noli Me Tangere* in London (National Gallery). Here then, we seem to have confirmation of Titian's having worked alongside Giorgione around 1508, in a special capacity very like Sebastiano's. What he learned from that experience was of immeasurable importance to him; for Titian became, after 1510, the great inheritor of Giorgione's legacy to Venetian painting. Though he was more volatile and dynamic in temperament from the first and soon moved away from the spirit of Giorgione's art, it was from Giorgione's example that he took up the use of colour and freedom of brushwork, and he also learnt from the classical discipline of Giorgione's later art. Vasari recognized this already when, in the first 1550 edition of his *Lives*, he concluded his Life of Giorgione by saying that Titian, as Giorgione's successor, had not only equalled, but surpassed him. According to the terms which he set up for himself in that first edition, Vasari did not deal with any artist who was still alive. So the fact that he said that much about Titian, and the way that he said it, shows already the recognition which Vasari would later spell out in detail in his second edition. After Sebastiano's departure for Rome, Titian indeed took up the challenge which it fell to him to answer.

103

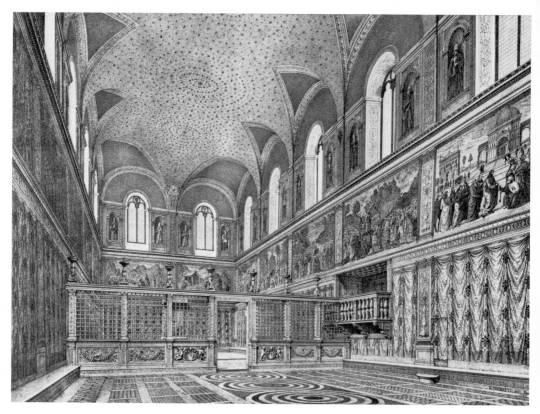

73 Reconstruction drawing by E. Steinmann of the Sistine Chapel in the early 1500s, looking towards the altar, before the ceiling frescoes and *Last Judgment* of Michelangelo and the tapestries of Raphael.

Chapter five
Reconstructing how works were displayed: Raphael's tapestries in the Sistine Chapel

IN JULY 1517 Cardinal Louis of Aragon was travelling in Flanders. At the end of the month he was in Brussels, and in the diary of the journey kept by his secretary, there is an entry which reads: 'Pope Leo is having sixteen pieces of tapestry made there, according to what is said, for the Chapel of Sixtus which is in the Apostolic Palace in Rome, for the most part of silk and gold; they cost two thousand gold ducats apiece. We were at the place to see them being made.' From the one tapestry which was finished, the Cardinal judged that they would be 'amongst the most beautiful in Christendom'. And two and a half years later, in December 1519, Marcantonio Michiel—who was probably the recorder of paintings in Venetian collections described in the last chapter—wrote in his diary: 'This Christmas the Pope showed in the Sistine Chapel seven pieces of tapestry, since the eighth had not arrived'; and he then went on to describe their subject-matter, which involved the stories of St Peter and St Paul spreading the Gospel of Christ. What Michiel was writing of was a very important event of the day for people in Rome: the first exhibition of these great tapestries, which had been woven in Flanders at tremendous expense, from cartoons made by Raphael.

In order to understand the impact of these tapestries, how they told their story, and how they were seen as works of art, it is necessary to reconstruct exactly how they were displayed. As was already pointed out at the end of Chapter 3, a very important principle and practice in the history of art is involved here. It is a principle which particularly affects cycles of works (most often frescoes) and works done for public buildings such as churches and palaces. Very often we cannot fully understand the character of a work, as the artist conceived and executed it and as the spectator of the day saw it, without going back to the way in which it was originally displayed. A church may have been rebuilt, or substantial architectural alterations may have been made to the space for which a fresco cycle or a series of paintings was originally done. Or objects of art or architectural elements which formed part of the original setting, such as windows or pillars, carvings or statuary, or the general furnishings of a chapel, may have been altered or no longer be there. In such cases the art historian has to reconstruct from

105

contemporary records, and from any visual evidence which may survive (such as prints or paintings made of the church or palace before changes took place), both the original appearance of the work and the whole context within which it was seen. He has to do this in order to be able to interpret properly such crucial features of the work itself as, for instance, the part played in an arrangement of frescoes by the framing elements in between one fresco and the next, or the perspective of a ceiling painting as it appeared to the spectator standing on the floor below. Furthermore, where the works are transportable ones, as is the case with paintings on canvas, the very sequence in which they were originally hung, and the scheme which they formed as a group may have to be reconstructed also.

Both these points are true of the Raphael tapestries made for the Sistine Chapel. These tapestries exercised a tremendous influence on virtually all Italian art during the rest of the sixteenth century, not to mention later artists; and they also represent the last full-scale scheme that Raphael was personally responsible for carrying through, before his death in 1520. (There are later cycles of frescoes in the Vatican and elsewhere for which Raphael had some responsibility in terms of ideas and the making of drawings; but the actual execution of these frescoes was the work of Raphael's assistants and followers, in some cases after his death.) It therefore becomes particularly important to know how exactly the tapestries originally went together as a cycle in the chapel, and how they looked in that setting. Dissatisfied with previous attempts to solve this problem, two English art historians, John White and John Shearman, set out in the 1950s to look into the question more thoroughly and intensively than had previously been done; they published their conclusions in 1958, dealing with both the tapestries themselves and the cartoons for them.

In order to follow the arguments that led White and Shearman to their conclusions, we have to begin as they did with the Sistine Chapel as it appeared in the early 1500s. The reconstruction drawing illustrated here brings together what is known on this subject. Originally, the wall behind the altar at the far end of the chapel had two round-topped windows in it. In the mid sixteenth century this wall was to be turned into a plain and unbroken one, on which Michelangelo painted his *Last Judgment* covering the whole of the wall. For this purpose Michelangelo had to paint out two frescoes which he had previously done at the top of this wall, as part of his decoration of the ceiling. In the middle of the chapel there was a screen dividing it into two parts: a chancel at the altar end and then, the other side of the screen, an area for those non-members of the chapel who made up the unprivileged lay congregation. This screen still exists, but it has been moved back towards the entrance. Originally it divided the chapel into two approximately equal areas, and its position then is marked by a low step, as can be traced from marks on the floor and on the singing gallery at one side. On the side walls of the chapel, to the left and right as one moves up to the altar (left and right will hereafter be used from this point of view) a team of artists called in during the 1480s had done a whole series of frescoes. These frescoes, most of which are still there, consist of full-length portraits

106

of the Popes in niches between the windows; and below them, on the upper halves of the lower walls, two series of eight frescoes running parallel to one another either side and telling the story of Moses on the left and the life of Christ on the right. Below these frescoes the side walls were painted with a decoration imitating damask hangings. It was at this level that the tapestries were designed to go. At this period the ceiling of the chapel, which takes the form of a barrel vault, was painted blue all over, with a decoration of stars, and the areas between the top windows and at the four corners (the lunettes and spandrels) were correspondingly plain.

Between 1508 and 1512, Michelangelo painted his famous ceiling decoration on the vault of the chapel. For this purpose he devised a framework of painted architecture, which completely disguises the actual curve of the ceiling, and down the centre he painted the story told in Genesis of God's Creation of the World and its aftermath, from the Separation of the Light and the Darkness, to the Flood and the Drunkenness of Noah. In narrative order these scenes run from the altar end back towards the chapel entrance. The spectator coming in at the chapel end and moving towards the altar, therefore, experiences the sequence in reverse (though visually the right way up), beginning with the scenes which involve Man and ending above the altar with God wrestling alone with the unformed universe. The central theme of this ceiling of Michelangelo's is the Fall of Man and the prophecy of his future redemption through the Coming of Christ. Below, in the fifteenth-century frescoes, both the Old Testament story of the life of Moses (the great forerunner of Christ in his leading of the Jews out of captivity and receiving of the Law on Mount Sinai) and the life of Christ on earth were told, in parallel to one another. Since therefore—to recapitulate— Michelangelo's ceiling told of Man's falling from grace and the wall frescoes of Moses and of Christ, what was needed, to make the decoration of the chapel tell the Christian story complete, was a depiction of the spread of the Gospel on earth after the death of Christ: specifically, how Peter and Paul had received their charge from Christ and gone out over the earth to convert Jews and Gentiles respectively. The Sistine Chapel, named after Pope Sixtus IV, was the palace chapel of the Pope, St Peter's successor by direct line according to the faith. So it was supremely appropriate that the whole message of Christianity, from the beginning of the world to the establishment of the Papacy, should be narrated on its walls, with strong allegorical links throughout between the Old Testament world of the prophets and forerunners, and the New Order which succeeded the Coming of Christ. By the addition of the tapestries, in fact, the transformation of the fifteenth-century scheme of the chapel, begun with the painting of the ceiling, would be brought to completion, and also brought into balance in terms of total visual effect. (Michelangelo's *Last Judgment*, which now occupies the altar wall, was not painted until 1536–41.)

When exactly the commission came to Raphael from the Pope, Leo X, to produce cartoons for a series of Brussels tapestries is not recorded, but it must have been around 1515, for a first payment was made to the artist in June of that year and another in December 1516, and an engraving had

already been made after one of the designs by 1516. The sum fixed for each cartoon, we are told by the diarist Michiel three years later, was the lordly one of one hundred ducats, making just about the same for the whole series as Raphael received for his contemporary series of frescoes in one of the Vatican rooms. At the end of July 1517, according to Cardinal Louis of Aragon's secretary, the tapestries were in the process of being made in Brussels, in the workshop of Pieter van Aelst. One was then finished, and the diarist adds that there were to be sixteen. This was either a mistake, or the number was later reduced. Exactly two years later, in July 1519, three finished tapestries had reached Rome from Flanders. On St Stephen's Day 1519, the day after Christmas, the seven tapestries which had now come were exhibited in the Sistine for the first time; and at the end of 1521 ten were inventoried, the number that we now have. Marcantonio Michiel's diary entry, also of the end of 1519, names seven tapestries as on exhibition, the eighth having not yet arrived. According to an account provided by the Pope's master of ceremonies, when the tapestries were first seen, 'the whole chapel was struck dumb by the sight of these hangings; by universal consent there is nothing more beautiful in the world; they are each worth two thousand ducats.'

Some time after 1527, the year of the Sack of Rome—for reasons directly connected with this—the tapestry-set was broken up and dispersed. Two of the tapestries went to Venice; some perhaps journeyed north to Lyon in France, and the rest went south to Naples. They came back again to the Vatican soon after, those in Venice via Constantinople, seven being returned by 1544 and the remainder in 1554. The set was evidently set up afresh, but in changed conditions of arrangement, for by now Michelangelo had covered the entire altar wall with his *Last Judgment* fresco. The tapestries have stayed in the Vatican ever since, apart from a brief trip to the Louvre in Paris during the French Revolution. It became customary to put them on display on certain feast days in the chapel or the palace or in the square outside; they are now displayed with the painting collection in the Vatican Gallery.

Meanwhile, many more sets of tapestries had been woven from the cartoons. Altogether upwards of sixty complete or partial sets are known. In 1534 the King of France bought three tapestries as the first pieces of a set of nine which he eventually acquired. Another set of nine, which suffered destruction in the Second World War through being in Berlin, was probably woven as a gift to another king, Henry VIII of England. In it, as in the French set and the original set for the Vatican, gold and silver thread was extensively used to enrich the effect. A third set was also made in Brussels for the Duke of Mantua, and many further sets were made by other weaving shops in Brussels and Paris also, continuing down into the seventeenth century.

As for the cartoons, access to which (or to copies) allowed tapestries to go on being produced, seven of these survive. The history of them is worth telling too. After the original set of tapestries had been woven from the cartoons in Brussels, the latter must have been copied. For the originals

were regarded already as great works of art in their own right. One is recorded in a Venetian collection, that of Cardinal Grimani, in 1521 and passed on to his nephew. In 1573 the cartoons as a group were in Brussels, though damaged and not in use (for by now a set of copies is recorded as existing there for that purpose). But from then until the early seventeenth century they are lost from sight. We do not know who had them during this time, but in 1623 Prince Charles of England bought the seven that were left and arranged for them to be shipped from Genoa to Mortlake, where James I had set up a tapestry factory four years earlier. Copies of the cartoons were made there, new borders designed as the original ones were no longer appropriate, and more than a dozen further sets of tapestries were then woven at Mortlake.

When Charles I's collection was sold, after his execution, the cartoons were reserved for the Council of State. They had been cut up into strips, in order to facilitate the weavers' work, and they were kept at this time packed in 'Large Deal Boxes'. In the later 1670s they narrowly missed being acquired by Louis XIV of France. After the Mortlake tapestry factory closed down at the end of the seventeenth century, they were pasted together again, and a gallery, built earlier by Sir Christoper Wren in the royal palace at Hampton Court, was remodelled by him for their display there. Since then they have remained in the Royal Collection in England. In the nineteenth century Prince Albert, Queen Victoria's consort, made a special study of Raphael and, after his death, the cartoons were moved to the Victoria and Albert Museum in London. It is there that they are to be seen today. They offer, as a group, one of the great artistic experiences that a visitor to England can have. Since they were done on paper in a technique closer to watercolour than fresco painting, with charcoal drawing underneath, they have been considerably rubbed and damaged over the centuries, and also, probably, frequently repaired. Some of the colours were changed in the process, and the joins between the strips filled in. But recently they have been cleaned and repaired according to modern methods. Raphael's own hand is evident virtually everywhere in their execution. Though in his other work of this time Raphael used assistants to a considerable extent, here their contributions seem to have been limited for the most part to the settings, to minor details and to the making of designs for the borders. X-rays now taken of sample areas also suggest that in the early stages of the actual painting of the cartoons the assistants were given parts to do in preliminary form, but that Raphael went over their contributions later, revising and strengthening them. The total conception on the other hand is in each case essentially Raphael's own.

In their reconstruction of how the tapestries were hung White and Shearman began with five assumptions: first, that the ten tapestries we now have represent the whole of the original series, and no more were thought of or planned; second, that the order of the episodes shown corresponded to the order of events as told in the Gospels and Acts of the Apostles; third, that both of the sequences involving St Peter and St Paul, began, like the Christ and Moses frescoes, at the altar of the chapel; fourth, which is perhaps the

109

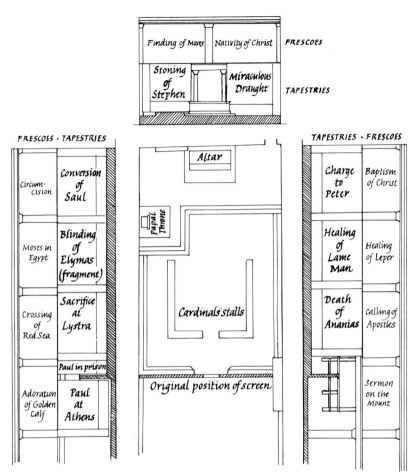

| Finding of Moses | Nativity of Christ | FRESCOES |
| Stoning of Stephen | Miraculous Draught | TAPESTRIES |

FRESCOES · TAPESTRIES

Circum-cision	Conversion of Saul
Moses in Egypt	Blinding of Elymas (fragment)
Crossing of Red Sea	Sacrifice at Lystra
	Paul in prison
Adoration of Golden Calf	Paul at Athens

Altar

Papal Throne

Cardinals' stalls

Original position of screen

TAPESTRIES · FRESCOES

Charge to Peter	Baptism of Christ
Healing of Lame Man	Healing of Leper
Death of Ananias	Calling of Apostles
	Sermon on the Mount

74 Diagram after John Shearman showing the original arrangement of the tapestries in the Sistine Chapel. Above the altar was a painting of the Assumption of the Virgin.

most crucial of all, that a consistent scheme of lighting was adopted for each of the scenes and that it corresponded to the fall of light into the chapel through its actual windows (such consistency of lighting in a cycle of works is normally maintained in Italian art of the Renaissance, as we have seen already in the series of frescoes in the Brancacci Chapel; it was, there-fore, reasonable to suppose that Raphael adhered to the same principle here —in fact, in a letter of 1515, Raphael, who had been commissioned to do a painting for Isabella d'Este of Mantua, wrote asking for specifications of the space and the lighting in the room, and where the painting was to go); and fifth, that the tapestries had to fit, according to their measurements, in the

available space along the walls of the chapel, proceeding out and down from the altar towards the halfway screen.

How did Shearman and White get involved in the problem in the first place? So far as he can recall now, John Shearman, as a young student assigned this topic to work on, began with an irritation with the existing reconstruction. He started playing with photographs, in particular considering the Peter-Paul relationship. He tried Paul on the left. From that point on a 'fit' began to emerge; points such as the consistency of lighting were added in after that; and he remembers finding out only very late on, with relief, that the chancel screen had in fact been moved. Generally speaking, the argument as a whole was progressively strengthened and organized through discussion with his eventual co-author, and with a fellow student. He would like it added that since then he has changed his view on many points (revisions made in a fuller account of the tapestries and cartoons that he published in 1972 are reflected in parts of this chapter); and that he expects to do so again.

The tapestries, as woven, had ornamental borders containing allegorical designs. They also had, along the bottom, borders with narrative scenes woven to look like low-reliefs sculpted in bronze, with the colouring limited correspondingly to shades of browney-gold. Some of the side borders, which are treated like dividing pillars, are missing from the Vatican set, but the Madrid and Mantua sets can be used to fill in the gaps here. And it would make good sense for there to have been two of those borders rather than one in each of the corners—giving then a total of eleven in all.

Let us now look at the reconstruction at which White and Shearman arrived (Ill. 74). Beginning at the right of the altar, we have on the end wall the *Miraculous Draught of Fishes,* followed on the right wall by three further stories of St Peter, culminating at the end of the chancel in the *Death of Ananias.* (The *Blinding of Elymas* tapestry appears as only a fragment, because in the case of the Vatican set this particular tapestry suffered damage lower down, during or after the 1527 Sack of Rome.) Returning from here to the altar wall and moving again outwards into the chapel, this time on the left side, we have first the *Stoning of St Stephen* (the reason this tapestry is smaller than the rest has to do, most probably, with the existence of a bench to one side of the altar, and the companion consideration of making the two compositions on the altar wall balance one another in their proportions; otherwise the measurements of the tapestries fit the available space very closely indeed). Then on the left wall there are three stories of St Paul, followed by a narrow vertical tapestry of *St Paul in Prison,* and outside the screen, in the lay area of the church, a further large tapestry of *Paul Preaching in Athens.* If this is the arrangement which Marcantonio Michiel saw in December 1519, we have a completely logical explanation for his omitting three tapestries. The seven which he saw he described quite correctly in their narrative order. The eighth, the *Death of Ananias,* he mentioned as not yet having arrived. And the reason he made no reference to two more, which would complete the scheme, was that he could see no room *within the chancel* for further tapestries to go.

111

In order to understand how the arrangement works in narrative and theological terms, we must study its iconography. To begin with the question of left and right: the right was, as it has always remained, the place of honour, and therefore appropriate for St Peter as the Prince of the Apostles. Throughout the early Christian and medieval periods, one normally finds St Peter on the layman's left and St Paul on his right, because the left here was taken as being the right side of Christ himself. But the question was evidently not properly settled at this period. One finds cycles which have the arrangement just described, but also an equal number of cases where the converse is true. We also have a formal letter written to Pope Leo X by his Master of Ceremonies around 1515, provocatively arguing that Peter rather than Paul should be given precedence, by being placed on the left of the Crucified Christ. It seems possible from the existence and force of that letter that the Pope had just formally decided the opposite; and this supposition gives support, in terms of both date and principle, to a corresponding arrangement for the tapestries that the Pope had on order then.

We begin to the right of the altar with two scenes in which Christ appears, in episodes from his life on earth; these scenes are appropriately nearest to the altar. The sequence then goes on to the *Death of Ananias*, which forms part of the story of how the faithful sold their property, in order to obtain money for the poor. The distribution of the proceeds is seen to one side of this scene; and Ananias' death came from his holding back some of the money that had been earned. The administration of these funds led, in turn, to the need to appoint deacons; and so it is appropriate that from here we move to the *Stoning of St Stephen*, who was the first deacon of the church as well as its first martyr. But for this we have to go back to the altar and begin again on the other side. St Paul was present at that stoning and so this forms the proper introduction to his story on the left side. The first two scenes to the left of the altar, furthermore, the *Stoning* and the *Conversion of Saul* (St Paul), are also those in which Christ appears, as an apparition in the sky above in both cases, coming from the direction of the altar.

As for the borders mentioned earlier, White and Shearman's reconstruction gives us, along the bottom of the tapestries, beginning with the *Stoning* and moving to the right from there, a series of episodes from the history of the Medici. The two episodes either side of the altar involve key events in the career of Pope Leo X, which are given the places of honour; and then on the right wall there are six further episodes which go, apart from one slip-up, in chronological order. The corresponding bottom borders on the left side of the chapel involve stories from the life of St Paul. And the borders between the tapestries, just two of which are shown here out of the five originals that survive, include representations of such traditional figures in learned and theological iconography as the Fates, the Seasons, Time and various of the Virtues. The decorative and heraldic rôle of these borders, each with its ribbon- and leaf-ornament and the Pope's coat of arms at the top, is obvious. Their allegorical contribution to the total scheme is much more difficult to determine, especially since several of the

75 Two details from the tapestry borders showing allegorical figures and the Medici arms. Vatican, Rome.

original set are missing; the general theme is probably to do with Pope Leo once more and the personal and political triumph of his personality over adverse circumstances.

As for the question of lighting: in this reconstruction the scenes are consistently lit throughout, depending on whether they are on the left or the right, according to the fall of light into the chapel through the windows in the altar wall. In the two tapestries illustrated which both come on the left side, the *Stoning of Stephen* and the *Conversion of Saul*, the light comes into the scene from the right; this can be determined quite simply from the direction of the shadows. In the first this is straightforward. In the second the illumination of the main scene issues from Christ himself, who lit up Saul's darkness; but the frame around this scene and the imitation relief

113

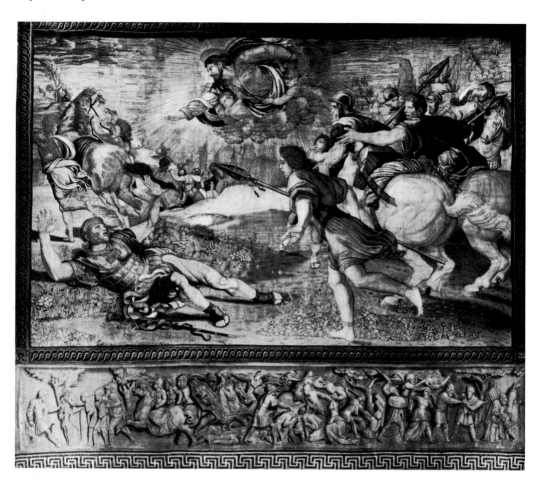

below are both, if we look carefully, lit from the right also. (In the cartoons, for reasons which will be explained later, everything is reversed, including the light.)

We can now begin to talk about the interconnection of the tapestry designs with one another, in terms of composition and the total effect of the scheme. On either side of the altar are two scenes with landscape settings. The landscape of the *Stoning of Stephen* in fact continues into the *Conversion of Saul* to its left. There is a similar range of hills beyond, consistent between the two in its level, as well as a stony foreground in both cases; and a tiny splash of colour at the top right in the *Conversion* represents, though this cannot be made out in reproduction, a continuation of the hills at the top left of the *Stoning*, which are coloured blue-white as if they were covered with fresh snow. Similarly, the water at the right of the *Miraculous Draught*

114

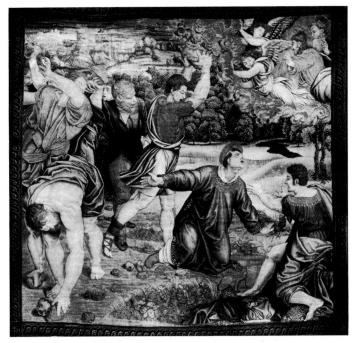

76 Raphael, *The Conversion of Saul,* tapestry. Vatican, Rome.

77 Raphael, *The Stoning of Stephen,* tapestry. Vatican, Rome.

78 Raphael, *The Miraculous Draught of Fishes*, cartoon. Royal Collection, Victoria and Albert Museum, London.

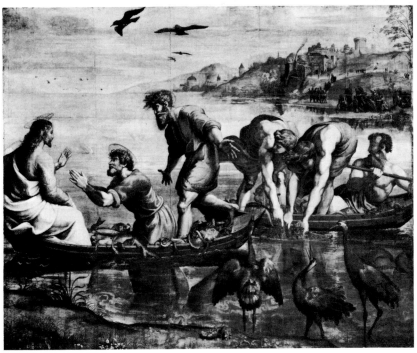

115

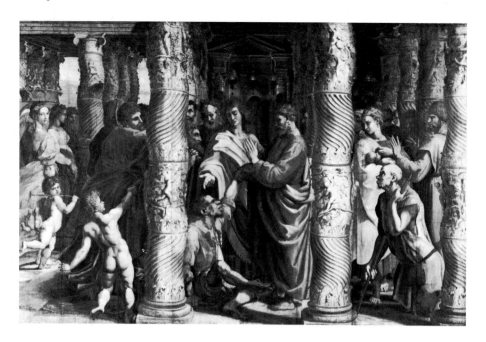

appears at the same level at the left in the *Charge to Peter,* and the boat in which Christ sits in the first case, which is at the left in the cartoon but to the right in the tapestry, continues as a compositional element into the next design; for one finds the prow of another boat, jutting in by the shore-line on the left in the tapestry of the *Charge to Peter.* Beyond these two pairs of tapestries, in the centre of each side wall, are two scenes with grand architectural settings. These settings balance one another across the chapel, and create, with their stability and weight, a point of rest between the tapestries either side of them. In the last two large tapestries within the chancel, and also the narrow *Paul in Prison,* the perspective of the scene assumes a viewpoint for the spectator slightly off-centre, so that there is a gentle movement to the right on the left side of the chapel at this point, and vice versa on the other side.

Iconography comes back here as well. For instance, the fifteenth-century frescoes which were mentioned earlier as being on the level above the tapestries tell the story of the Life of Christ down the right side of the chapel, and St Peter appears four times in those frescoes, twice in a leading role. The story of St Peter in the tapestries therefore ties in with these frescoes, in the sense of showing Peter, on the same side as they, in his continuing role as the vicar of Christ. There are also connections or parallels with the frescoes in some of the subjects shown in the two cases; for example, below a healing by Christ, probably that of the leper, is the *Healing of the Lame Man,* with a relationship of design as well as theme. And again, the last tapestry on the left, of *St Paul Preaching,* is set apart from all the others by being hung outside the chancel. Correspondingly, in that tapestry

116

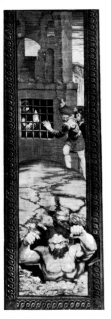

79, 80, 81 Raphael, *The Healing of the Lame Man* (cartoon), Royal Collection, Victoria and Albert Museum, London; *St Paul in Prison* (tapestry), Vatican, Rome; *St Paul Preaching in Athens* (cartoon), Royal Collection, Victoria and Albert Museum, London.

Paul, facing outwards from the chancel, preaches not only to his Athenian audience, but also, by implication, to the lay congregation in the chapel; and this audience is to be thought of as completing the half circle formed by Paul's listeners, who are on a lower level within the design, a level which may be understood as corresponding to the one from which this tapestry was viewed by the congregation, when hung.

Raphael designed the cartoons in the reverse direction from the way the tapestries would come out, it being the practice of weavers to work from behind the fabric with the design facing them. Besides entailing a change in the direction, right or left, from which the light is shown coming, the factor of reversal has also other implications for the character of the designs. In drawings that exist by Raphael for one of them, the *Charge to Peter,* we have both a study of the figure arrangement which corresponds to the tapestry, and also a mirror image of that composition in the form of fragments of a cut-up drawing organized in the reverse direction, that of the cartoon. Thus, Raphael evidently had in mind, throughout, how the design would come out in reverse. But the fact that it was in the cartoons that he actually worked out dramatic effects means that the details of movement and gesture do not always succeed with quite the same force in the tapestries. But what is astonishing is how little is generally lost in reversal. The balances and sequences that go across the chapel and from altar wall to

117

82, 83 Raphael, *Christ's Charge to Peter*, cartoon (Royal Collection, Victoria and Albert Museum, London), and tapestry version (Vatican, Rome).

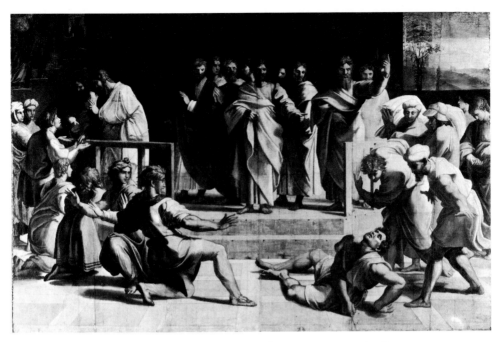

84 Raphael, *The Death of Ananias*, cartoon. Royal Collection, Victoria and Albert Museum, London.

side wall were, unquestionably, planned, and the designs thought out accordingly.

At this point in his development, Raphael was working with large figures and figure groups, very close up to the picture-plane and dominating their setting. His figures are almost like statues individually, in their bulk and solidness; and whether the scenes are peaceful or violent ones, he gave his figures extraordinarily powerful gestures and movements, which reach and carry quite literally across the space in between, as can be seen particularly in the dying Ananias and the figure to his right reacting to him, or in the address of Paul to the audience to whom he preaches, and the reactions there. One can see these effects even better in the cartoons, due to their medium, than in the tapestries themselves. The scenes have an extraordinary dramatic, and even rhetorical power. The settings, especially the architectural ones, are correspondingly stepped up in scale, so that they support and echo the grandeur of the figures, and each design works from this point of view in its own right, for the spectator standing immediately facing it and concentrating on it, as well as in relation to its neighbours.

But though each scene may be effective individually in this way, to interpret the total scheme, one has to consider the co-ordination of the tapestries, in both themes and design, with what was already there in the chapel. We have seen, for example, the principle of consistent lighting

119

serving as a basis and argument for the reconstruction arrived at. Now, accepting that reconstruction, one can, so to speak, put the process of deduction into reverse, and look at some further implications raised by the placing of the various elements in the chapel's decorations relative to one another. The case of the two scenes of healing paralleling one another has already been mentioned. And again, there are cases where the finding of a common theme—such as the theme of the institution of the Ministry, shared by the fresco above of *Baptism* and the tapestry of the *Charge to Peter* directly below it—helps to pin down, among varying possibilities, what the governing considerations about a particular subject and its representation were. That such considerations loomed large in the planning of Renaissance schemes of decoration is known for a fact, both from documentary evidence and from the internal evidence yielded by the schemes themselves. Contracts between patron and artist sometimes specified in exactly this sort of way what was to be done, as when a nobleman commissioned for his country retreat a whole cycle of frescoes glorifying the history and exploits of his family. In other cases—cases where there is a religious or mythological or historical 'programme', as it is called, too complex for the artist himself to have been solely responsible for, or to have been readily familiar with all of the necessary detail—there was almost certainly some learned intermediary between patron and artist. In the present instance, it is likely that Raphael had a theological consultant from the papal court, to assist him on the iconological aspects of planning and placing; and behind that there would have been the interest in these matters of the Pope himself.

One can see, now, how much is gained in understanding of the tapestries, through reconstruction of how they were displayed. Aspects of the spiritual significance of the series become known, a matter both of the subject-matter itself, as Raphael laid it out, and of his artistic vision in interpreting and executing that subject-matter, through the intermediacy of his cartoons. Though one does not see the tapestries in place in visiting the Sistine Chapel today, the whole scheme must in fact have been almost as majestic, and no less spiritually moving in its total effect, than the famous ceiling up above. It is possible, indeed, that Raphael was influenced in his designs by the awe-inspiring qualities of the Michelangelo ceiling, with its vision, like Raphael's, of an ideal human grace and power.

85 Raphael, *The Sacrifice at Lystra*, cartoon. Royal Collection, Victoria and Albert Museum, London.

86 Raphael, *The Blinding of Elymas*, cartoon. Royal Collection, Victoria and Albert Museum, London.

87 Georges De La Tour, *The Denial of St Peter*. Musée des Beaux-Arts, Nantes.

Chapter six
A forgotten artist rediscovered: Georges De La Tour

IN 1810 the Museum of Nantes in France acquired two paintings which belonged to a distinguished citizen of the town named François Cacault. Both of them were signed with the name of 'G. de la Tour'. One of them was also dated. Representing St Peter's denial that he knew Christ, it is a candle-lit interior scene, with a serving-maid over on the left holding up the flaming candle that provides this scheme of lighting, and sheltering it with her other hand. Over to the right, against a bare background wall that is in shadow, a group of soldiers in armour are gambling with dice around a table, absorbed in the game. One of their company, in a plumed hat, appears as a dark shape this side of the table, in silhouette against the light. And at the back left the aged Peter, wrapped in a cloak that emphasizes his hunched-up, closed-in pose, and with the fall of light showing up particularly the expression in his eyes, is seen responding cravenly to the serving-maid's questioning, with a corresponding gesture of his hand.

The French artist of the seventeenth century who put his name to these paintings was born in March 1593 in the town of Vic-sur-Seuille, a few miles from Nancy in the east of France. In 1620, after working as a painter for at least three years in Vic, he moved to the town of Lunéville, in the Duchy of Lorraine, establishing himself as a master artist there; he made this town his home until his death in 1652. He may have gone to Paris between 1636 and 1643, when his name is absent from the registers of the town, but this is conjecture. In 1623–24 the Duke of Lorraine commissioned two works from him, but there is no indication of which these were. Louis XIII received a *St Sebastian* from him according to a source of 1751, but again we do not know which particular painting this was. The only other sure point is that around 1644 De La Tour caught the attention of the French governor of Lorraine, who gave several works by him to the town of Nancy; but again there is no clear later history for any of those paintings. In 1648 he was a founder member of the French Academy of Painting and Sculpture. Four years later he died.

The Museum of Nantes did not give much consideration to its acquisitions. For more than a hundred years they attributed the two paintings to quite a different De La Tour, an eighteenth-century artist, famous for his portraits in pastel, whose first name was Quentin. And when in 1913 the

Museum came to realize that this could not be right, the painting was then listed in its catalogue as by Georges, but he was called 'a seventeenth-century painter about whom we have no information'.

How could it happen in the history of art that an artist who was so important and successful in his time could become so completely forgotten in this way? And how did he come to be rediscovered again, entirely within this century, so that we now have a sizable number of paintings by him, and he is now recognized as one of the truly outstanding artists of the seventeenth century?

The reasons for the complete eclipse of this artist seem to be two: he was provincial and he was unfashionable. First, and perhaps most important, he worked throughout his life in one of the more remote provinces of France, the Duchy of Lorraine. He was therefore working in what is called a provincial situation. In both geographic and cultural terms he was largely cut off from the major artistic centre of France, namely Paris, the capital. His connections were with a middle-class circle of patrons in his home town and with members of the French administration in the province, not even with the Court of the Duchy of Lorraine itself. His art, therefore, has no connection with what the French artists centred on Paris were doing at the time. No knowledge of that art is implied at any point in De La Tour's way of working. Instead, he went back to European developments of one or two decades earlier, deriving from the art of the great Italian, Caravaggio. His art has a temper and flavour of its own, an absence of sophistication and up-to-dateness, which is part of what one means by the term 'provincial'.

Louis XIV, the Sun King—successor to Louis XIII to whom Georges De La Tour had presented one of his paintings—succeeded in setting up a dictatorial régime of taste, administered by Colbert (his Minister of Fine Arts) and the painter Charles Le Brun, and governing all the official art produced during his reign. The dictates of this régime excluded any kind of art that did not conform to official requirements: requirements which called particularly for the glorification of the monarch and gave preference to historical and exemplary subjects above all others. De La Tour's subjects, never having been chosen or elaborated with such considerations in mind, did not fit into the approved categories. His work did not include any portraits either, and it had none of the qualities of frivolity and elegance which were to become the hallmarks of French painting in the eighteenth century. Rather, his pictures were severe and Dutch-influenced; they got no attention for this reason during the eighteenth century either.

Brief notices giving information about his career did appear in print during the 1600s and 1700s; but only one writer, in 1751, named any paintings by him. Much later, in 1863 and 1899, two historians of the art of Lorraine published for their local interest personal information about him and extracts from the municipal accounts of his home town, Lunéville, which involved transactions between the Town Council and the artist. Four subjects of paintings, all religious, were named in those documents: a *Nativity*, a *St Alexis*, a *St Sebastian* and a *Denial of St Peter*. But at the close of the nineteenth century there was still no painting known by Georges De

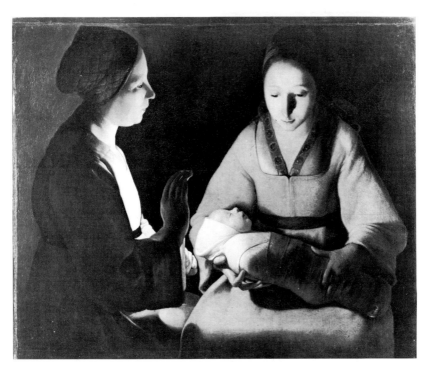

88 Georges De La Tour, *Nativity*. Musée des Beaux-Arts, Rennes.

La Tour. In 1900 an art historian making a survey of the French museums mentioned the *Nativity* at Rennes and the so-called '*Prisoner*' (actually *Job and his Wife*) at Epinal. He listed the first of these paintings as by Le Nain— a designation which breaks down now into three different brothers, best known for their mid-seventeenth-century paintings of peasant subjects. And the second painting, though tentatively describing it as being like the Rennes one, he listed as 'Anonymous'.

In 1915, the Director of the Berlin Museum, Hermann Voss, set out to reconstruct the artistic personality of Georges De La Tour. He had as his materials literary references, local sources and the two signed paintings at Nantes. In his first article he compared a third work, the *Nativity* at Rennes, and took the step of maintaining that the three paintings were by the same hand. Because the First World War was in progress, this article did not reach the libraries of other countries for some time. It was not until 1922 that its content was made known to French art historians by one of their number; and he in turn had had his attention drawn to it by an Italian, Roberto Longhi, who had also come across De La Tour independently in the course of doing research on the spread of Caravaggio's influence over Europe.

125

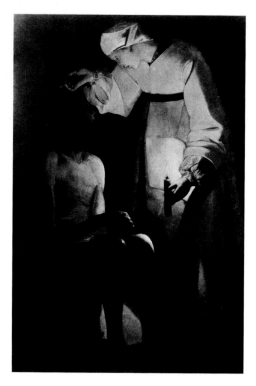

89 Georges De La Tour, *The Prisoner* (*Job and his Wife*). Musée Départemental des Vosges, Épinal.

90 Georges De La Tour, *The Card Cheater*. Louvre, Paris, Collection Landry.

That was a beginning, and in 1924 the curator of the Epinal Museum was able to attribute the *'Prisoner'* there to De La Tour. Two years later the Louvre in Paris acquired its *Adoration of the Shepherds,* which had been found in Amsterdam and identified as a De La Tour by Voss, and the same year, 1926, a painting of a *Card Cheater,* which was again signed, was found on top of a cupboard in an antique shop by a French collector. This was a crucial discovery, because the painting was an exception to the current idea of De La Tour's paintings up until that time: it was not lit by a source of light contained within the picture, such as a candle or lantern. And it established for the first time the connection between De La Tour's work and the Caravaggio-influenced Utrecht School of the early seventeenth century.

The following year the Berlin Museum acquired its *St Sebastian,* another work which Voss had recognized as a De La Tour; and in 1928 Voss published an article which ended with a list of six paintings: the two at Nantes, those at Epinal and at Rennes and the Berlin and Louvre ones. Interestingly, he left out the *Card Cheater* and rejected a painting in the Louvre of the *Denial of St Peter,* which had been bequeathed to the Museum in 1870 and had by now gained an attribution there to De La Tour.

It was in the early 1930s that De La Tour's importance really began to be

126

91 Georges De La Tour, *St Sebastian*. Gemäldegalerie, Berlin.

re-established, through exhibitions which made his work known to a wider audience than simply art historians. In 1932 there was a big exhibition of French art in London in which two paintings were included. Even more crucial was an exhibition in Paris two years later, 'Painters of Reality in Seventeenth-Century France', which was designed to bring out the tradition of 'realism' in French painting involving the depiction of common everyday subject-matter—the very tradition which had been swept into the back-ground by eighteenth-century taste. Ever since the end of the First World War, furthermore, the leading trends in contemporary art had been ones that accented the traditional values of full, strong modelling of the figure and firm and continuous surrounding contour; and this was a further reason why De La Tour's art (along with Piero della Francesca's) found a climate ripe for special appreciation of its qualities. During the Paris exhibition two further paintings were actually brought forward by their owners as possible De La Tours and were accepted as authentic. By now, furthermore, evidence which bore on lost works had begun to be collected and recognized as important: that is, evidence in the form of engravings, fragments, studies and works which appeared to be school pieces rather than originals. Between 1935 and 1939 five more paintings were found, two in Paris, one in a London collection, one more in a French provincial museum and still another amongst lumber in a loft in Nancy. A sixth addition, a Christ, was found during the Second World War in France but the find was only published after it.

The particular role of exhibitions, in establishing an artist's quality and achievement and making it better known, having now been brought out, we may appropriately take a jump forward in time here, to the year 1972. For that year saw the mounting of an exhibition in Paris, which was the first ever to be devoted entirely to the work of De La Tour.

Such exhibitions today have, in effect, a double purpose: they are put together as a way of summarizing and extending the state of knowledge on the subject; and they are also put on as a way of introducing the artist in question to a larger public. Exhibitions devoted to a single artist in this way can rarely, if ever, be ideal. Firstly, it is never possible to borrow every single one of the artist's works; and secondly, the exhibition can only last for a limited period, and so even the scholar who goes back repeatedly, is not allowed that gradual, spread-out process of acquaintance and re-acquaintance which may be necessary to his asking the right questions in front of the work, or his noticing in it those points which will turn out to be of the greatest consequence. Nonetheless, the discussions and speculations, stirred up by the works in the flesh and their presentation, are bound to be greatly rewarding. This exhibition comprised a core of thirty-one major paintings, and then a 'study section', of thirty odd further works, representing for the most part replicas, copies and derivations of other kinds. For the scholar there was a comprehensive, fully illustrated catalogue; for the larger public that came in, a helpful guide-sheet (and also a film showing with magnified details from the paintings). And though most of the key master-works had been seen in previous exhibitions or were accessible in

their usual locations, two new discoveries were included, so recent as to be known first-hand at that point only to those who had made or verified them: one painting found just a few weeks before in storage in an out-of-the-way English art gallery, the other sent from a far-off and little-known museum in Russia, where it had first been identified two years earlier. During the exhibition it was announced that the *Card Cheater,* still in the collection of the man who had first found it, had been acquired by the Louvre; this made it its fifth De La Tour.

Altogether—counting a number of major works which were not in the 1972 exhibition—we have now somewhere between twenty-five and fifty paintings claimed or recognized as being by De La Tour. This may not seem very many for thirty years of production, but they are of consistently strong quality, and more than enough to give this artist back his proper place in the history of seventeenth-century art. We can see from these paintings what the special qualities are which both appeal to contemporary eyes and guarantee De La Tour his importance. Through his handling of light and dark and the treatment of facial expression, De La Tour gives his religious figures a stark and simple, yet at the same time strongly mystical quality. These are common people, peasants standing in for the saints and other figures of Bible story, whose piety and simplicity is brought home to us in their gestures of work and prayer and concentration itself. And in most of his paintings De La Tour handles shapes in a stark, almost geometric way, while at the same time light gives a wonderful glow to the treatment of surfaces and substances.

Those features and qualities are the direct expression of De La Tour's provincial temperament, and also (since this was a time which saw a religious revival in Lorraine—particularly associated with the Franciscan order) of the period in which he lived. Now that a comprehensive exhibition has been staged, and now that these qualities have become clearly and generally recognizable as belonging to this artist, it may be said that the modern rediscovery of De La Tour is, in essentials, complete.

But now a whole range of further questions presents itself. The most basic is to decide in what order his works were painted and how he developed as an artistic personality. Although a good many of his paintings are signed, in a variety of forms (such as Gs De La Tour and Georgius Delatour), only two are dated. The *Denial of St Peter* at Nantes carries the date of 1650, but its quality suggests that assistants were involved in its execution, so that it is not too safe a guide. There is a *Repentant St Peter,* now in the Cleveland Museum in the United States, which is dated 1645. There is also a *St Alexis* which could perhaps be connected with a commission given to the artist in 1648, but this is only hypothetical.

That is all that we have in the way of dates; and the documents concerning the artist's career are not much help either towards reconstructing how he developed as an artist, except in a general way.

What does the art historian do in order to construct a picture of the artist's development when there is only one securely dated work of his, and that a late one? We dealt with a similar problem in the case of Giorgione,

129

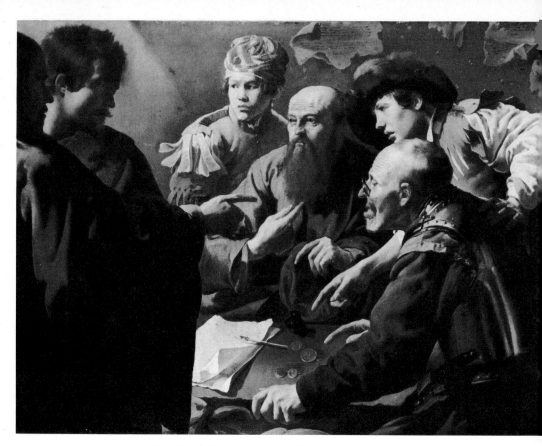

92 Hendrick Terbrugghen, *The Calling of St Matthew*. Centraal Museum, Utrecht.

but there the total time-span involved is less than ten years; whereas De La Tour's career stretched over more than three decades. Also, in Giorgione's case we have Vasari's Life as a starting point, even if it has to be treated with care. With De La Tour, no such account exists; there are only brief notices from the seventeenth and eighteenth centuries, and not even any pictures by him named before 1751.

The obvious thing in this situation is to begin by grouping the paintings according to their general type and character. There are two sorts of paintings: genre scenes (that is, scenes of common or everyday life), which involve subjects of gaming and fortune-telling amongst others; and then religious scenes, for example, Bible stories and saints. The illustrations show that De La Tour's way of painting hands and feet remains very much the same throughout all these works. It is a hallmark of his style, involving rounded fingers with a rather waxy quality and legs which sit very flat and look as if they were sculpted out of wood.

The two genre scenes illustrated here involve a great deal of ornamental detail. Fabrics and jewellery are given attention in their own right and

130

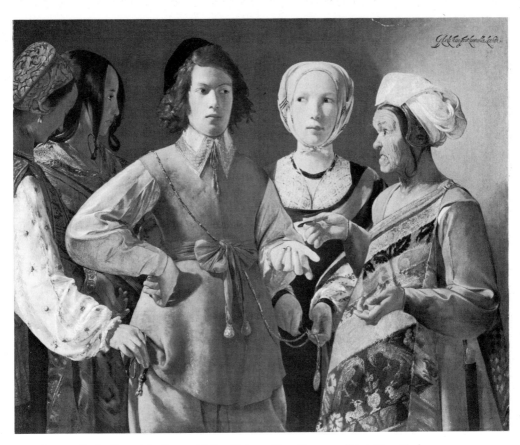

93 Georges De La Tour, *The Fortune Teller*. Metropolitan Museum of Art, New York, Rogers Fund, 1960.

there is a lot of supplementary still-life detail involving objects such as watches, glasses and coins. By comparison, the religious subjects are all simpler, lacking such elaboration of detail.

The two genre scenes, the *Card Cheater* and the *Fortune Teller,* show a strong connection with the paintings done early in the seventeenth century by Caravaggio's northern followers, the members of the School of Utrecht. Illustrated here is the *Calling of St Matthew* painted by Hendrick Terbrugghen, one of the members of this School, in 1621. It shows the calling of the tax collector by Christ, who enters the room on the left. It is essentially a low-life scene. Putting this work alongside the two De La Tours, one can compare particularly the head of St Matthew himself, seated at the table, with the profile of the old crone to the right in the *Fortune Teller*. There is a similar kind of attention to costume, as seen in the jackets of the two young men and the cap of the centre one. The lighting is obviously similar in the way it falls on the faces, and so is the relative bareness of the setting. Finally, there is a strong connection in the way the two artists shape the faces of their figures and render the flesh of the face and hands.

131

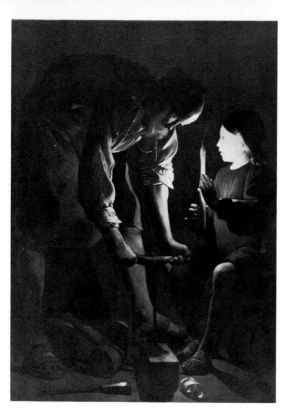

94 Georges De La Tour, *St Joseph as a Carpenter*. Louvre, Paris.

95 Georges De La Tour, *St Jerome in his Study*. Louvre, Paris.

The resemblances to Terbrugghen's work are altogether less strong in paintings like the *Nativity* and *Joseph as a Carpenter*. It is to be expected that dependence on other artists would be strongest in the early work of a painter, at a period when he was still forming his own personal style: it therefore follows that the *Card Cheater* and *Fortune Teller* are likely to be early paintings of De La Tour's, roughly from the 1620s. Compare these two genre scenes with *St Jerome in his Study,* with which they have at least characteristics in common. For the light comes from a source outside the painting, rather than one within it. The wrinkles on the face are like those of the old crone in the *Fortune Teller* (and the two old men in the Terbrugghen), the hairs are treated more individually, and the same applies to the still-life objects of which, again, there is a whole group spread out over the table in the foreground. It is therefore probably slightly later than the two genre pictures, but not nearly as late as, say, the *St Peter* of 1645.

On the basis of contrasts and comparisons like these, art historians have come to agree that between the 1620s and 1640s De La Tour developed in the direction of simplicity and reduction. They have divided De La Tour's work up into three broad periods: an early period from about 1620–30, which includes the two genre scenes and the *St Jerome;* a middle period from about 1630–40, in which would fall the *St Joseph as a Carpenter,* where the atmosphere is solemn, all movement is eliminated and the glow of light has a mystical quality, and probably the *'Prisoner'* also; and finally a third

132

96 Georges De La Tour, *Repentant St Peter*. Cleveland Museum of Art, Cleveland, Gift of Hanna Fund.

period from about 1640–52 in which, in paintings like the *Nativity* and the *St Sebastian attended by Mourning Women*, the shapes become more schematic and strongly geometric, and so also does the composition as a whole. The sequence between these three types of painting seems reasonably logical and consistent.

But what guarantee have we that De La Tour's development went in that particular direction? The *St Peter* of 1645, which is our only clearly dated work, is more naturalistic than the *St Sebastian*: in, for example, the way the feathers of the cock are painted and the inclusion of the tassel in the lap and the pattern on the top of the lamp. In principle, therefore, it could be possible that De La Tour, between his middle and his late periods, moved from reduction and simplicity towards greater naturalism, rather than the other way round. And that could mean that the *St Sebastian* and the *'Prisoner'* come before the 1645 *St Peter*, and the *St Joseph* after it. We cannot be absolutely sure that this is not the case. But we do have a way of

134

testing the argument that De La Tour moved towards simplicity. It involves looking outside the work of De La Tour himself to the larger question of the development of French painting during the seventeenth century.

Let us take as a guide here the work of Nicolas Poussin, who was France's foremost painter of the seventeenth century but worked mainly in Rome. Poussin's dates are 1593/4–1665, so that he was born just a year or two later than De La Tour and lived on thirteen years longer. Both painters were French, but since Poussin was mainly in Rome and De La Tour in provincial Lorraine, there is no particular reason to think that their paths ever crossed.

In Poussin's case there is nothing like the same problem of dating his works. Many are dated, and where disagreement exists, it is limited to the order of the paintings within, say, three to five years. In the 1620s, when Poussin was establishing himself as an artist, as was De La Tour, we find him doing works like the *Triumph of David,* of which only a section is illustrated. It can be seen from this detail that at this time, probably about 1625–27, Poussin rendered hair and helmet plumes with a good deal of attention to patterns and textures and the way these forms pick up light. His rendering of drapery is rather complex, with lots of little folds and rather gracious curves. All these features are paralleled in De La Tour's *Fortune Teller* and *Card Cheater.*

In a second Poussin of about ten years later, of which again a detail is shown here, the *Adoration of the Golden Calf* of about 1633–35, the treatment of the clothing has become more simplified. There is now a very strong and positive contrast of lights and darks throughout, so that the heads and bodies, rather than just having light falling upon them, are now actually modelled by the illumination. The organization of the figures in relation to the space brings them closer towards the front of the picture (so that the effect is starker and grander in its scale). All three of these features are ones to which we find quite direct analogies in De La Tour's *St Joseph,* as compared to his *St Jerome.*

97, 98 Two details from paintings by Poussin. Left: *The Triumph of David* (by permission of Dulwich Picture Gallery); right: *The Adoration of the Golden Calf* (National Gallery, London).

99 Nicolas Poussin, *Holy Family on the Steps.* National Gallery of Art, Washington DC, Samuel H. Kress Collection, 1952.

Finally, in a third Poussin of a decade later still, the *Holy Family on the Steps* of 1648, the grouping of the figures forms a very strong and powerful triangle, both on the surface and in three dimensions (imagine a plan of the composition made from above). This principle of geometry, which is symbolized in the action of St Joseph, making a mathematical calculation, is carried through with equal strictness to the head of the Madonna and also to the architecture. The whole conception is very calm and still. Here then, is a parallel to the last stage in De La Tour's development, as can be seen by comparing the *St Sebastian.*

How are we to explain these successive parallels, given that De La Tour and Poussin never knew one another nor, almost certainly, had any familiarity with one another's work?

We are dealing here with a tendency which lies outside the individual artist: a tendency for all art of a certain civilization to move, over a period of years, in the same general direction. This is a recurring phenomenon in the history of European art, and one that has fascinated art historians.

Heinrich Wölfflin, a German art historian of the later nineteenth and early twentieth centuries, whose *Principles of Art History* focused on this kind of problem, proposed an explanation involving the idea of style. Each artist, according to him, had his own personal style; but beyond this there was also a national style, linking together what all German artists or all Italian artists were doing at different periods; and finally a period style. According to him, period styles went through a cycle of development, reaching a high point of development and then gradually falling off, until ultimately they gave place to a new period style.

Another Viennese art historian of the beginning of this century, Max Dvorak, offered a different kind of explanation, based on the hypothesis of a *Zeitgeist*—the 'spirit' of a period or time. Art, in his view, always reflected the contemporary *Zeitgeist,* and therefore the different artists of a period expressed themselves in accordance with it. Other art historians, particularly those of Marxist persuasion, have attributed a similar kind of role to the political and social factors which form part of history itself.

136

They have suggested not simply that art reflects the political and social concepts of its period, but that the development of art is driven along by these factors.

The trouble with explanations of this kind is that for periods in which the artist is a strongly self-conscious individual, the argument becomes circular. Dvorak found support for his view in studies which had been made of late Roman sculpture. Corresponding to the fact that the men who did those sculptures had the status of craftsmen working on commission, usually from the state, a development could be traced from stage to stage, showing 'naturalism' gradually and steadily giving place to 'abstraction' in the rendering of the human figure. Once, however, the artist becomes recognized or recognizes himself as an individual, as in Europe at least from the Renaissance on, the *Zeitgeist,* as it is reflected in art, has to be first deduced from the work of individuals, and then reapplied to show how they conformed to it. No exception discovered can ever disprove the rule; for if an artist does not conform to the *Zeitgeist,* the choice not to conform to it proves its existence just as well.

For periods in which a civilization exhibits considerable unity and homogeneity over a limited time-span, Wölfflin's conception of period style also works very well. This is true, particularly, of Italian art of the early sixteenth century, which he used as an example for study in depth. Giorgione's art of 1505–10, for instance, definitely moves in the same general direction as Raphael's and Michelangelo's during those same five years. The development of High Classicism in Italy between 1500 and 1520 involves a growth to a high point around 1510, and a gradual move away from that high point during the next ten years. Though there does seem to be a definite cycle in that case, it is dangerous to assume that all art necessarily has to develop in the same way, and that the direction can never in principle be reversed or modified by any particular artist.

Such explanations are in any case part of a general theory of history. A great artist is an original creative spirit, challenging the possibility that there can be laws of a more impersonal kind. Certainly no one theory of a general or impersonal sort is likely to be able to explain everything that actually happens. In the adoption of such theories there is a constant temptation present to force the material so that it fits the theory and confirms it.

Nevertheless, artists of the same period do parallel one another in the successive stages of their work—in a way that goes beyond coincidence—without each knowing what the other has been doing; and this is particularly likely to be the case when the artists belong to the same country, or to countries which are closely linked by cultural ties. So simply on the principle that there are period factors affecting French art of the seventeenth century, we can be fairly sure, because of the path Poussin took over the same period, that the second and third stages of De La Tour's development could not have been the other way round. And so the development of his art by decades, even though dates are missing, can be reconstructed with reasonable confidence.

137

100 Johannes Vermeer, *Girl Asleep*. Metropolitan Museum of Art, New York, Bequest of Benjamin Altman, 1913.

138

Chapter seven
Disguised meaning in pictures:
Vermeer and Velasquez

IN MAY 1696, in the city of Amsterdam in Holland, a sale of paintings was held which included a large group of works by the seventeenth-century Dutch artist, Johannes Vermeer. The collector who put the works up for sale, who was probably a bookseller and publisher in Vermeer's home town of Delft, owned about half of the Vermeers known to us today. Among the paintings in the sale was one which can be identified as the *Girl Asleep*. In the catalogue of the sale it was referred to as 'A Drunken Sleeping Young Woman at a Table'.

Why should the girl have been described as drunk, when she is at first sight simply dozing? Is there more to this picture, which seems so simple and straightforward, than readily meets the eye? Vermeer is normally taken as a painter of genre scenes—everyday scenes set in interiors of the period. But is there more to some of his pictures than just that?

The question arises because investigations show that paintings by other seventeenth-century Dutch artists which are, on the face of it, simply flower-pieces or fruit-pieces actually contain hidden meanings of a symbolic or allegorical kind. Most often these meanings have to do with the transience of life. Putrid fruits may signify that death follows hard on maturity; bouquets, especially of roses and peonies, may be symbols of transience, since they wither and die so fast; lizards, snakes and toads included at the bottom of still-lifes may refer to the decomposition of man. The fly, the disseminator of disease, may represent sin. Other objects may carry a Christian meaning. For example, a piece of bread and a glass of wine, placed either side of the vase of flowers, may be eucharistic symbols, standing for the promise of man's redemption and resurrection by means of grace. The apple may stand for original sin, and cherries symbolize the heavenly fruit brought by Christ to man when he came down to earth.

The inclusion of still-life objects which carry a symbolic meaning is one of the leading features of northern European art of the fifteenth century. Where the paintings in question are religious, these objects, for example, candles and candlesticks, towels and basins, and discarded shoes, overlay the subject represented with a whole complex of symbolic meanings. In the seventeenth century such symbolic meanings were still widely understood. But the Dutch artists who brought them into their work now did so in

101 Johannes Vermeer, *Diana and her Companions*. Mauritshuis, The Hague.

102 Johannes Vermeer, *Christ in the House of Martha and Mary*. National Galleries of Scotland.

disguised form. Their implications have to be sought out. Indeed, it very often happens that a particular still-life element can have a variety of possible meanings; and which one applies has to be deduced from the context of other objects in which it appears, and from searching out other comparable representations. We must equally not assume that because Vermeer and the other leading Dutch artists of his period show us aspects of everyday reality, they were painting simply what they saw. Even the flower painters seldom worked directly from nature. We can tell this from the fact that they always painted cut flowers; these were expensive, so we find them repeating the same bloom from picture to picture, and also putting together flowers which did not bloom in the same season.

Vermeer's paintings are clearly based on the observation of reality. We can see this from the way in which he observed and laid out the space of his rooms. According to a modern speculation, he used either the *camera obscura* (an observation box which functioned like the camera aperture of today in focusing interior scenes) or a system of double mirrors. The way in which he rendered the fall of daylight on to objects and walls, and the textures of rugs and clothing is also directly based on observation. But the fact that he observed these things with extraordinary concentration and clarity does not mean that when he came to paint he was recording exactly what he had before him. He worked in a selective way, combining different aspects of the things he had seen.

Vermeer's range as a painter was not limited to genre. Early in his career he did a painting of a mythological subject, *Diana and her Companions,* which shows the goddess being washed by her maidens. He also did a religious subject, *Christ in the House of Martha and Mary*. The choice of

140

103 Diego Velasquez, *Christ in the House of Martha and Mary*. National Gallery, London.

subject is an interesting one. In the paintings of the great Spanish seventeenth-century artist, Velasquez, the same story served as a moral admonition relating to kitchen life (Christ admonished Martha for complaining of her kitchen duties). In one particular early Velasquez there is in the foreground a kitchen scene with an older woman speaking warningly to a young servant-maid who is working on the pots and looks cross; and to explain what the scene means and what her warning is about—namely that the maid should do her work cheerfully and with a good conscience (for, as the great Spanish mystic, Saint Theresa, expressed it, 'Christ walks among your pots just as he visited Martha's kitchen')—we have a little scene included in the background of Christ at table with Martha and Mary. In Spanish still-lifes of this kind, known as *bodegones,* the inclusion of such a spiritual message elevated this class of painting, traditionally lowest in the scale, to a higher level.

From Vermeer's maturity, we have a painting which is actually just such an allegory, an allegory of the Faith. Though the setting is one of Vermeer's usual interiors, with tiled floor, a great woven hanging, and still-life objects throughout the room, the woman who appears in this setting is an allegorical figure. This can be clearly recognized from the fact that she has one foot on a globe, that she sits beside an altar with a crucifix and chalice on it, and also from her gesture of hand to breast, and eyes turned upwards. Vermeer seems to have taken his subject from a popular Italian handbook of symbols

142

104 Johannes Vermeer, *Allegory of the New Testament*. Metropolitan Museum of
Art, New York, Michael Friedsam Collection, 1931.

of the late sixteenth century, the *Iconologia* (Iconology) of Cesare Ripa. A Dutch version had actually come out in 1644. Ripa had said that Faith is represented by a seated lady holding a chalice in her right hand, and resting her left hand on a book with the world under her feet. An apple, representing the cause of sin, should be included nearby and a snake crushed under a corner-stone. All of these elements are present in the Vermeer, but the artist departed from Ripa's specifications in putting the chalice to one side of the woman, and also in a number of other respects. In particular, Ripa said that a painting of *Abraham's Sacrifice of Isaac* should be shown in the background, and Vermeer substituted a painting of the *Crucifixion*. Though Vermeer allowed himself liberty in these ways, the very fact that he combined symbolic elements with a seventeenth-century interior setting makes this picture of his not very successful: to modern eyes it seems rather clumsy.

More interesting still is his painting of *The Artist in His Studio*. This again involves a domestic setting; at first sight it looks as if it were simply a representation of the artist painting from a model who is posing for him. With his back to the viewer, the artist is painting in the leaves and flowers of the girl's head-dress on his empty canvas. But as early as February 1676, just after Vermeer's death, his widow already mentioned this picture under the title *The Art of Painting,* which clearly implies that there is an allegorical side to the work beyond its straightforward subject. In the mid nineteenth century, when Vermeer was rediscovered, this reference to the picture was not known, and it was assumed that the artist shown was Vermeer himself, at work in his own studio. It is now recognized that the model posing is to be identified as Clio, the Muse of History. According to Ripa, this figure is to be shown with a laurel wreath, trumpet and book, all of which are included here. And when this identification is combined with the inclusion of a map on the wall behind, which shows the seventy-seven provinces of the Netherlands, the general allegorical theme of the painting suggests itself as having to do with the glory and undying fame of the art of painting— probably Dutch painting.

Let us now go back to Velasquez. At near enough the same date, the Spanish artist did a painting which carries within it, in similarly disguised form, an equivalent kind of allegory: an allegory, in this case, of the way in which the raw materials of art are transformed into the finished art object. To describe how that aspect of the painting came to be unravelled is in fact to describe, for a single picture, a progress corresponding to the successive stages in which symbolic meanings were uncovered in the whole group of Vermeers discussed within this chapter.

The first written record that we have of the painting's existence, found in a 1664 inventory of works owned by the Spanish collector for whom Velasquez had evidently done the picture seven or so years earlier, refers to it as *The Fable of Arachne*. There is no obvious reason within the picture for a title of that sort. The scene shows the Santa Isabel tapestry factory in Madrid, with the preparatory labours being carried out by the workers up front, and a finished tapestry hanging in the background. After it had

144

105 Johannes Vermeer, *The Artist in His Studio*. Kunsthistorisches Museum, Vienna.

145

become royal property in the next century, it was recorded, from the 1790s on, by the title which seems the right and obvious one on the face of it, and which it still carries today: *The Tapestry Weavers.*

Nineteenth-century writers on Velasquez, and some twentieth-century ones too, saw in it no more than that. The attention paid to the actual poses of work and the fall of light on to the scene, along with details such as the piled-up wool and the impression of a blur made by the turning spinning-wheel—these were the elements on which their interest focused. This was, of course, the way in which the art of their own time had been developing, under the sway of Realism and Impressionism. They were led to interpret all paintings as if they were essentially direct, on-the-spot, unposed records of life and activities. But what those writers were doing, in effect, was to impose on to a seventeenth-century work a set of attitudes and approach to nature appropriate to their own time, and make the application of those concerns into the governing consideration affecting what Velasquez did. But this approach was inevitably weakened by the presence in the painting of a number of elements which were ignored, by-passed or left unexplained.

The most crucial of these elements was the group of figures on the raised level to the rear. Judging by the elegant clothes they wear, these figures might easily be members of the court visiting the factory. But what about the figure on the left of the group, who faces across to the right? The helmet identifies this figure as the goddess Pallas Athena—and what is she doing there? The rendering of her pose and figure link her very directly with the tapestry beyond, and the same with the figure next to her, thereby giving rise to the reading of one or both of these figures as part of the tapestry design. But that reading breaks down because the tapestry design is based on a well-known painting, Titian's *Rape of Europa,* which has no such figure or figures in it. So Athena must be standing in front of the tapestry. Once that was established, it was not long before, in successive contributions published just a year apart, two scholars were able to put the whole thing together. In an article of 1948, a Spanish art historian, Diego Angulo Iniguez, went back to the 1664 title referred to, *The Fable of Arachne.* Ovid tells how Athena presided as a goddess over the craft of tapestry-weaving in particular, and in this capacity she was challenged by Arachne, who got herself turned into a spider for her presumption. (An Italian translation of Ovid's text, with sixteenth-century illustrations, is known to have been in Velasquez's personal library.) Where then is Arachne in this painting? If the foreground figures represent mythological personages as well as working women, she, who was a girl of low descent according to Ovid, could be the young woman shown winding yarn. If, further, the foreground scene corresponds to the first part of the story, the old woman with the distaff could be Athena, in the disguise she took on for her encounter with Arachne, before she revealed herself as a goddess. And that revelation could be depicted to the rear, with Athena in helmet and armour and an appropriate pose, and Arachne appearing a second time there, as the figure next to her to whom her action is addressed.

In 1949, building on that interpretation so far, a European-trained scholar,

146

106 Diego Velasquez, *The Tapestry Weavers* (*The Fable of Arachne*). Prado, Madrid.

Charles de Tolnay, was able to go still a stage further. Taking the contrast
of foreground and background as a key element in itself, he proposed that
Athena appears at the rear as goddess of the Fine Arts, as opposed to the
craftsmanship depicted in the foreground; and that the figures accompany-
ing her in that separated, stage-like space, represent individually the four
major Arts. Music would be so identified then by the viola she has with her.
Painting would be represented by the presumed figure of Arachne, directly
linked here with Athena, in the moment of revelation to which she responds,
by association with the tapestry behind, itself done after a painting. And
Sculpture and Architecture would be the two remaining females, completing
the quartet that one would expect. The theme of the whole painting would,
then, turn on the idea of Athena as a bridge between foreground and back-
ground scenes. As goddess of both the major and the minor arts, combining
under her surveillance both idea and craftsmanship, she symbolically
affirms her authority over the process by which the fruits of rough and
menial handiwork are turned into the splendours of the finished work
of art.

147

107 Johannes Vermeer, *The Lacemaker*. Louvre, Paris.

108 Johannes Vermeer, *Woman Weighing Pearls*. National Gallery of Art, Washington DC, Widener Collection, 1942.

Velasquez and Vermeer did not exclusively produce paintings with complicated meanings. Many of their works are as straightforward in subject as they appear to be —for example, Vermeer's *Lacemaker,* a study of a young girl completely absorbed in her domestic task. One could hardly suppose there was any allegorical meaning present here, and the same with the *Young Lady Reading a Letter* (Ill. 115). (There is admittedly a map there, but no reason to think that it has to do with where the letter comes from!)

Woman Weighing Pearls is another painting which contains more than meets the eye. The woman may possibly be weighing gold, as it is hard to tell exactly what she has in her scales. Again, we have someone concentrating on a task, daylight flooding into the interior, and still-life objects around. But the painting on the rear wall shows the *Last Judgment:* Christ in Majesty judging the quick and the dead. The very way in which this painting is placed in relation to the woman's action already led Vermeer's nineteenth-century rediscoverer, the art critic Thoré-Bürger, to recognize that an allegorical point was intended, even though he had little interest in hunting down literary evidence that would clarify it. 'Ah, you are weighing jewels?' he wrote. 'You will be weighed and judged in your turn.' It seems clear that this painting belongs amongst the large number of seventeenth-century Dutch works which are technically known as *vanitas* pictures, in which jewels and gold and a mirror are symbols of human pride and conceit. The allegorical message of the painting would therefore correspond to the passage in St Matthew's Gospel where Christ is reported as saying, 'Lay not up for yourselves treasures upon earth, where moth and rust doth corrupt, and where thieves break through and steal; but lay up for yourselves treasures in heaven. . . .'

109 Frans Hals, *Malle Babbe*. Gemäldegalerie, Berlin.

There are, in fact, quite a number of other paintings by major Dutch artists of the seventeenth century, where the straightforward subject that the artist painted may have an allegorical meaning or implication attached to it as well. Thus a painting by Frans Hals of a *Boy Blowing Bubbles* may also be a *vanitas* picture, because bubbles burst and are gone. Two round paintings by Hals of the head and shoulders of young boys, one drinking and the other playing the flute, probably come from a series representing the five senses, these two standing for the senses of taste and of hearing. And a very famous Hals, the so-called *Malle Babbe,* a portrait of a grimacing and probably drunk old woman with an owl perched on her shoulder, may be more than just a representation of a low-life type. For the owl, as well as standing for wisdom, can also stand for folly and drunkenness. Birds and animals, indeed, offered many opportunities at that time for such references. In domestic scenes between man and woman, the offering of a gift of game may carry special overtones, depending on the particular type of animal or bird being given: a hare suggests the man's designs on the woman, a young game bird that she is 'tender game' for his advances.

150

110 Rembrandt, *Self-portrait*. Iveagh Bequest, Kenwood.

In seventeenth-century art, as in Renaissance and earlier art too, a single figure can normally be identified as of more than obvious significance by the attributes he wears or carries. One of Rembrandt's single figures, show-ing a man with a knife, was identified in the eighteenth century as an assassin, and in the nineteenth century as Rembrandt's cook. But this was simply wishful thinking. He is in fact St Bartholomew, shown, as was normal, with the knife that was used to flay his skin. A case where it is less easy to be categorical is a late self-portrait of Rembrandt's from about the same time as the *St Bartholomew*, showing the artist against a background on which are inscribed parts of two large circles. A convincing interpretation of these circles has not been reached so far, though there have been a number of suggestions, including the idea that they are magical signs or refer to the perfection of God, and the idea that they are emblems of theory and practice in art. Their shapes may have been suggested by a certain kind of world map which hung on the walls of Dutch houses. And there seems little doubt that one main reason why Rembrandt put them in was to stress the geometry of his composition here. But it remains possible that this is not

151

111 Rembrandt, *The Syndics* (detail). Rijksmuseum, Amsterdam.

the only reason for their being there, and that they do also have some, as yet undiscovered, symbolic significance.

Pictures within pictures, as in Vermeer's art, occur very often in Dutch painting of this period. In another late Rembrandt, his *Syndics* (Officials of the Drapers' Guild), painted in 1662, the very greatest of all seventeenth-century Dutch group-portraits, a little painting is shown hanging in the room in which the Syndics are gathered together, showing a burning city or a beacon. It clearly does have something to do with the general theme of the work, though interpretations of it differ. If it shows a burning city with flames coming from the walls of a tower, it could serve as a reminder of the vanity of earthly power. Or if the burning tower is a look-out beacon for seafaring people, then the image would be a symbol of good citizenship and good government. This second interpretation is, perhaps, the more likely one, given the solemnity and authority of the officials shown gathered together.

To come back now to Vermeer's *Girl Asleep*, here too there is a picture within the picture. At the upper-left, above the woman's head, we can see the leg of a Cupid with a mask upon the ground. Some have drawn the con-clusion that there is an allegorical touch to the painting having to do with

love. The girl, they suggest, is disappointed and unhappy in love, or having a fantasy of love as she sleeps; or the mask refers to the deceptions of love, or to the self-deception of drunkenness itself; or the lady has gone to sleep while vainly awaiting love. There are, however, two other Vermeers in which a similar or identical painting of a standing Cupid (but without the mask) appears, and in neither case does it seem to have any special significance to the subject, which involves a young woman standing at her music.

Is there more meaning in the objects on the table? There is a jug and an empty glass on its side. Right in front of the girl is a second, nearly empty wine glass, though this cannot clearly be seen now because the picture has suffered damage in this area. It might be that the girl had been left to clear the dinner-table after a meal, and had fallen asleep while doing this. But the glasses are prominently placed in relation to her. And the painting was described in 1696 as showing a girl who was drunk. Comparisons with other paintings and prints of the seventeenth century, in which drunkenness is the theme and empty glasses and pitchers appear correspondingly, give support to this interpretation; and even the girl's dress is in fact a subtle indication of the state she is in. For, though her costume may look orderly enough, the collar she wears with two tails was properly, at this period, tied at the neck in order to hide any suggestion of a cleavage in the bosom. That the girl has untied this collar shows that she is far gone in her inebriation. The painting would therefore be a warning to drink moderately or not at all: though this of course leaves us no wiser about why the girl got drunk.

It only remains to be said that such hidden or disguised meanings in seventeenth-century Dutch works remain secondary aspects of the paintings in question. The presence of a warning or moral principle was not intended to be obvious; and such meanings are therefore properly called 'hidden' ones. The primary aspect of such Vermeers as the *Woman Weighing Pearls* and the *Girl Asleep* remains what it has always been, a fragment of everyday reality observed in perfectly beautiful detail. The symbolism should not interfere with our looking at the paintings, from that point of view. It was surely not meant to. But it is both interesting and important that such secondary meanings are present.

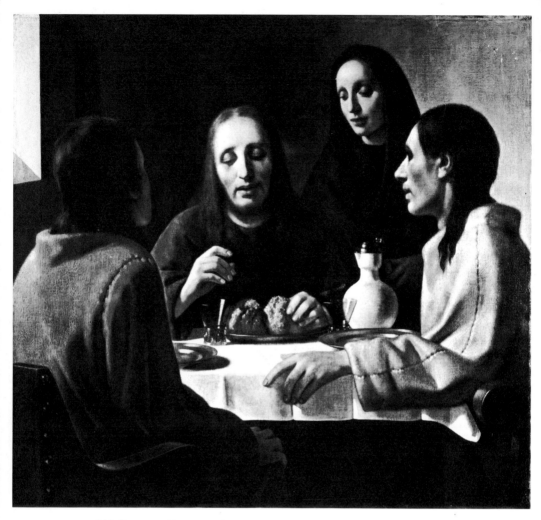

112 Hans van Meegeren, *Supper at Emmaus.*

Chapter eight
Forgery and its detection: the hand of Hans van Meegeren

IN 1937 the Boymans Museum in Rotterdam acquired, through the Rembrandt Society of Holland, a painting which it believed to be a crucial work by Johannes Vermeer (1632–75): a *Supper at Emmaus,* newly brought to light and previously completely unknown. For seven years the painting hung in a place of honour in the Museum. Then at the end of the Second World War, through a largely accidental chain of circumstances, a Dutch artist by the name of Hans van Meegeren (1889–1947) confessed to the world that he had painted the picture. A scientific commission was convened to investigate the claim and brought together evidence convincingly supporting its truth. In 1947 van Meegeren was brought to trial on the charge of forgery. He was found guilty, but died before the end of the year. The *Supper* was removed from its place and has never been shown again, though there are still postcards of the painting to be found, which call it a Vermeer on the back.

How did all of this happen—both the acceptance of the painting as a Vermeer, and its subsequent condemnation as a forgery? What is the importance of the whole story for one's understanding of what forgery involves, and the place of forgery in the world of art?

When a work of art of the importance of the *Supper at Emmaus* is suddenly revealed to be a modern fake, the story naturally becomes a sensational news-item; particularly if the artist responsible has confessed. But what exactly is a fake? Between a painting's being an original by a major master and its being an absolute fake made with the intent to deceive, there are many intermediate degrees. It may turn out to be a school piece, or by a follower rather than the artist himself. It may have been left unfinished and completed by another hand, possibly very much later; or it may have been substantially revised or retouched or prettied up at some later point, perhaps because of its poor condition or damage to it, or to make it more superficially attractive. Again, works by other artists of the same period may get under the wrong name, and may simply be of less exalted authorship. Then there are copies and imitations which were not originally made with any intent to deceive, but which may be passed off as originals subsequently on the art market, either by unscrupulous persons or simply by mistake. So where the label on a picture in a museum turns out to

need changing as time goes on, in at least ninety-five cases out of a hundred there will be no question of a forgery.

This is a point which is liable to escape the notice of people who get excited over stories which show the art world being deceived and seem to prove its general fallibility. A great many pictures in museums, even the most important ones, tend to go down in importance as research and study proceeds; but others go up. One needs to be aware of all this before over-rating the significance (money apart) of mistakes that are made. But the story of Hans van Meegeren is nevertheless an unusually telling, as well as an enthralling case.

Van Meegeren was the most imaginative of forgers, particularly in his *Supper*—and also the most skilful in his preparations. He was supremely successful in his deception. Very few people in the art world seem to have had real doubts, and these only came out later. It was only after he had confessed, that scientists and technicians stepped in and looked for support-ing evidence in the make-up of the paintings.

When a forgery is that imaginative and successful, the psychology of the man responsible naturally intrigues us, and quite a lot is known, or can be divined, about the motives and factors in van Meegeren's make-up which led him into becoming a forger and spending as much trouble as he did.

He was a delicate and stunted child, small for his age, and had a weak heart. This seems to have given him an inferiority complex from the beginning, and a desire to be the centre of attention. He was first en-couraged to paint by an artist called Korteling, who was extremely meticul-ous and steeped in the history of artistic methods and techniques. From Korteling, van Meegeren learnt the procedures of the Dutch seventeenth-century masters including Vermeer. He went to the Institute of Technology at Delft, Vermeer's birthplace, with a view to becoming an architect, which was what his father wanted; but art was his passion. He won the Gold Medal of the Hague Academy with a drawing of the interior of a church, a prize which helped him to sell other pictures. With the support of his newly married wife, he cut his final exams and, braving his father's threats to cut him off without a penny, made art his profession. In 1914, when he took his degree in art at the Hague Academy, he was asked to paint a still-life as part of the examination; and as a prank on the professors who were sitting at a table beyond, he put them into the canvas as well as the still-life itself.

In 1916 he had his first exhibition, which was a success. One of the leading Dutch art critics, a certain de Boer, was amongst those who praised it particularly, and there seems to be direct reflection of van Meegeren's desire for revenge on the art world in the fact that, as his marriage broke up, ending in divorce in 1923, he took the wife of this art critic as his mistress. She became his second wife in 1929. In 1921 he had his second exhibition. He was now doing paintings with biblical subjects, such as the *Jesus Among the Doctors* of 1918 illustrated here. They were criticized as superficial and mere virtuoso pieces. It was now that he began to feel a sense of deep-seated grievance against the critics and the art world in general. He became gradually more difficult and vain about his work. He

113 Hans van Meegeren, *Jesus Among
the Doctors*, 1918.

believed the critics were prejudiced and ignorant and lacked real apprecia-
tion. Furthermore, the paintings of his which sold best, portraits of ladies
of society, were the ones he liked least himself. Unable to settle down after
his student years, he travelled widely for distraction. With two friends he
put out a magazine called *The Fighting Cock*, which was intended to expose
the superficiality of modern art. Its focus on the venalities of the art world
made it almost libellous, but it lasted only one year. It seems to have been
one of those same friends, associated with the magazine, who first put into
van Meegeren's head the idea of forgery, since this friend had been doing
restoration and had become annoyed by the attitude and judgment of the
experts.

In 1932 van Meegeren moved with his second wife to the South of
France and bought a villa there. Now the real story begins. He needed
money to support his first wife and the children of that marriage, and also
to indulge his expensive social tastes; and though he continued to do
portraits, of tourists on the Riviera, he seems to have embarked almost at
once on his master plan and to have staked everything more and more on
this during the next few years. His wife apparently did not concern herself

157

with what was going on. Focusing on the Dutch seventeenth century and Vermeer in particular, van Meegeren began his research by collecting materials. He obtained the pigments which Vermeer himself had used. Vermeer's blue came from lapis lazuli, a semi-precious stone, whereas the blue pigment used now is a chemical product which is easily distinguishable. For yellow, Vermeer used gamboge, which is a hardened resin, and yellow ochre which is an earth product coloured with ferric oxide; both of these colours are now artificially prepared. The reds which Vermeer used came from cochineal and cinnabar; and his white, the last of his main colours, was white lead. This is poisonous, hard to prepare and easily discoloured, and later a zinc white or zinc oxide came into use instead. As Vermeer had done himself, van Meegeren ground the pigments which he obtained by hand, so that the particles should appear of different sizes under the microscope; if a pigment is mechanically ground each particle is identical. This was a typical problem that he had to face.

In 1935–36 or thereabouts, still at the villa, van Meegeren produced four paintings, two purporting to be Vermeers, which are illustrated here, one a Terborch and one a Frans Hals—which were probably trial pieces, since they were never sold. As forgeries, they were relatively elementary. Since a forger does not commonly have sufficient imagination or art-historical knowledge to produce a completely original work, and yet needs to create a painting which immediately recalls his model without being an obvious copy of any one picture, the commonest kind of deliberate forgery involves the combination of elements from two or three different pictures. All four

158

114 Hans van Meegeren, *Woman Reading Music*.

115 Johannes Vermeer, *Young Lady Reading a Letter*. Rijksmuseum, Amsterdam.

116 Hans van Meegeren, *Woman Playing Music*.

of these first forgeries of van Meegeren's are of this type. The head and costume in one of the 'Vermeers', the *Woman Reading Music,* is directly based on the head in a real Vermeer, the *Young Lady Reading a Letter.* Van Meegeren simply changed the pose from a standing to a seated one and added a pearl necklace and drop earring found in other Vermeers. The work on the rear wall, instead of being a map, is based on the picture which appears within the picture in two different Vermeers, with the same grouping used but a change in one of the figures. Similarly, in the second Vermeer forgery, the *Woman Playing Music,* the window at the left and the head-dress come from different Vermeers again. As for the furniture and still-life objects in the two paintings, such as the chairs and lute and papers and prints and tablecloth, they are elements of the sort that recur again and again in Vermeer's interior scenes; and the same with the tiled floor reflected in the mirror. These elements are simply changed around into differing variations and combinations, so they do not correspond exactly to any one painting as a set. In fact, van Meegeren now began to keep actual objects of the sort Vermeer used in his studio for this kind of purpose. Some of them were found there much later, including the white jug in the *Supper at Emmaus,* which is just like the one in Vermeer's *Girl Asleep.* The reason why van Meegeren took very little imaginative trouble about the composition of these first forgeries seems to be that he regarded them as experiments in the artificial ageing of paintings, and he probably did not try to sell them because he thought them below the standard that he could ultimately achieve.

159

There were two ways by which van Meegeren could create a 'Vermeer'. Using the same pigments and media mixed in the same proportions, he could imitate Vermeer's art directly as he did in the above two cases, and then doctor the painting after it was done. After the paint had dried in the normal way, that is, an antique look would then have to be given to it by the use of a chemical or varnish. This method, van Meegeren decided, was not enough to produce a really authentic appearance. So he took up the second alternative, which involved the discovery of a new medium to take the place of oils: a medium which would allow the picture to be baked in an oven so that it came out with the appearance of being three centuries old. Normal media, such as linseed oil, would cause the paint to blister or become discoloured if baked. Oil of lilacs gave good results, since it left little trace after evaporating and the colour stayed fresh, but it did not solve the problem of heat resistance. But in 1936 van Meegeren, working with a special oven that he designed in which the painting rested face down upon the elements, finally hit on the answer that he needed by introducing two chemicals, phenol and formaldehyde, as hardeners. Testing the results he could get by applying these chemicals with the brush along with the pigments, and raising the temperature to over 100°C, he found that the paint could not be dissolved afterwards by any normal solvents. This was exactly what he wanted, because one of the first tests of a painting of doubtful age is whether the paint can be easily dissolved or not.

He was now ready to begin on his master creation, the *Supper at Emmaus*. For this purpose he used a large seventeenth-century canvas of the *Resurrection of Lazarus* which he had acquired. He took it off its stretcher, and cut it down to the size that he wanted. With pumice stone, soda and water he removed the paint, leaving only the bottom layer which would show up under X-ray and again suggest age for the work painted on top. Patches of white lead that he could not remove were to be turned into a white element, the tablecloth in his *Supper*. Thus, the *Supper* was planned around an area which needed, for technical reasons, to be a particular colour.

Now came the actual painting. It was here that van Meegeren showed his real brilliance. Vermeers are very rare, and the total number of paintings quite small. Furthermore, there is little certainty as to the chronology of Vermeer's art, with only one painting dated. Given the fact that Vermeer had done, early on, a religious painting of *Christ in the House of Martha and Mary*, mentioned in the last chapter, before turning mainly to genre scenes, art historians had mooted the possibility that he might have done other religious works, and even a whole period of biblical paintings. Discussion of this possibility was much in the air at this time. If there were such paintings, as yet undiscovered, it was reasonable to expect that they would relate back to the work of the great Italian Caravaggio; and the composition which van Meegeren produced is very similar in a general sense to a Caravaggio of the same subject which van Meegeren had seen in Italy in 1932.

When the painting was ready, after six months of work, van Meegeren baked it successfully. To induce cracks in the surface, he rolled it around a tube. He also cut off a strip from one side and put it away, to prove that

he had done the work. This action of his suggests that, at the time, duping the art world and getting his revenge in that way on those whom he felt had slighted him as an artist in his own right was an even more important motive than financial gain, which is the most usual one with a forger. For he must have had in mind at that point, when he hid the strip away, that one day he would bring it out and prove his authorship. He remounted the painting on the original stretcher, using the same nails, and filled in the cracks with Indian ink to give the effect of dust accumulated there. He also flaked off paint at the corners and damaged the underneath of the canvas and varnished the work.

He then had to invent a convincing story which would enable him to sell the picture: a story which would explain the lack of provenance (earlier history of ownership for the work) when he presented it as a new discovery. The story that he came up with was typical in its construction of the kind used by forgers and contained attractive elements of a romantic kind. He said that he had found it at a sale, in a cheap market of worthless pictures. It came from a rich French family which had gone bankrupt, and wished to conceal its name in selling up. The story went that the head of the French family had married a girl from Delft, whose dowry included some old paintings. Van Meegeren said that to protect the family's anonymity, he had to dispose of the painting through an agent, and he went to a solicitor with this story, to find out if he would act for him.

The solicitor submitted the canvas to a Dutch expert, Dr Abraham Bredius, who accepted it immediately as a Vermeer (he was eighty-two and almost blind). It was sold through an art dealer to the Boymans Museum for the then equivalent of almost £60,000 ($300,000), of which van Meegeren received about £40,000. It was never technically examined, except with the eye and the magnifying glass.

Announcing the discovery with great enthusiasm in *The Burlington Magazine* art periodical in November 1937, Bredius wrote of it in terms which are now naturally rather embarrassing for their fulsomeness. He said that it belonged, in his opinion, to Vermeer's early period and cited as particularly beautiful the Vermeer signature (the monogram IVM) which van Meegeren had not omitted. (Interestingly, van Meegeren's own initials, H.V.M., corresponded to the monogram in the last two letters, and his first name was only one letter different from Vermeer's first name [Han and Jan]. This may well be one of the reasons why van Meegeren was originally attracted to Vermeer, before he even thought of forgery. And there is the engaging legal point that if he had put on an 'H' instead of an 'I', the charge of forgery, which legally involves passing off one's own work as someone else's, could perhaps not have been used against him.) After careful restoration of the damage, the painting was shown to the public in a specially roped off area of the Boymans Museum, and van Meegeren went there himself to see it.

No careful comparisons with other Vermeers were apparently made by the officials involved in the purchase. Some experts, particularly outside Holland, did not believe in it. Duveen, the New York art dealer, got a cable

117–119 Hans van Meegeren, *Mother and Children* (left) is in the artist's own undisguised style. The *Washing of Christ's Feet* (right) and *Last Supper* (opposite) purported to be by Vermeer.

from his agent in Paris, when the painting was still in a bank vault there, which ended 'PICTURE ROTTEN FAKE'. With the advantages of hindsight we can see that there is something rather sickly about the expressions, particularly that of the Christ. And there are a good many common qualities in the faces of a perfectly terrible drawing of van Meegeren's own, *Mother and Children,* a work which has a lurid and film-starish quality, related to the popular cinema of that period. The particular way of shading the eyelids, mouth and nose is remarkably close, suggesting that even a great forger cannot disguise his own artistic hand.

Van Meegeren's vanity now seems to have got the better of him. He was able to convince himself that the price he had got for the *Supper* was what his own work was really worth, and that the day when he would own up could be put off a little further. He produced another forgery at the same villa, then moved in 1938 to a more luxurious one at Nice and did another one there. These two were both forgeries of the work of Pieter de Hooch: an *Interior with Drinkers* and one with *Card Players*. They were again carefully done, partly because van Meegeren was now forging a different artist. They were sold to two Rotterdam collectors, in 1939 and 1940. Only the outbreak of war caused a stirring of panic in van Meegeren. The money he had left was in Dutch bank notes, and he abandoned the South of

162

France and bought a house at Laren in Holland. Then came the German invasion of Holland, leading to the demoralization of the country, the rise of black market transactions and underground activities of all kinds. Threatened by the economic inflation and unwilling to reveal his secret as yet, van Meegeren went back to forgery.

Between 1940 and 1945, he produced five more forgeries, all of them Vermeers. The first two were a *Last Supper,* and a *Head of Christ* which purported to be a study for it. Both of these were sold to the Dutch collector van Beuningen, who in 1941 sold the *Head* back to the dealer from whom he had bought it, in order to be able to afford the more important *Last Supper.* The *Last Supper* again involves the idea of an imaginary religious period in Vermeer's art. But it was much more carelessly painted and weak in its grouping, with some of the same heads used over again. It was done over a seventeenth-century canvas of a *Hunting Scene,* by a minor artist called Hondius, of which a photograph was later found. Van Meegeren's increasing sloppiness, as he became brazenly confident of his powers and of the unlikelihood that he would be found out, is still more evident in the *Washing of Christ's Feet* of 1943, where the quality of the expressions is even more lurid and sickly. In both of these works, the resemblance of Christ's features to those in van Meegeren's own 1918 painting, *Christ Among the Doctors,* becomes even more marked and obvious; and the same is true of the handling.

One other forgery of this late period also deserves mention. As described earlier, in his Vermeer forgery *Woman Reading Music* van Meegeren had

163

shown, hanging on the rear wall, a variant of his own invention of a painting which appears in the background of two genuine Vermeers. This painting has turned out to be a work by the early seventeenth-century artist Dirck van Baburen, the *Procuress,* which exists in two versions, one in Boston and the other in Amsterdam. Van Meegeren now did a copy with minor changes of this Baburen and endeavoured to pass it off as a copy by the young Vermeer. This was an imaginative idea again, but scarcely a convincing one.

It must be understood that none of these later forgeries are likely to have been accepted under normal circumstances. While the war was on, the Dutch wanted to keep their national treasures out of Nazi hands. The real Vermeers hidden away during the occupation of Holland were not available for comparison, and travel was also banned, so that no checks could be made on the invented stories that van Meegeren continued to provide about the origins of the paintings as he disposed of them. The acceptance of the *Supper at Emmaus* equally helped the sale of these later forgeries; for once the possibility of unknown Vermeers turning up had been accepted, a pattern was established for this happening again. The same dealers were involved throughout, and the *Washing of the Feet,* which was bought by the Netherlands State in some haste, was certified by a committee set up for the purpose. This committee was very conscious of the need to make a quick decision under the circumstances.

It was the sale to the Nazi leader Goering of the painting *Christ and the Adulteress* that was finally the cause of van Meegeren's being found out. It was not van Meegeren's own wish to deal with the Nazis. Approached by a new dealer at that point, he sold the painting to him on condition it remained in Holland. But, through the intervention of two bankers, it went to Goering. Goering, as it happened, in order to acquire it, gave back to Holland two hundred less valuable Dutch works, which was the one good thing that came out of van Meegeren's dubious operations. (Though there was a tendency in Holland after the war to regard him as a traitor to his country, this is one charge that cannot be held against him.) As he went on from forgery to forgery, he became fantastically wealthy, burying some of the money in his garden and buying hotels and night clubs with the rest. After moving to Amsterdam, he broke up with his second wife, and by 1945 he was old and tired and keeping himself going on drugs.

After the war, a commission set up by the Allies to recover lost paintings taken by the Germans found the *Adulteress* in Hitler's country retreat at Berchtesgarten, with a written record of its sale. Without any suspicion of the truth, the Dutch police went to van Meegeren with this record in search of information about the picture's origin. The story van Meegeren dreamed up was unsatisfactory and, under repeated questioning, he finally broke down and to get out of his difficult position confessed that he was the artist himself. His written statement immediately became front-page news. The authorities asked him to do a copy of the *Supper* to substantiate what he said, but he proposed, with typical vanity, to go one better and paint a Vermeer before witnesses. He thereupon began a *Christ Among the Doctors*

164

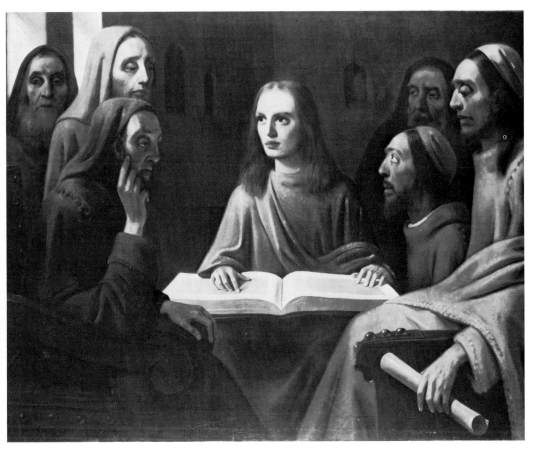

120 Hans van Meegeren, *Christ Among the Doctors*, 1945.

and spent two months on it. The charge against him was altered meanwhile from one of collaboration with the Germans to one of forgery and, as a result, he refused to age the picture by his usual means. Like the wartime forgeries, it is a sloppy work of no particular quality; it has all the characteristics one would expect of the artist who did the *Supper at Emmaus,* only more obvious and exaggerated.

The trial took two years to come up, and in the meantime van Meegeren was declared bankrupt, after the claims from the buyers of his paintings came in and the state put in its own claims for unpaid tax. He was also beginning to be seriously ill with heart trouble, and was moved to hospital in 1947.

After van Meegeren's arrest a scientific commission had been convened, under the leading technical expert of the Netherlands, Dr Paul Coremans,

head of the central laboratory of the Belgian Museums. This commission reported in time for the trial, which took place in October 1947. Though its findings have the advantage of hindsight, they are extremely important: X-ray examination of the 'age crackle' on the pictures showed many more lines than there should be in an old painting, and discrepancy between the surface cracks and those revealed under the surface. X-rays also brought out the existence of the seventeenth-century *Resurrection of Lazarus* canvas that was used for the *Supper at Emmaus* and the Hondius that was used for the *Last Supper*—in the latter case, very clearly indeed. The white lead that van Meegeren had been unable to remove before painting the first work also showed up clearly in the upper part of the picture. As described earlier, van Meegeren had also cut the canvas of this picture, and, though the missing piece was never found, evidence of the cut was revealed in the shape of a clean edge such as one would not normally find, since a canvas usually decays where it is tacked at its edges. In the villa at Nice were found the lamp, the plate and the maps which appear in the forgeries, and also the pigments used. Finally, chemical tests confirmed what had earlier been suspected, the presence of cobalt (which is a modern pigment) mixed in with the lapis lazuli in two of the paintings; and the phenol used in the baking was found in a cross section of the layers of paint.

At the trial, the *Supper* itself was not included in the charge of forgery, because of a ten-year statute of limitations under Dutch law; but it was constantly referred to. The paintings were hung around the court and Coremans used lantern slides to project his evidence. Van Meegeren made only two points in his defence: first, that he had painted for his pleasure and had been driven to continue the forgeries by a force beyond his control; and second, that the reason he sold the works at such high prices was that any lower price would immediately have made them suspect. He was found guilty but, because of his health, given a token sentence of a year in prison. He died just two months later, at the very end of 1947. Some of his paintings were put up for sale, others impounded because of the complicated financial position that he left to his heirs. The *Supper* itself had been taken down from its place and was put away. The *Christ Among the Doctors* was bought by Raymond Oppenheimer, the golfer, for his uncle Sir Ernest, a diamond millionaire, and now hangs in a church in Johannesburg, South Africa.

Nor does the story quite end there. Van Beuningen, the collector who had bought the *Last Supper,* came to believe, with the support of a man called Decoen, that there was a case to be made that his own painting and the *Supper at Emmaus* were real Vermeers after all. There followed a dismal tale which involved unscrupulous searching for evidence on van Beuningen's part and virtual persecution of Coremans. Its unsavoury details can be left out here; anyone interested can read Decoen's book, *Back to the Truth,* which came out in 1951, and judge for himself the arguments presented there. When another version of the *Last Supper* forgery (painted in 1939) was discovered at the Nice villa, and found to be over still another seventeenth-century painting, which van Meegeren had accurately described, the

last gap in the credibility of the details he had given was filled in; and the law-suit which van Beuningen had brought against Coremans, on the strength of his case, was ultimately dropped.

What conclusions and lessons can be drawn from the whole van Meegeren story? First, forgeries will continue to exist and to be manufactured, simply because of the financial incentive. So long as the great artists are highly valued there will be encouragement to the forger to get to work and make some easy money. This is particularly so in the case of modern forgeries, since they involve no problem of ageing. Or, as with van Meegeren, the forger may be driven on by a feeling that his talents have been slighted, and that he can get even with the art world by showing that he can produce, say, a Picasso just as well as Picasso can. He both casts doubts on the credibility of those who do the judging, and at the same time establishes his own talent.

The story of van Meegeren serves as a warning. The experts have to keep up with the forger all the time on the technical front. They must come up with new scientific tests, just as the forger, knowing what they will look for, tries to bypass those tests that he knows they will make. Both the museum man and the private collector must check thoroughly before buying. Today, partly as a result of the van Meegeren forgeries, the museum man, before acquiring any previously unknown and unrecorded work, will be likely to submit it to intensive technical examination.

The argument is often heard that if no one can tell the difference, a forgery must be as good as the real thing. This is not so easy to answer. A skilful painting in the style of a great master can indeed give as much genuine pleasure as a painting by that master's own hand. (As we have seen, during the Renaissance the practice of using studio assistants was perfectly acceptable.) A forgery need not, therefore, automatically lose all aesthetic value once it is exposed. But there are two things to be remembered. One is that after a certain lapse of time—some say as short as twenty-five years— even the most imaginative forgery begins to look less convincing. People's way of looking at an artist changes, and a forgery, like any work of art, inevitably bears the stamp of the age when it was painted. The other point is a moral one. A forger is cashing in on our knowledge of the history of art. By giving us false information about the painting's date he leads us to apply false standards and make false assumptions, for we can never look at a painting totally objectively. A forger is pretending to an originality that he does not possess. He is dishonouring the very aspects of a great artist's creativity which make that artist's work live from century to century.

167

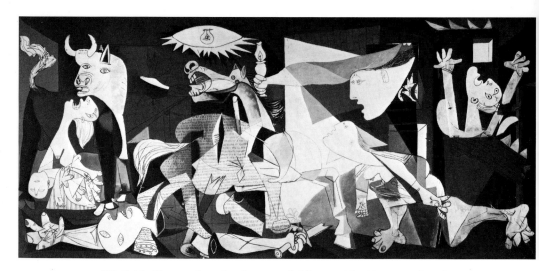

121 Pablo Picasso, *Guernica*. On extended loan to The Museum of Modern Art, New York.

Chapter nine
Understanding a modern picture:
Picasso's *Guernica*

IN APRIL 1937, at the height of the Spanish Civil War, German bombers, acting on the orders of General Franco, attacked and destroyed the ancient Spanish town of Guernica. This was an outrage in a double sense. First, Guernica had an extraordinary place in the history and tradition of Spain. It was the centre of government of the Basque people—a distinctive and proud race who had preserved over centuries their own customs, and even a language of their own. Much of Basque legend and faith was focused in the city. Buildings which stood there and institutions which still flourished there commemorated Basque history and the origins of the race. It had, then, something of the character of a sacred spot: as Delphi was sacred to the Greeks because of the oracle there, so Guernica had its oak tree, a dried stump six hundred years old. This was true not only for the Basques themselves but, through them, for Spain as a whole. And second, the bombing had no military justification. The town harboured nothing of strategic or economic importance. Franco was deliberately striking at one of the prides of Spain; and through the bombing, which was quite unheralded and unexpected, large numbers of non-combatants were killed, particularly women and children. The Spanish Civil War has been called the first act of the Second World War, with its confrontation of Fascism and Communism; the bombing of Guernica was equally a predecessor of the saturation bombing of later wars.

Shock at the outrage was tremendous. It had its implications for every thinking man concerned with the state of Europe, irrespective of his country, but especially for every Spaniard. And Pablo Picasso, though he had spent most of his life as an artist in Paris, was a Spaniard in his bones and in his upbringing (he had been born at Malaga in 1884). Three months earlier Picasso had been invited by the Spanish Republican Government to do a mural that would hang in the Spanish Pavilion at the Paris World's Fair that year. Picasso had accepted, but he did not actually begin work until 1 May—in other words, a few days after the bombing. Then he decided immediately to do a mural based on the outrage. He worked with incredible speed, which was characteristic of him, so that eight days later he had already determined the general form that his composition would

122–124 Pablo Picasso, first state of *Guernica* (above) and drawings dated 1 May and 2 May 1937. On extended loan to The Museum of Modern Art, New York.

take. Its scale was enormous: $11\frac{1}{2}$ feet high and nearly 26 feet wide. In July the canvas was ready. It went on view in Paris on one of the end walls of the Spanish Pavilion.

Picasso dated every one of his preliminary studies for the mural, and he also had it photographed at each stage, so that we can follow in detail the emergence of the picture. This is something which is specifically modern in its implications. Since the Romantic movement in the nineteenth century, emphasis has fallen, increasingly and with increasing intensity, on the artist's individuality and consciousness of himself, to the point where an artist such as Picasso could believe that everything he did was worth preserving for posterity, as a record of his creativity. So we have, with *Guernica*, a much more complete archive of what happened than we would normally have in any previous period, when preliminary studies were not valued and have only survived by chance. With Picasso, also, we are dealing with an artist who was much more self-consciously articulate about the ideas and beliefs behind his work than artists tended to be in earlier times.

The earliest drawings, those of 1 May, one of which is illustrated here, show that Picasso had determined from the start that he would include a horse, and a woman with a lamp stretching out of a window. Thus, though news photos may have had some effect on Picasso's choice of images, as we shall see, there was no question of a composition recording the actual historical event: the fall of bombs or the ruin and burning of the city. Two of the horse studies already contain the idea of a horse shooting its head straight up, while its innards pour out of a hole in its stomach; and by

170

2 May we get a powerfully muscled bull and a fallen warrior clutching a broken spear, who lies beneath a horse with grotesque pincer-like jaws. The first complete compositional study, done on 9 May, includes a running woman and a blaze of fire to the right and a shrieking woman with bare breasts at the left. From this point on, then, Picasso has determined that a cast of women would stand for the fact that many innocent women were victims of the outrage. All the major elements of the final picture are present, but Picasso makes many changes of organization and grouping as he works forward on the canvas itself. He first drew in forms with a rapid, fluent line, and then went over the canvas section by section, blocking in large areas of black and grey. This was a way of working that allowed the possibility of constant revision while the mural was actually in progress.

Comparison with traditional ways of doing preparatory work will bring out the modernity of Picasso's method. In the past, a painter would probably have tackled a work on the scale represented by *Guernica* by first making a series of notes and sketches, possibly using wax models to study the layout of the figures and the patterning of the shadows; then composing a smaller and freely done version of the whole work; and finally a full-scale 'cartoon' for transfer on to canvas. Examples of all these stages survive from the past and are valuable evidence for the art historian in reconstructing the creative process. But they all involve the idea of a logical and steady progress towards achieving a clearly conceived end result. In their place, Picasso adopted a working method which permitted numerous shifts and changes all along the way. These changes have been studied by a visual psychologist, Rudolf Arnheim, in a book specifically devoted to the subject. He has been able to show that, from the point of view of visual relationships and visual effect, these revisions had the double role of making each image more powerful in its own right, and at the same time making the compositional relationships between each major form and its neighbours more and more interlocking.

What other kinds of question need to be answered about *Guernica,* as a modern painting and as a key work of Picasso's?

First of all, there has been a good deal of speculation as to why colour is absent from the mural. Why did Picasso limit himself in the final canvas to black, white and grey, when he had used colour (red, yellow, blue) in some of his preliminary studies? One answer is that Picasso adjusted his palette according to the work's destination—limiting himself in this way because the work was going to hang in a contemporary architectural setting, a rather stark and bare modern pavilion by the Spanish architect José Luis Sert, built of concrete, glass and steel. This is no doubt true, but there are two other points about the limitation to black and grey which are perhaps even more telling. First, Picasso was a Spaniard commemorating a Spanish tragedy, a scar on the face of his own country, and the great old masters of Spanish painting, from whom Picasso had learnt as he grew up, had established a tradition involving the use of low-keyed, relatively monochromatic colouring. The general mood of Spanish painting had tended, ever since the sixteenth century, to be sombre, ascetic and penitential. (Along with

172

Picasso, another Spaniard in Paris who had contributed importantly to the creation of Cubism, Juan Gris, evidently had a sense of this too, to judge by the use both made of a restricted palette in Cubist paintings of 1909–11.) At the beginning of the nineteenth century, moreover, the Spanish artist Francisco de Goya had dealt with a theme similar to that of Guernica in his famous series of etchings, the *Disasters of War*. Goya had seen war in terms of brutality, outrage and man's despicable inhumanity to his fellow man. And since the *Disasters* were etchings, Goya had of course worked exclusively in terms of black and white, so that his grizzly scenes of carnage emerge into the light of truth out of a background of darkness and gloom. There is certainly a general affinity between Picasso's use of dark and light and Goya's. Secondly, when an artist is working on a large scale, he characteristically first blocks out his values in blacks and greys, in order to determine and adjust the general pattern of lights and darks. Picasso had already used these two values, without any colours, for a large painting of 1925, and he would do so again in 1945. This palette, then, is not exclusive to *Guernica* in Picasso's work as a whole. Blacks and greys make it easier to discern the working process. It is as if the process of creation were in some way being embodied or preserved in the character of the final work and becoming part of its content. Finally a simpler explanation, that black, white and grey carry here their traditional associations of mourning and death.

The imagery in *Guernica* consists of a horse, lamp and electric light in the centre, a bull to the left, a fallen warrior, various distraught women, and indications of buildings. Though news photos of the days immediately following the bombing may have directed Picasso's thoughts by showing buildings destroyed and the bereaved in their anguish, none of the particular imagery here was in fact specially invented for this occasion. Rather the opposite. Each of these images is already found in some equivalent or related shape in prior works of Picasso's of the 1930s. Between 1933 and 1935, for instance, he had done a series of bull-fight paintings showing the agonized and, typically, shrieking horse at the mercy of a hulking bull, or horse and bull up against one another at the kill.

Another remarkable antecedent is the etched plate of 1935 called the *Minotauromachy*. It shows the Minotaur of classical legend, half man and half bull; a dead female matador with her breasts exposed lying over the back of a horse; two girls with a dove watching at a window; a Christ-like figure on a ladder at the left looking back and down; and a little girl holding a lamp. This plate, incidentally, handles lights and darks very much as Goya had done. What is the theme here? It has nothing to do with war. It can be interpreted in terms of what we now know of Picasso's personal life in the 1930s, particularly his love-life, and even psychoanalyzed. But if we do not choose to probe in that direction but stick rather to what is conveyed in the work itself, quite clearly innocence is contrasted here with violence. The dichotomy between good and evil presences is not, however, that clear-cut. The bottom half of the bull, for instance, who seems threatening from his head, has the anatomy and physique of an antique hero such as

173

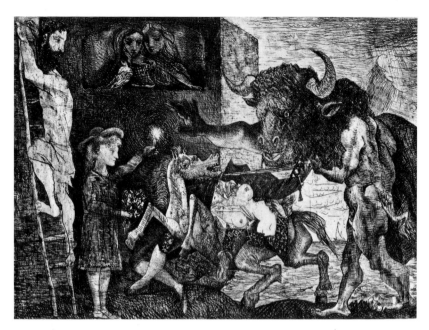

125 Pablo Picasso, *Minotauromachy*. Collection The Museum of Modern Art, New York.

126 Pablo Picasso, *The Dream and Lie of Franco*. Collection The Museum of Modern Art, New York, Gift of Mrs Stanley Resor.

174

Hercules, while the Christ figure is more slender and weak-looking. The sword with which the Minotaur runs through the matador seems to be the matador's own. Furthermore, the Minotaur appears in several pictures of the mid 1930s in a relatively humane role. In a painting of April 1936, for instance, he is moving house. He draws along a cart containing an agonized horse, which this time is giving birth; and in the cart there are also pictures and a ladder which might be from the artist's own studio. Again, therefore, the imagery suggests a confusion and dislocation of values, an ambiguity between good and evil, corresponding on the one hand to upsets in Picasso's domestic life and, on the other, to the total upset of values that war or the approach of war brings in its train.

Finally, in January 1937 Picasso had done a series of eighteen etched designs accompanied by a poem, which he entitled *The Dream and Lie of Franco*. These designs had a specific propaganda role. As an attack on Franco, they were in due course reproduced on postcards and sold for the benefit of the Republican government. In the nine panels illustrated here Franco is shown surrealistically as a turnip head with three grotesque tubers growing from it and a crown on (right of the middle row). This head confronts a bull with rays of light issuing from its head. Other panels show a pastoral scene of love and tenderness with a horse and bearded man asleep, and alongside this a war-scarred landscape with a young girl lying in it; the Franco figure as a knight in armour, with a standard and a winged horse lying on its back; and in the centre the bull disembowelling a horse, which now has the same tubers as Franco, with disgusting creatures pouring out from its inside. The remaining four scenes were added later, while *Guernica* was in progress, and involve motifs found there as well: a woman frenzied with grief, one being killed with her children, and a third rushing from a burning house with her children in her arms. As can be seen from the fact that the signature and date are backwards, Picasso made his design here the other way round, so that the imagery should be read from right to left in each case. All these different cases, then, involve images which have special meanings for Picasso, but which take on different implications and suggestions according to the context in which they appear and the character of the work as a whole. The horse may be winged in one case like Pegasus and tuberous in another like the Franco figure, and the bull may be similarly either threatening or radiant with light.

Is any help forthcoming on the meaning of *Guernica*'s imagery from Picasso himself? Artists' commentaries on their work are particularly important nowadays when art does not have the kind of public that it tended to have in earlier periods: that is, an audience sharing beliefs with the artist and his patron and basically familiar with the symbols used. As a result, the modern artist has been particularly encouraged to make statements about his work, in the expectation that these may help explain his pictures to the public. How much ought we to depend upon what he says? Obviously the artist is in a privileged position in a good many ways. He is the only one who can tell us the ideas which he had in mind, the state of his feelings at the time, and the problems which came up in the course of the

work. But when it comes to the question whether those ideas *are* in fact communicated, or those feelings put across in the actual work, it is still up to us to decide. Nor is it simply a matter here of determining what the artist intended to do, and then deciding whether or not he succeeded in doing it, because most often the question is whether or not what the artist can tell us is really relevant to the work itself. Artists may be deceived in their thinking about what they are doing or did. Their natural medium of expression is visual, not verbal, and therefore what they say in words may well be parenthetical, or even irrelevant, to the work. They are not immune, just because they are artists, to correction or challenge from us. And most often, in fact, though their statements are helpful, they are helpful in a secondary sort of way—supporting what we get from the work itself but leaving us free to go well beyond them in our interpretation.

Picasso has made a number of statements about his art at different times in his life, but generally he has taken the attitude that his works should speak for themselves, without the intervention of explanation from the artist, and most of his public statements have been in effect declarations of this philosophy of his. He has spoken generally about the nature and processes of his art in order to correct misconceptions (as in his famous words 'I do not seek, I find'), rather than talking about any particular work.

In private, though, he could be more revealing. Françoise Gilot, who lived with him for many years, has recorded conversations in which Picasso talked about the whole of his art, in all its different stages, very much as one would to an intelligent but uninformed person to whom one wanted to give some feeling, in quite simple terms, of what it was all about. The same dichotomy between the public and private Picasso comes through in his art itself—in the contrast, for instance, between the politically-inspired works like *Guernica* and the pictures of children or of sad harlequins and strolling players. Indeed it is a dichotomy which in one way or another affects every modern artist.

In the case of *Guernica*, we have first of all a statement made by Picasso in May 1937, in which he committed himself to the Republican (anti-Franco) side in the struggle taking place in Spain, saying that he stood for the cause of the people and for freedom, as against 'reaction and death', and that his whole life as an artist was an expression of that commitment. He described how, when the Civil War broke out, he had been appointed to and had accepted the post of Director of the Prado Museum in Madrid, the great repository of Spain's art. And he went on to say, that he was working on a painting which he would call *Guernica*. In it, and all his recent work, he was clearly expressing, he said, 'my abhorrence of the military cast which has sunk Spain in an ocean of pain and death'. Obviously this was a political statement, defining Picasso's position at the time, which it was important as a Spaniard that he should make clear. The statement is more related to the *Dream and Lie of Franco* as a propaganda work than to *Guernica* itself.

Later, when asked in an interview about the specific images in *Guernica*, Picasso said that the horse represented the people and the bull brutality and darkness. But when he was pressed to say if the bull stood specifically for

176

Fascism, he refused to go any further beyond his first statement. This was tantalizing of him, but we can see that it fits with the shifting and ambivalent character of the bull- and horse-images in works of his before *Guernica*. And it seems clear that he did not want to distract from the force of the images by laying down a single clear-cut meaning, which might tempt people not to look for themselves.

How, then, are we to interpret the imagery of *Guernica*? Let us, first of all, compare it with the work of two other artists who also, under the impact of the Spanish Civil War, dealt with related themes, but in a totally different manner from Picasso. The Mexican artist, Siqueiros, in his painting called *Echo of a Scream*, illustrates the horror and carnage of the war in the fashion of a reporter, presenting it with a built-in implication as to how we ought to react. The sculptor Julio González suggests the heroism and spirit of the Spanish people through the image of a stalwart and erect Spanish peasant.

Picasso works much more indirectly. The general theme of *Guernica* concerns those civilized values which are enshrined in the tradition of Europe in general, and Spain in particular: the humane Western tradition of life, in the broadest sense, and the assault upon those values which war brings with it. Picasso's answer, when he was asked about the painting's symbolism, fits here, in the sense that it was couched in general allegorical terms like these, involving the Spanish people on one side and brutality and darkness on the other.

There is a family of images in *Guernica*, each one of which has some sort of direct antecedent in Picasso's earlier art. Each of these images is crystallized in the painting in such a way that it underscores one specific trait of human feeling and reaction: a trait which is envisioned in its most drastic and accentuated form. The horse, as Picasso renders it, evokes immolation; the woman with the dead child in her arms, in another part of the painting, evokes grief and lamentation at their highest pitch. Each separate image, then, can stand on its own as poignant detail of an extremely powerful kind.

These images are put together with one another in relationships which tell no story, but rather intensify the mood of the work as a whole: a mood which, as implied by what was said earlier about the colours, involves mourning and anguish. Immediately next to the grieving woman at the far left, for instance, there is a bull towering over her. Their two mouths are open, and are positioned side by side; they are made analogous to one another, simply as forms. The bull may be brutal, but the force of grief is equally savage and shrill. Brutality at the same time necessarily involves strength, and the very erectness of the bull suggests that an impersonal strength may arise out of the violence and anguish. By dislocations of form and intensifications of expression, Picasso consistently evokes, throughout the painting, collapse and confusion of a frenzied kind. But he also evokes the possibility that, somehow, a resolution may emerge from the chaos and rise above it.

From its very beginning, the imagery of *Guernica* refers back in many different ways to the great classical Western tradition of art and values. There are elements in it that relate, by association, to classical Greek art:

177

originally the fallen warrior at the bottom carried a helmet and spear like those of the goddess Athena. In the final version, this same figure became dismembered and fractured like a broken ancient statue. At one stage, too, the bull had a Zeus-like head. Again, the motif of the dead child and the mother's grief brings to mind the Christian theme of the Massacre of the Innocents, very common in Renaissance and Baroque art, and behind that, ancient reliefs of maenads, the frenzied votaries of the god Dionysus. And the presence of the two protagonists of the bull ring, bull and horse, recalls the long-standing place of the bull-fight in Spanish life and tradition.

One more observation about the work's construction bears on the same point. Picasso's main expedient for organizing the composition was to use a large strong triangle within which the central figures are compressed. The broad base of this triangle corresponds to the base of canvas, and from the head of the warrior to the left and the feet of the running woman to the right, its two sides rise very clearly back towards a central apex, just above the lamp. This triangle, with its equal sides, reminds one very much of the sculptured pediments of Greek temples, which consist of long triangular pieces over the columns at either end. The sculpture held within such pediments always depicted heroic legend and mythology; some of this heroic content has its equivalent in *Guernica,* since there too we get a warrior with a spear, a horse and various strongly built women. Here, however, it is as if such a pediment had been ridden over and broken up by a steam roller. We read the composition across from right to left and back again; and the surface, which corresponds to the forward plane of a Greek pediment, seems to buckle back and forth before our eyes. It is as if modern violence buckled what was ordered and stable about the Classical art of antiquity and the Western tradition descending from it, distorting and throwing it into dislocation and confusion.

A reading of *Guernica's* imagery arrived at in this way certainly goes far beyond Picasso's own statement. But it has its justification in the whole character of the work, and can be supported by parallels in other works of Picasso's, particularly ones which indicate his familiarity with the kind of Renaissance and later art which has been mentioned.

During and after the last stage of *Guernica,* Picasso did a number of 'postscripts', in the form of separate versions of some of the key figures. One of them, a *Head of a Weeping Woman,* dated 28 October 1937, is illustrated here. It shows that the creative heat with which Picasso worked on *Guernica* was not confined to that canvas alone, but spilled over outside it. There was an emotional hangover or surplus which demanded the creation of further related works. But the modest scale of this *Weeping Woman,* the fact that it is a self-contained work, and its colouring (wash) shift the imagery of *Guernica* from a public to a more personal level.

This in turn leads into a larger issue, the place of *Guernica* in Picasso's development. After it there is a definite parting of the ways in Picasso's art between his humanism and his sheer ability to improvise and manipulate forms. Humanism comes back again in two sculptures done during the Second World War: the *Skull* of 1941 with hollowed eyes and broken nose,

127 Pablo Picasso, *Head of a Weeping Woman.* Fogg Art Museum, Harvard
University, Cambridge, Mass., Purchase—Frances H. Burr Memorial Fund.

suggesting the wartime mood, and the *Man with the Lamb* of 1943, which is an upright, naked figure of an oldish man, carrying a young lamb before him. Those two works, however, are exceptions. Broadly speaking, Picasso's work after *Guernica,* through all its different later phases, was personal and improvisational in character.

From a technical point of view, Picasso was using in *Guernica* devices, involving the splintering of anatomy into parts and the superimposition on one another of semi-geometric forms, which come out of his invention of Cubism a quarter of a century earlier. And the buckling effect described earlier may be too extreme for the painting to work successfully in its final form as a surface arrangement. What worked well here in terms of pure line, in the preliminary studies, does not work so well when blacks, white and greys are added, which tighten up and bring forward the spaces between the figures.

There is also the whole question of the readability of the images them-selves. Does *Guernica* add up to more than a series of powerful and poignant details combined with one another, but ultimately separate in their impact? More than any other Picasso, this painting has a potential of speaking to the world at large. Its scale and the scope of its imagery declare this to be so. But does it really succeed in communicating in a 'public' way? Would it, for example, make any consistent impact on a person who had no knowledge of modern art or Picasso's earlier art? Or would that person simply find it confusing and difficult to make sense of?

These questions are matters of opinion and judgment. One would not normally ask them of a comparable large painting by an older master, partly because the conditions of communication were quite different then from what they are in the modern period, and partly because the work has in fact stood the test of time. But though Picasso has long since come to occupy an extraordinary place in the history of modern art, in terms of achievement as well as fame, his ultimate status as an artist is not yet fully assured. Whether *Guernica* really is a masterpiece in the same full sense as the greatest works in the past is not yet settled, and will depend ultimately on the critical questions which have been raised here. It is with such questions that a study in depth of a modern artist should properly end.

Epilogue: the art historian today

ONE WAY in which art history goes forward is through the ever fresh injection into it of current concerns and values. Art historians' views of the art of the past are constantly being modified in interesting ways by contemporary trends. For example, the art scene has today become completely international. There is no longer any sort of a time gap between developments in New York and London, Tokyo or Berlin, or any sort of a communication gap affecting artists' knowledge of what is going on elsewhere. Art history has become correspondingly international in its coverage and emphases—looking for developments which cut across the boundaries between different countries, or for meaningful parallels which ignore national divisions and distinctions. The contemporary art scene has also put a strong emphasis on the use of images deriving from the artist's own culture—objects such as comic strips, photos of film stars, cigarette packaging and so on. Thus art historians have looked with similar interest at the emblems and symbols used by past artists which form part of the total culture of the time, as for example a banner carried in a religious procession or a sign used by members of a sect; and, alongside the rational aspects of belief and thought, the dark, irrational and often hidden areas of superstition as well as the mystical and the occult—which are again much in vogue at the present—have come in for attention.

Traditional distinctions between 'high art', the preserve of an élite, and other forms of art, addressed to or simply accepted by a larger audience altogether (as photography is for example), have given way, over the last years, to a more evenly graduated spectrum of what is taken to be 'art'. Art historians have shown an increased interest both in studying those forms of art in their own right, and also in looking at the work of art in a way that assumes the artist's desire to reach a non-exclusive audience. And finally much contemporary art shows a commitment on the part of the artist to the idea of laying bare his whole personality, in whatever he creates. Such ideas tend to percolate from art to art history, so that the separation between the artist's personality and what he creates is much less assumed, as an axiom, than it has been in the past.

But the justification of art history should, at the close of this book, be put into more permanent and fundamental terms. Its value is not, after all, self-

evident. Art is a luxury. It is not one of the basic needs of the human race. The kind of paintings discussed in this book have always appealed to, and been appreciated by, a wealthy and privileged minority. When it comes to increasing the visual awareness of the majority today, photography and film are likely to be more effective than painting or sculpture. And if art is a luxury, art history must be a luxury of luxuries—the icing on the very top of the cake!

All the humanities face the same problem of justifying the time and concentration spent on them, and there can be no final answer. It comes down to questions of the values that make up civilization. Getting into works of art through art history, it can fairly be claimed, leads to improved sensibility, increased visual awareness, and not only from a purely aesthetic point of view. Art has been used in the past in a variety of ways, for display and for worship, for enjoyment, propaganda and so on. There are benefits that quite clearly follow from this. One learns, from studying art historically, how things looked in the past, how people lived and spent their time. The political issues and social ills of a particular era are also often reflected in art. But these are really side-benefits, because art represents here simply one of a number of tools and materials which are available in cultural study; and to consider the works from this kind of standpoint says nothing about the greatness of some works and the relative insignificance of others, and why this should be so. The same applies to the capacity of art to show the abiding and recurring constants of human thought and feeling.

There is, however, a key difference between art and other forms of cultural expression. Literature has to be approached through language, and even with English there are changes of so substantial a kind that it is not that easy to find one's way now into Anglo-Saxon poetry or Chaucer, while there are many passages in Shakespeare which call for a glossary. Music and theatre, the performing arts, involve interpretation. Art in contrast, simply because it is a visual medium, is less strongly affected, in terms of response to it, by intervening changes in the medium, or the form of presentation adopted. It has in this sense a particular kind of immediacy and directness, which strongly affects its appreciation.

Furthermore, and here there is no difference from literature or philosophy or any other kind of creative writing, the great masterpieces of art represent the highest reaches of imagination and creativity, and in that sense a kind of ideal. In art history one enters into the personality of the great artist as a thinker and a creator. To do this is a commitment, the nature of which has nothing to do with the kind of 'myths' about the relationship between the lives of artists and their works, on which movies and popular novels are based; nor is it a matter of communing with the great in some largely intuitional kind of way. Rather, what counts is the deep and true and forceful understanding that is reached through a study of art history: of what it took to produce a particular work of art. It has been one of the points of this book that the experience gained, from the study of art in this way, is an unfolding and a greatly enriching one.

182

References and books for further reading

This list includes both general works in English which give a fuller introduction to the painters and their background and more detailed references for readers who are interested in following up the particular cases discussed.

INTRODUCTION

Verrocchio-Leonardo 'Baptism':
G. Passavant, *Andrea del Verrocchio als Maler*, Düsseldorf, 1959, pp. 77–79 (the fullest account of both the historical recognition of joint authorship and the pictorial differences).

Lotto 'Odoni': J. Pope-Hennessy, *The Portrait in the Renaissance*, Bollingen Foundation, London and New York, 1966, pp. 228–31 (noting theme of ravages of time).

Van Gogh forgery: J. B. De La Faille, *Les Faux Van Gogh*, Paris and Brussels, 1930, pp. 3–5 and 11, no. F 527 bis; and *The Work of Vincent Van Gogh, His Paintings and Drawings*, American edition, New York, 1970, p. 592, no. F 527a.

On sources: Titian: R. W. Kennedy, 'Tiziano in Roma', *Il mondo antico nel rinascimento. Atti del V convegno internazionale di studi del rinascimento*, Florence, 1958, p. 238; E. Panofsky, *Problems in Titian, Mainly Iconographic*, London and New York, 1969, p. 151.

Rembrandt: K. Clark, *Rembrandt and the Italian Renaissance*, London, 1966, New York, 1969, ch. 4.

Gauguin: R. Field, 'Gauguin, plagiaire ou créateur', *Gauguin*, collection Génies et Réalités, Paris, 1960, p. 165.

CHAPTER ONE

Giovanni Morelli: The English edition of his *Italian Painters* (1889), trans. C. J. Foulkes, London, 1892–93 and later editions, has as its introduction an account of his life and work by Sir Austen Henry Layard. See also Edgar Wind, *Art and Anarchy* (The Reith Lectures), London, 1960; revised edition New York, 1968 (paperback), ch. 3, 'Critique of Connoisseurship'.

Bernard Berenson: His essay 'Rudiments of Connoisseurship' (1902), in *The Study and Criticism of Italian Art*, 2nd series, London, 1920, p. 111ff., provides a good introduction to what connoisseurship entails. The long opening essay in *Three Essays in Method*, Oxford, 1927, 'Nine Pictures in Search of an Attribution', is more of a self-conscious reconstruction of how the results were arrived at. There is a readable biography of the man by S. Sprigge, *Berenson*, Oxford, 1960.

Max J. Friedländer: His book *The Connoisseur* (1919) has been translated as *Art and Connoisseurship*, London, 1942. There is a volume of recollections by him, *Reminiscences and Reflections* (1968), trans. R. Magurn, with introduction by R. Heilbrunn (ed.), London and New York, 1969 (paperback), recreating the art world of Berlin before and after the First World War.

Discoveries: M. Jaffé, 'The picture of the Secretary of Titian', *Burlington Magazine* 108, 1966, pp. 114–26.

D. Mahon, 'Contrasts in Art Historical Method, Two Recent Approaches to Caravaggio', *Burlington Magazine* 95, 1953, p. 212; D. Sutton, 'Seventeenth-Century Art in Rome', *Burlington Magazine* 99, 1957, p. 113.

H. Gerson, 'La lapidation de Saint Etienne peinte par Rembrandt en 1625', *Bulletin des musées et monuments lyonnais* 3, no. 4, 1962, pp. 57–62, trans. as 'A Rembrandt Discovery', *Apollo* 77, 1963, pp. 371–72. Slive's translation (1963, see below) of a phrase from the French is used.

F. J. B. Watson, 'The Newly

Discovered Tiepolo Ceiling', *Apollo* 81, 1965, pp. 186–88.

M. Roskill, 'An Unexpected Gauguin Discovery', *Boston Museum Bulletin* 62, no. 328, 1964, pp. 81–88.

Rembrandt and Lievens: S. Slive, 'The Young Rembrandt', *Allen Memorial Art Museum Bulletin* 20, no. 3, 1963, pp. 136–37; J. Rosenberg and S. Slive, *Dutch Art and Architecture 1600–1800*, London and Baltimore, 1966, p. 84.

Barberini Master: F. Zeri, *Due dipinti, la filologia e un nome: il maestro delle tavole Barberini*, Turin, 1961.

CHAPTER TWO
Masaccio: Ugo Procacci, *All the Paintings of Masaccio* (1961), trans. P. Colacicchi, London and New York, 1962; Luciano Berti, *Masaccio* (1964), trans. Pennsylvania, 1967; *Masaccio, Frescoes in Florence*, introduction by Philip Hendy, New York, 1956 (for large colour plates of Masaccio's work in the Brancacci Chapel).
Distinction of hands: R. Longhi, 'Fatti di Masaccio e di Masolino', *Critica d'Arte* 45–46, 1940–41, pp. 145–91; C. Gilbert, review of L. Berti, *Masaccio* (1964, trans. 1967), *Journal of Aesthetics and Art Criticism* 27, 1969, pp. 465–66 (state of studies and of current agreement).
Uffizi altarpiece: *Mostra di quattro maestri del primo rinascimento*, exhibition catalogue, Florence, Palazzo Strozzi, 1954, no. 1 (summary of earlier opinions).
S. Maria Maggiore, Florence, altarpiece: H. Lindberg, *To the Problem of Masaccio and Masolino*, Stockholm, 1931, pp. 125–31 (for parts given to Masolino); U. Baldini, 'Masaccio', *Encyclopaedia of World Art*, New York, 1964, Vol. IX, pp. 512–13; C. Gilbert, forthcoming book, for affirmative linking of Horne predella.
Brancacci Chapel: P. Murray (ed.), *An Index of Attributions made in Tuscan Sources before Vasari*, Florence, 1959, pp. 110–15 (for other paintings in Carmine also); R. W. Kennedy, review of M. Salmi, *Masaccio* (1932), *Art Bulletin* 16,

1934, p. 396 (for scaffolding); U. Procacci, 'Sulla cronologia delle opere di Masaccio e di Masolino tra il 1425 e il 1428', *Rivista d'Arte* 28, 1953, pp. 3–55 (for chronology and order of paintings).
Reggello altarpiece: L. Berti, 'Masaccio 1422', *Commentari* 12, 1961, pp. 84–107.

CHAPTER THREE
Piero: K. Clark, *Piero della Francesca*, London, 1951, revised edition 1969; Piero Bianconi, *All the Paintings of Piero della Francesca* (1957), trans. P. Colacicchi, London and New York, 1962; Philip Hendy, *Piero della Francesca and the Early Renaissance*, London and New York, 1968; Roberto Longhi, *Piero della Francesca* (1927, second edition 1942) trans. L. Penlock, London, 1930; C. Gilbert, *Change in Piero della Francesca*, New York, 1968 (fundamental for its rescrutiny of numerous points of detail); O. del Buono, *L'Opera completa di Piero della Francesca*, Milan, 1967 (for summaries of opinions).
Individual works: Fresco of a saint, ? Julian: M. Salmi, 'L'affresco di Sansepolcro', *Bollettino d'Arte* 40, 1955, p. 230ff.; unsigned note by editor, 'A Fresco Fragment by Piero della Francesca', *Burlington Magazine* 98, 1956, p. 445 (including remarks on quality); *Mostra di affreschi staccati*, exhibition, Florence, Forte del Belvedere, 1957, catalogue by L. Berti, no. 1.

Perugia altarpiece: C. Brandi, 'Restauri a Piero della Francesca', *Bollettino d'Arte* 39, 1954, pp. 253–57.

S. Agostino altarpiece: M. Meiss, 'A Documented Altarpiece by Piero della Francesca', *Art Bulletin* 23, 1941, pp. 53–70; K. Clark, 'Piero della Francesca's St Augustine altarpiece', *Burlington Magazine* 89, 1947, pp. 204–09.

Williamstown altarpiece: U. Gnoli, 'Una tavola sconosciuta Piero della Francesca', *Dedalo* 11, 1930, p. 133; Sterling and Francine Clark Art Institute, Williamstown, Exhibit Eight, 15th and 16th c. paintings, 1957, no. 416.

Signorelli altarpiece: B. Berenson,

'An early Signorelli in Boston', *Art in America* 14, 1925–26, pp. 105–17.

CHAPTER FOUR

Giorgione: Luigi Coletti, *All the Paintings of Giorgione* (1961) trans. P. Colacicchi, London and New York, 1962; P. Zampetti, *Giorgione e i giorgioneschi*, exhibition catalogue, Venice, Palazzo Ducale, 1955; L. Baldass and G. Heinz, *Giorgione*, Vienna, 1964, English ed. London, 1965; E. H. Gombrich, 'Renaissance Artistic Theory and the Development of Landscape Painting', *Gazette des Beaux-Arts* 41, 1953, pp. 335–60. S. J. Freedberg, *Painting in Italy in the Sixteenth Century* (2 vols.), London and Baltimore, 1970, ch. 2 (this author's critical summary and synthesis on the subject).

Individual works: Tempest: C. Gilbert, 'On Subject and Non-Subject in Italian Painting', *Art Bulletin* 34, 1953, pp. 211–16; for the new suggestion of an allegorical interpretation, E. Wind, *Giorgione's 'Tempesta'*, Oxford, 1969, p. 4, and for the newer suggestion still that is cited, N. T. De Grummond, 'Giorgione's "Tempest": the Legend of St Theodore', *L'Arte* 18–19/20, 1972, pp. 5–53.

Laura: E. Verheyen, 'Der Sinngehalt von Giorgione's "Laura" ', *Pantheon* 26, 1968, pp. 220–27.

Judith: J. Bialostocki, 'Recent Research, Russia, I' (citing T. Fomicheva), *Burlington Magazine* 99, 1957, p. 188.

Castelfranco Madonna: R. Longhi, *Viatico per cinque secoli di pittura veneziana*, Florence, 1946, pp. 19–22.

Fondaco: M. Roskill, *Dolce's 'Aretino' and Venetian Art Theory of the Cinquecento*, New York, 1968, pp. 324–26 (summarizing evidence); a further detached fragment, R. Palluchini, *Tiziano* (2 vols), Florence, 1969, pl. 14.

Kingston Lacy Judgment of Solomon: Barbara Knowles Debs, *Sebastiano del Piombo—The Venetian Works*, Harvard Ph.D. thesis, 1967.

CHAPTER FIVE

Raphael: Ettore Camesasca, *All the Paintings of Raphael* (1956, second edition 1962), trans. L. Grosso (2 vols), London and New York, 1963; Oskar Fischel, *Raphael*, trans. B. Rackham (2 vols), London, 1948; W. Suida and L. Goldscheider (ed.), *Raphael*, Oxford, 1941; Nello Ponente, *Who Was Raphael?*, trans. J. Emmons, Geneva, 1967.

The Cartoons: *The Raphael Cartoons*, introduction by John White, London, 1972; J. White and J. Shearman, 'Raphael's Tapestries and their Cartoons, Part I', *Art Bulletin* 40, 1958, pp. 193–221; J. Shearman, *Raphael's Cartoons in the Royal Collection and the Tapestries for the Sistine Chapel*, London, 1972.

CHAPTER SIX

Georges De La Tour: S. M. M. Furness, *Georges de la Tour of Lorraine, 1593–1652*, London, 1949; C. Wright, 'Georges De La Tour—A Note on his Early Career', *Burlington Magazine* 102, 1970, p. 387 (reviewing documents); A. Blunt, 'Georges de la Tour' (review of F.-G. Pariset, *Georges de la Tour*, 1948), *Burlington Magazine* 92, 1950, p. 145, and *Art and Architecture in France 1500–1700*, London and Baltimore, 1953, pp. 177–78. Cf. also *The Age of Louis XIV*, exhibition catalogue, London, Royal Academy, 1968, nos. 21, 23, 26; A.-M. Bougier, *Georges de la Tour, peintre du roy*, Bruges, 1963, pp. 56–57.

Successive rediscoveries: H. Voss, 'G. Dumesnil de la Tour', *Archiv für Kunstgeschichte* 2, 1914–15, fasc. 3–4, pls. 121–23; L. Demonts, 'Georges du Ménil de La Tour, peintre lorrain au début du XVIIe siècle', *Chronique des arts et de la curiosité*, 30 April 1922, pp. 60–61; A. Philippe, 'Le Musée départemental des Vosges', *La renaissance de l'art français et des industries de luxe*, September 1924, pp. 505–12; Voss, 'Georges du Mesnil de la Tour, A Forgotten French Master of the 17th Century', *Art in America* 17, 1928–29, pp. 40–48; C. Sterling, *Les peintres de la réalité en France au XVIIe siècle*, exhibition catalogue (third edition), Paris 1935.

1972 exhibition: P. Rosenberg and J. Thuillier, *Georges de la Tour,* catalogue, Paris, Orangerie des Tuileries.

Fortune-Teller: F.-G. Pariset, 'A Newly Discovered De La Tour, "The Fortune Teller" ', *Metropolitan Museum of Art Bulletin* 19, 1961, pp. 198–205.

Art historians mentioned at the end of the chapter: Heinrich Wölfflin's *Principles of Art History* (1915), can be read in the English translation by M. D. Hottinger, London and New York, 1932.

Two parts of Max Dvorak's study *Kunstgeschichte als Geistesgeschichte* (1928), have been published in English: *Idealism and Naturalism in Gothic Art,* trans. and ed. R. J. Klawiter, Indiana, 1967; and 'El Greco and Mannerism', trans. J. Coolidge, *Magazine of Art* 46, 1953, pp. 14–23.

CHAPTER SEVEN
Vermeer: Ludwig Goldscheider, *Johannes Vermeer, The Paintings, Complete Edition,* London, 1958, second edition 1967; Lawrence Gowing, *Vermeer,* London and New York, 1953; Vitale Bloch, *All the Paintings of Vermeer,* trans. M. Kitson, London and New York, 1963; A. B. de Vries, *Jan Vermeer of Delft* (1939), new English edition London and New York, 1948; S. Slive, ' "Een dronke slapende meyd an een tafel" by Jan Vermeer', in *Festschrift Ulrich Middledorf* (2 vols), Berlin, 1968, pp. 452–54, with earlier interpretations of Vermeer paintings cited, especially: A. J. Barnouw, 'Vermeer's zoogenaamd "Novum Testamentum" ', *Oud Holland* 32, 1914, pp. 50–54 (Allegory of Faith); K. G. Kultem, 'Zu Vermeers Atelierbild', *Konsthistorisk Tidskrift* 18, 1949, pp. 90–98 (Artist in Studio); W. Bürger (E. Thoré), 'Van der Meer der Delft', *Gazette des Beaux-Arts* 21, 1886, p. 460 (Woman Weighing Pearls).
Velasquez: José Lopez Rey, *Velasquez's Work and World,* London and New York, 1968; Denys Sutton, *Diego Velasquez,*

London and New York, 1966–67; Elizabeth du Gué Trapier, *Velasquez,* New York, 1948; M. Soria, review of E. Lafuente, *The Paintings and Drawings of Velasquez* (1945), *Art Bulletin* 27, 1945, p. 215, and 'An Unknown Early Painting by Velasquez', *Burlington Magazine* 91, 1949, pp. 124–27; C. de Tolnay, 'Velasquez' "Las Hilanderas" and "Las Meniñas" (An Interpretation)', *Gazette des Beaux-Arts* 35, 1949, pp. 21–32, citing earlier literature, especially D. Angulo Iniguez, 'Las Hilanderas', *Archivio Español de Arte* 81, 1948, pp. 1–19.
Specialized studies on symbolism: I. Bergstrom, 'Disguised Symbolism in "Madonna" Pictures and Still Lifes', *Burlington Magazine* 97, 1955, pp. 303–08 and 342–49; S. Slive, 'Realism and Symbolism in Seventeenth-Century Dutch Painting', *Daedalus* 91, 1962, pp. 469–500, and 'On the Meaning of Frans Hals' "Malle Babbe" ', *Burlington Magazine* 105, 1963, p. 432ff; E. de Jongh, *Zinne- en minnebeelden in de schilderkunst van der zeventiede eeuw,* Holland, 1967, pp. 25–42 (for bird and animal symbolism in erotic contexts); A. Bredius, *Rembrandt, The Complete Edition of the Paintings* (third edition, rev. H. Gerson), London, 1969, p. 551, no. 52 (citing earlier opinions); C. de Tolnay, 'A note on the Staalmeesters', and H. van de Waal, 'The Mood of the "Staal-meesters" ', *Oud Holland* 73, 1958, pp. 85–89.

CHAPTER EIGHT

Van Meegeren: John Godley, *The Master Forger, the Story of Hans van Meegeren,* London and New York, 1950, and (as Lord Kilbracken) *Van Meegeren,* London, 1967 (the second is a more sober assessment of van Meegeren's achievement); Paul Coremans, *Van Meegeren's Faked Vermeers and De Hoochs,* trans. A. Hardy and C. Hult, London, 1949 (report of the scientific commission); Jean Decoen, *Back to the Truth. Vermeer-van Meegeren; Two Genuine Vermeers,* trans. E. J. Labarre, Rotterdam, 1951 (presents counter-

claim about two of the paintings; as stated in my text, readers may be left to judge the validity of the arguments for themselves); A. Bredius, 'A New Vermeer', *Burlington Magazine* 71, 1937, p. 211 (publishing the Supper at Emmaus); Baburen forgery: *Illustrated London News,* 7 January 1961, p. 23; Christ among Doctors: J. Emerson, 'Postscript to the Van Meegeren Affair', *Go,* Oct/Nov 1951, pp. 66–67; Van Beuningen's actions: J. Russell, 'Revenge Keeps Its Colour, The Last of Van Meegeren', *Sunday Times,* 23 October 1955; M. Roskill, 'Post-Mortem on a Forger', *Cambridge Review,* 5 June 1954, pp. 523–24, and various lectures given on the Van Meegeren story 1949–53. **Forgeries in general:** Otto Kurz, *Fakes, A Handbook for Collectors and Students,* London and New Haven, 1948 (paperback, New York, 1967); George Savage, *Forgeries, Fakes and Reproductions, A Handbook for the Collector,* London, 1963.

CHAPTER NINE

Picasso: Roland Penrose, *Picasso, His Life and Work,* London and New York, 1958 (paperback, New York, 1962); Alfred Barr, *Picasso, Fifty Years of his Art,* New York, 1946; John Berger, *The Success and Failure of Picasso,* Harmondsworth, 1965 (a provocative critical study); C. Greenberg, 'Picasso at Seventy-five' (1957), in his *Art and Culture,* Boston, 1961, pp. 64–66. **Guernica:** Rudolf Arnheim, *Picasso's Guernica, The Genesis of a Painting,* Berkeley, 1962 (study by a visual psychologist of the work's evolution); Sir Anthony Blunt, *Picasso's Guernica,* Oxford, 1969; R. Goldwater, Trask lecture on Symbolism in Modern Art, Princeton University, 1958, repeated New York University, Institute of Fine Arts, 1959 (stressing architectural context); H. B. Chipp, 'Guernica, Love, War and the Bullfight', *Art Journal,* 33, 1973–74, pp. 100–115; J. Larrea, *Guernica,* New York, 1947, pp. 56–57; D. Gioseffi, 'Picasso, Guernica ed i codici mozarabici', *Critica d'Arte*

12, 1963, pp. 6–24. (Cf. also R. Kauffman, 'Picasso's Crucifixion of 1930', *Burlington Magazine* 111, 1969, pp. 553–61.)

EPILOGUE
D. D. Reiff, 'The Scope and Import of the Study of Art History', *The Baylor Line,* Baylor University, Texas, Jan/Feb 1968, pp. 30–32.

FURTHER INTRODUCTORY READING IN ART HISTORY
The following art history books, many of them classics in the field, are all available in paperback, either in Britain or the USA. They are grouped here under subjects and periods. Books on individual artists, and studies limited to particular styles or works have not been included here, since they can be found easily by looking under the artist's name or the subject-heading in library catalogues and shelf listings. Period surveys have equally been omitted. Dates of original publication are given in parentheses, since it is important to be aware at what approximate date a book, or series of articles making up a book, first came out. The main listing is that of the current or most recent paperback edition.

General
Henri Focillon, *The Life of Forms in Art* (1934), trans. C. B. Hogan and G. Kubler (1942), New York, 1966; Arnold Hauser, *The Philosophy of Art History* (1958), London and New York, 1959; George Kubler, *The Shape of Time· Remarks on the History of Things,* New Haven, 1962; Herbert Read, *The Meaning of Art* (1931), fourth edition, New York, 1969.
Artistic techniques
Cennino Cennini (*Il Libro d'Arte,* early 15th century), *The Craftsman's Handbook,* trans. D. V. Thompson (1932–33, 2 vols), New York, 1960; W. G. Constable, *The Painter's Workshop* (1954), Boston, 1963.
Cross-studies (covering developments of more than one period)
Kenneth Clark, *Landscape into Art* (1949, also called *Landscape Painting*), Harmondsworth, 1956; Max J.

Friedländer, *Landscape, Portrait, Still-Life: Their Origin and Development* (1947), trans. R. F. C. Hull (1949), New York, 1963; Nikolaus Pevsner, *The Englishness of English Art* (1955), Harmondsworth, 1964; Heinrich Wölfflin, *Renaissance and Baroque* (1888), trans. K. Simon (1964), Ithaca, 1966.

Iconography
Erwin Panofsky, *Meaning in the Visual Arts* (1921–46), New York, 1955, London, 1970; Jean Seznec, *The Survival of the Pagan Gods; The Mythological Tradition and its Place in Renaissance Humanism and Art* (1940); trans. Sessions, New York, 1953.

Visual psychology
Rudolf Arnheim, *Art and Visual Perception; A Psychology of the Creative Eye*, Berkeley, 1954, London, 1956; Ernst Gombrich, *Art and Illusion, A Study in the Psychology of Pictorial Representation* (1960), Princeton, 1965.

Criticism
Roger Fry, *Vision and Design* (1900–20), London and New York, 1956; Clement Greenberg, *Art and Culture, Critical Essays* (1939–60), Boston, 1965, and London, 1973.

Collectors and Museum Men
Niels van Holst, *Creators, Collectors and Connoisseurs* (1960), trans. and expanded from the German, introduction by Herbert Read, London and New York, 1967; Germain Bazin, *The Museum Age*, trans. J. van Muis Cahill, New York, 1967.

Ancient Art
Charles T. Seltman, *Approach to Greek Art* (1948), New York, 1960; Rhys Carpenter, *The Aesthetic Basis of Greek Art of the Fifth and Fourth Centuries B.C.*, Indiana, 1959.

Medieval
Adolf Katzenellenbogen, *Allegories of the Virtues and Vices in Medieval Art* (1939), New York, 1964; Erwin Panofsky, *Gothic Architecture and Scholasticism* (1951), London, 1957, New York, 1964; Emile Mâle, *The Gothic Image, Religious Art in France in the Thirteenth Century* (1910), trans. D. Nussey, London,

1961, New York, 1958; Millard Meiss, *Painting in Florence and Siena after the Black Death* (1951), New York, 1964; Johann Huizinga, *The Waning of the Middle Ages* (1919), trans. F. Hopman, New York, 1955, and Harmondsworth, 1965.

Renaissance
Erwin Panofsky, *Renaissance and Renascences in Western Art* (1960), second edition, New York, 1963; Jean Alazard, *The Florentine Portrait* (1924), trans. B. Whelpton, New York, 1969; Erwin Panofsky, *Studies in Iconology: Humanistic Themes in the Art of the Renaissance* (1932–39), London and New York, 1962; Wylie Sypher, *Four Stages of Renaissance Style*, New York, 1955; Walter Friedländer, *Mannerism and Anti-Mannerism in Italian Painting* (1925–29), trans. 1957, New York, 1965.

Baroque to the 19th century
John Summerson, *Heavenly Mansions and Other Essays on Architecture* (1950), New York, 1963; Fiske Kimball, *The Creation of the Rococo* (1943), New York, 1964; Kenneth Clark, *The Gothic Revival, An Essay in the History of Taste* (1928), Harmondsworth, 1964.

Modern
Alfred Barr, *What is Modern Painting* (1953), tenth edition, New York, 1968; Robert Goldwater, *Primitivism in Modern Art* (1938), revised edition, New York, 1967; John A. Kouwenhoven, *The Arts in Modern American Civilization* (1948; original title *Made in America*), New York, 1967; James Richards, *An Introduction to Modern Architecture* (1940), revised edition, Harmondsworth, 1956; Nikolaus Pevsner, *Pioneers of Modern Design* (1936), Harmondsworth, 1964.

Oriental
Heinrich R. Zimmer, *Myths and Symbols in Indian Art and Civilization*, New York, 1946.

Recommended for book-seeking ·
E. Louise Lucas, *Art Books. A Basic Bibliography on the Fine Arts* (1938), revised edition, New York, 1968.

Index